THE
MAKING OF AMERICA
SERIES

LAKE
WINNIPESAUKEE

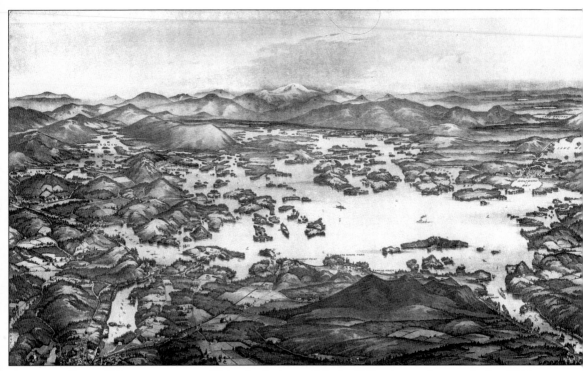

LAKE WINNIPESAUKEE. This depiction of Lake Winnipesaukee and the White Mountains was supplied for the tourists by the Boston and Maine Railroad in 1909.

THE
MAKING OF AMERICA
SERIES

LAKE
WINNIPESAUKEE

BRUCE HEALD

ARCADIA

Published by Arcadia Publishing,
an imprint of Tempus Publishing, Inc.
2 Cumberland Street
Charleston, SC 29401

Printed in Great Britain.

Library of Congress Catalog Card Number: 2001089081

For all general information contact Arcadia Publishing at:
Telephone 843-853-2070
Fax 843-853-0044
E-Mail sales@arcadiapublishing.com

For customer service and orders:
Toll-Free 1-888-313-2665

Visit us on the Internet at http://www.arcadiapublishing.com

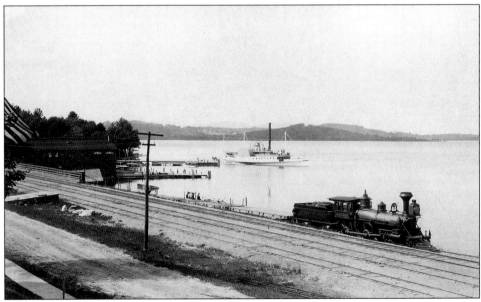

By Rail and by Water. This early-1880s photograph reminds today's readers of the importance of shipping and rail service in Lake Winnipesaukee's history.

CONTENTS

ACKNOWLEDGMENTS

Special thanks are extended to the following societies, companies, and individuals for their contribution to this volume: Alton Historical Society, the American Antiquarian Society, the Appalachian Mountain Club, John D. Bardwell, Robert & Barbara Bennett, Steven Bennett, Ronald Bergeron, Paul H. Blaisdell, the Boston, Concord & Montreal Railroad, Boston & Lowell Railroad, the Boston and Maine Railroad, Mary R. Boswell, Ella S. Bowles, the Center Harbor Historical Society, Solon B. Colby, Laura A. Dudley, Merrill Fay, Albert Fisher III, Gardiner Greene, William Greene, Barton McLain Griffin, Stephen Holden, Warren Huse, *Illustrated Laconia*, Starr King, the Laconia Historical Society, Stephen Laurent, Elizabeth Lavertur, Robert Lawton, the Meredith Historical Society, Herb Mattlage, James Morash, the Moultonboro Historical Society, Adair D. Mulligan, Robert Murphy, New Hampshire Department of Resources and Economic Development (DRED), New Hampshire Planning and Development Commission, the New Hampshire Historical Society, the North American Fisherman Club (Minnetonka, Minnesota), Samuel L. Powers, Chester B. Price, Porter Sargent, Ron White, Nancy Wilson, the Winnipesaukee Flagship Corporation, and the Wolfeboro Historical Society.

INTRODUCTION

Winnipesaukee is a mountain lake, yet it lacks almost all those wild, rough features of mountain scenery that usually characterize inland waters in mountainous regions. The mountains rise on all sides, but the shore, seen from the distance, is comparatively smooth and level. The islands, far from being precipitous and rocky, are covered with verdure and seem to float like fairy barks upon the broad mirror-lake.

The lake is usually approached in the calm and stillness of the noon-day sun. The spirit of repose, happening upon the hour and upon the escape from the hot dusty roads, harmonizes with the green foliage of the islands and the quiet surface of the water periodically ruffled by a mild, balmy breeze. Giving ourselves up to its genial influences, we no longer wonder at the Indian admiration that gave it the name, "the Smile of the Great Spirit."

The route by way of this lake is the finest approach to the White Mountains. Here is a vast antechamber from which we look up through the valley of the Saco to the towering peaks of the mountains. Yet neither this, nor the impression of lofty mountain scenery, completely constitutes the charm of the lake view. The attraction consists rather in the freedom from the care and turmoil of busy life, the feeling of quiet and repose engendered by the exquisite harmony of the outlines of the surrounding mountains, seen either from the lake or from the hotels on shore, and the inviting aspect of the little islands which everywhere glisten like emeralds on its bosom. The ever-varying hues of the landscape, running through the whole spectrum from sunrise to sunset, and transforming the lake into an opal gem, are sources of perpetual delight.

The lake is like a chameleon. Sail over it some afternoon when the sky is leaden with northern mists, and we may see, besides the simple beauty of its form, that the splendor of its color is ever changing. But most especially, under the magical influence of the evening light, the landscape appears unsteady, and the surrounding scene seems to undergo a change into something

rich and wonderful. At one moment, a wooded island blazed with a bright red and yellow, green and scarlet, and later a mixed mass of vegetated gray and purple.

Few words or pictures can express the majesty and beauty of which the lake offers or convey an impression of the loveliness that lifts it above the rank of prosaic splendor. Edward Everett spoke the following in Starr King's *The White Mountains*, 1866:

> I have been something of a traveller in our own country though far less than I could wish and in Europe have seen all that is most attractive, from the Highlands of Scotland to the Golden Horn of Constantinople from the summit of the Hartz Mountains to the Fountain of Vaucluse; but my eye has yet to rest on a lovelier scene than that which smiles around you as you sail from Weirs' landing to Centre Harbor.

The surroundings are scarcely less wild then they were in 1652, when Captain Edward Johnson and Simon Willard carved their initials on Endicott Rock near Lake Winnipesaukee's outlet at Weirs Beach in Laconia. But it is not a sense of seclusion amid the forest, of being shut in by untamed hills within the heart of the wilderness, that the lake inspires. Indeed, they are not shut in by any abrupt mountain wall.

For many years the presence of Native Americans prevented the Europeans from settling the territory. To make their first settlement safer, the proprietors from Exeter voted to clear a road to the Lakes Region and build two block houses, one at the southeast corner of the grant called White Hall (a part of Gilmantown) and the second at the Weirs, near the northern end of the present White Oaks Road in the section known as Aquadoctan.

By 1764, Colonial Governor John Wentworth completed a "Province road" from Portsmouth to Wolfeboro. The establishment of his summer home gives Wolfeboro the distinction of being the "Oldest Summer Resort in America." By 1768, the north and west sides of the Winnipesaukee River were chartered by the governor and council as a part of Meredith.

Lake travel has played a major role in the development of this Lakes Region, beginning with the primitive Native American canoes. Since the 1800s, horseboats, sailboats, rowboats, steamboats, racing boats, and the present motorboats have plied these waters.

By 1880, Winnipesaukee had attracted many admirers who built simple summer dwellings on the mainland shores and islands. With the coming of the railroad during the 1840s, and later the automobile, the number of visitors and residents has increased enormously. The thousands who visited annually at the turn of the century have become millions today.

The arrival of the railroad greatly affected local industries, and more significantly, tourism. With the advent of mass transportation came the grand hotels and the lavish summer resorts. The Boston, Concord & Montreal Railroad opened a road from Boston to Meredith Bridge (Laconia) on August 1,

1848; later, in the 1850s, it connected the road to the White Mountains, making the area more accessible for summer and winter visitors.

Fishing has always been a year-round sport, with salmon, brook and rainbow trout, pickerel, yellow and white perch, shad, smelt, and black bass all taken in their proper season. In fact, practically all fish native to New Hampshire are taken within the waters of Winnipesaukee. Winter fishing is a special feature, with tiny houses clustered here and there on the ice for the comfort of the fisherman.

Over the past 100 years, many boys' and girls' camps have sprung up on the shores of the lake. Summer theaters, public beaches, chalets, marinas, cabins, motels, hotels, condominiums, camping areas, boatyards, and ski resorts continue to embrace the landscape. Regattas, summer concerts, snowmobile trails, cross-country skiing, and sled dog racing have continued to enrich the ever-increasing desire for outdoor entertainment.

The simplicity and vitality of the Winnipesaukee landscape is a tonic for the vacationer—a relief from the wearisome harness of regularity. *Lake Winnipesaukee* offers the reader with a few glimpses of the loveliness, romance, and legacy of the lake, a reflective and nostalgic history of the people, industry, and culture of its past. Throughout the Lakes Region, breathtaking scenery and the lingering charm of bygone days captivate those who visit and also those who know the lake well, and here we wish to capture some of the characteristics of a place that give such pleasure.

We may venture to say that within a very small radius of America is there such a concentrated wealth of spectacular mountains, valleys, and waterways. The climate, natural resources, and superb accommodations make an irresistible combination for all who visit the Lakes Region. It is truly a "Beautiful Water in a High Place."

—Bruce D. Heald, Ph.D.

1. The Lake's Geology and Features

Nestled among the foothills of the White Mountains lies one of the most beautiful bodies of water in the world, Lake Winnipesaukee, "the Beautiful Water in a High Place." It is safe to say that Winnipesaukee is one of the three largest freshwater lakes in the continental United States that lies wholly within the borders of one state. Winnipesaukee, New Hampshire's largest lake, with an area of 72 square miles and a mainland shoreline of 186 miles, is dotted with 274 habitable islands and surrounded by the foothills of the White Mountains. The lake is one of the most beautiful scenic areas in the world with islands ranging in size from those of over 1,000 acres to tiny dots of rock and turf that are scarcely large enough to hold a small summer camp. Within the small bays and coves may be found the quaint little villages that make the Lakes Region so famous.

Standing upon any elevation of the region, one may command a magnificent view, a vista from a natural verandah, and from the many cottage sites, one may experience the enhancement of heavily wooded hillsides, ancient forest growth, and ragged situations of wilderness that are common presentations on the shoreline.

This glacial-formed lake is 504 feet above sea level, approximately 23.5 miles long, and from 1 to 15 miles wide at its widest point. An examination of a topographical map indicated that, at one time, the Belknap and Ossipee Mountains, located on either side of the lake, were active volcanoes. This lake is very deep, with a maximum depth of 300 feet and is mostly spring fed. When looking at these mirroring waters, one gathers the impression of great depths. However, the general depth varies from 35 to 90 feet. There are, of course, many exceptions to this rule with soundings from over 300 feet, southeast of Rattlesnake Island; depths of 105 feet southeast of Steamboat Island; and 100 feet is a common depth off Mark Island toward Governor's Island.

Many years ago, a great canyon extended through the eastern section of Lakeport, which would be parallel with the present channel now serving as an

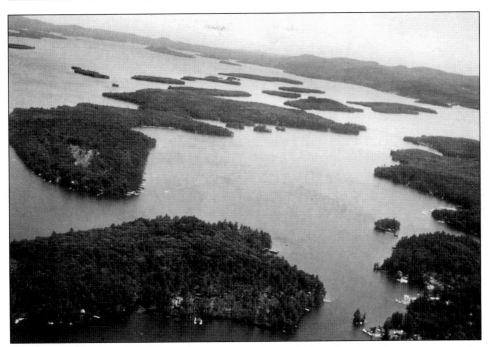

AERIAL VIEW OF LAKE WINNIPESAUKEE. This southeasterly view shows many of the islands clustered near the center of the lake called the "Forties," with Bear Island in the center and Pine Island to the left foreground.

outlet for Paugus Bay and Lake Winnipesaukee. This large canyon gave the appearance of a vast artificial canal, which encompassed most of Lakeport village.

Some scientists believe that 1,000,000 years ago a great ice cap accumulated in Canada. As this ice cap grew, it slowly spread out in all directions. Its southern border crept steadily southward until it completely covered the White Mountains and extended as far south as Cape Cod and Long Island, New York. As it moved, it gripped the soil and plucked out blocks of bedrock. The ice thus came to have embedded in it a great load of rock waste of every size.

The work of the ice sheet was finally halted when the climate became warmer and the glacier melted away. As this great mass of ice melted, it dropped its load of clay and boulders irregularly about the country. This glacial drift may be seen almost everywhere today. The water that flowed out of the melting ice also carried great quantities of sand and gravel, much of which was spread or heaped irregularly about the Lakes Region. It may be reasonable to assume that the massive ice cap created great ravines.

Undoubtedly, the great pressure of the lake first broke through the center of this natural dam until gradually these pressures had eaten away and split the dam off from the eastern hill ranges at Lakeport. The final destruction might well have been completed by an earthquake that realized the channel as one views it today. All this water release and quake washed a great deal of debris down the channel

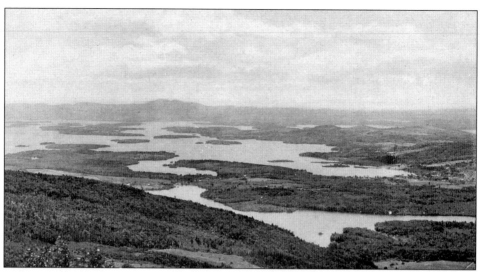

A VIEW OF THE LAKE FROM RED HILL. This grand sheet of water is majestically framed by mountain ranges and quaint villages—a view unchanged by man.

and unquestionably helped to form the sandbars on which a major portion of the city of Laconia now stands.

Edgar H. Wilcomb, in his 1923 publication *Winnipesaukee Country Gleanings*, records the following:

> The rough, broken region southwest of the Weirs, at the head of Lake Paugus, back to the Meredith hills, shows evidence of enormous volumes of water and ice having passed down this way, checked and turned in its southerly course by Raccoon Mountain, forming a part of the westerly section of the great natural dam at Lakeport, indicating that the level of the water was high enough to flow north of Blacksnout Mountain, northwest of the Weirs, as well as between this mountain and the Gilford Mountains. Old Blacksnout must have withstood a terrific battering of water and ice cakes during the tremendous flow, before and after its tough old head was uncovered.
>
> When the great dam broke at Lakeport, an immense flow of water must have started in that direction. Probably the bulk of the water first flowed through the valley comprising the present Intervale and Lily Pond section, east of White Oaks hill, but it is obvious that there was another channel west of the White Oaks, at what is now the Weirs, and that the waters scoured out this channel so rapidly that it eventually became lower than the Intervale channel, until it constituted the only outlet of the lake.
>
> At this period the present site of Laconia and all the territory embraced in the basin bounded by the great natural dam at Lakeport, the

hills east of Laconia, the Sanbornton hills and the elevated section west of Meredith Center, was doubtless submerged by another lake of considerable size, somewhat lower than the others, held back by another big natural dam across the present valley between Belmont and Sanbornton, a considerable portion of which was swept away by the floods until the present valley and channel of the Winnipesaukee river was formed, leaving the small lake south of Lakeport and the larger one southwest of Laconia, separated by the sand banks at Laconia.

It is generally accepted that there have been six or seven glacial periods during the earth's life and that each time they have advanced and receded from and toward the polar regions. Indeed, latter-day inhabitants of the western end of Lake Winnipesaukee and on the shores of the chain of smaller lakes and the Winnipesaukee River have reason to be grateful for the fact that a narrow ridge of rock extending across the valley at New Durham was the cause of the present outlet of the lake.

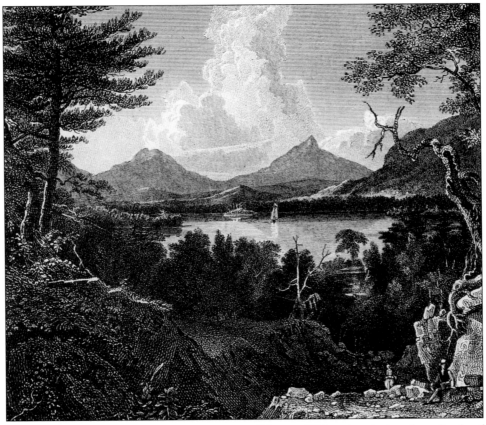

THE COMPLEMENT OF MOUNTAINS AND WATER. *This print depicts the solitude of Center Harbor Bay against a backdrop of the foothills of the White Mountains.*

2. The Vanishing Nation

Many years before the white settlers advanced upon this soil, there was living in this area a powerful tribe of Native Americans. How many generations they had occupied this territory is unknown. There is, however, evidence of their hunting grounds, winter settlements, fishing habits, and from the artifacts left in this area, it would be a safe assumption to estimate several thousands of years. Their chief meeting place was in the neighborhood of Concord, where they are known to have cultivated their corn. These people lived mainly on fish and game, making annual migrations from the interior to the seacoast.

Within the upper region of northern New England, there existed two prominent tribes known as the Abenakis and Sokokis. The name of Abenaki was derived from "Wobanaki" (Land of the East), the name given by the Canadian Algonquins to the country of the Canibas and other Indians of Arcadia. By that, the French called these people the Abenaquiois and later Abenakis, which means "the Indians from where the daylight comes," or "the people of the East." This name was first applied to all Native Americans from Maine to Nova Scotia, but later it was given in particular to those living in Maine, from the Saco River to the Penobscot.

The tribal name of Sokoki was derived from "Sokoakiak," a person from the South country, or one living under the noon-day sun. It applied to those living between the Saco and Connecticut Rivers, which included most of what is now New Hampshire. The French called these people Sokoquiois and later Sokokis.

Their campsites and villages were scattered throughout the state and were known to English merchants and fur traders by Indian names that described the locality in which they lived. For example, the Coosucks lived at the Pine Place, the Penacooks at the Crooked Place, the Suncooks at the Rocky Place, the Naticooks at the Cleared Place, and so on.

The pestilence of 1616 through 1618, which resembled yellow fever, was fatal to nearly 90% of the New Hampshire tribes and affected the Maine Indians to the

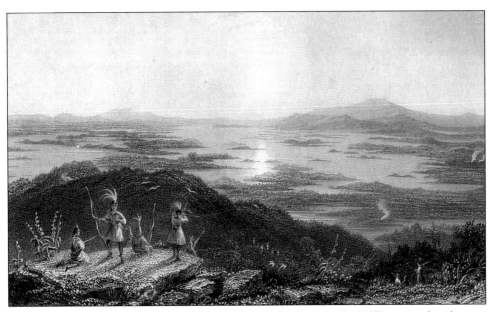

AMERICAN INDIAN LIFE ON THE LAKE. This 1836 depiction by William Bartlett shows a band of early American Indian hunters looking out from upon the summit of Red Hill across Lake Winnipesaukee.

same degree. Up until this time, the Sokokis and Abenakis had more than enough warriors to discourage neighboring tribes such as the Mohawks, centered in western Massachusetts and eastern New York, from making raids into New Hampshire and Maine. However, in 1633, an epidemic of small pox swept through Maine, New Hampshire, and eastern Massachusetts, further weakening the tribes to such an extent that the neighboring Mohawks did in fact raid their villages with little opposition. They not only stole their furs, but took enough prisoners to carry their loot back to Albany, where it was sold to Dutch traders.

Before the Native American tribes became reduced in numbers by pestilence and emigration, nearly 3,000 lived along the banks of the Merrimack River and its tributaries, from the White Mountains to the Atlantic, a distance of approximately 200 miles. By 1674, according to General Goodin in his *Historical Collections of the Indians,* "There are none of these people left at this day three hundred men besides women and children."

In 1614, 60 years previous to Goodin's notation, the Winnipesaukee tribe alone consisted of more than 400 people with villages and campsites at Alton Bay, Melvin Village, Wolfeboro Falls, Moultonboro Neck, Lochmere, Laconia, and the Weirs. There are few, if any, islands in the lake that have not produced considerable evidence of aboriginal occupation. Most of these people made their winter headquarters at the Weirs (Ahquedaukenash), where tons of smoked, dried fish were stored annually for winter consumption and where the hills at their back protected their dwellings from the prevailing northwest winds.

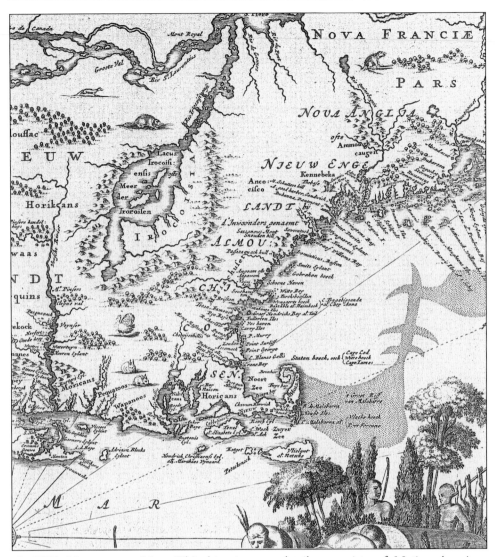

A 1527 MONTANUS MAP. This historic map details a variety of Native American settlements across New England.

Like all of the tribes of the Merrimack valley, the Winnipesaukees were tributaries and confederates of the Pennacooks, and their customary holidays were a sort of movable feasts of the Pennacook confederacy, alternating between the leading fishing places, such as Pawtucket, Namoskeag, and Winnipesaukee.

The Winnipesaukees maintained a permanent fish-weir, or Ahquedaukenash, as they called it, at the outlet of the lake where all the tribes were invited to assemble for the spring and fall catch. One remarkable fact connected with the fishing at this point was that nothing but shad was captured. Of all the migratory fish that left the sea during the spring for their spawning ground, the shad alone

reached the lake, the eel sought the congenial mud, and the alewives, being small, took to the smaller brooks and ponds. Salmon and shad proceeded together, until reaching the forks of the Merrimack in the town of Franklin, they parted company. The salmon headed up the Pemigewasset, which, having its sources high among the mountains and its course through a long stretch of shaded woods, afforded those cold waters, plunging torrents, dark pools, and wild mountain streams in which these fish found their favorite spawning ground.

Shad, however, preferring warming and quieter waters, took to Winnipesaukee, and through that river passed into the lake in countless myriads, where there was favorable opportunities for the development of the millions of eggs that were required to supply the waste of the original stock, constantly depleted by ravenous fish.

Ahquedaukenash literally means a dam, or stopping-place, and was constructed in the following manner. Large granite boulders were placed in an irregular line across the river, the boulders representing the angles of a crooked rail fence, and at a proper distance below the falls. Wherever it was practical, strong sapling stakes were driven into the bed of the river and used for the same purpose of fencing. These stakes took the place of rocks, but at the outlet of Winnipesaukee, this was impractical, owing to the solid river bed. Having prepared the foundation, the rocks being some 10 or 12 feet apart, a netting was then woven of twigs and tough and pliable bark, with meshes sufficiently close to prevent the fish escaping. This netting was strung entirely across the river, above and against the rocks, excepting a space between one or two of the rocks or stakes, these areas being left open for the fish to pass through in their progress up the river. Through these openings the whole force of the fish must and did pass.

As few of them scaled the falls until after repeated efforts and the rapidly advancing "school" crowded steadily through the opening, it follows that the pen (ahquedaukenash) was soon full. Now was the time for the Indian shad-catcher. Expert fishermen were then selected for the catch, manned the canoes, and pushed out among the pent-up prisoners, and with spear and dip-net, they lost no time in filling the canoes. Returning to shore, they handed their catch to the squaws, who stood ready, knife in hand, to split the fish, and hang them up to smoke for winter on the center pole of the wigwam, or laid them out to dry in the sun.

Remnants of the "pen" may still be seen at the outlet of the Big Lake. Stones, which once held the uprights of the wooden fish-weirs in place, showed the first settlers where the original Indian fishing weirs were located, but these stones were used in 1766 to make a wing dam for Ebenezer Smith's sawmill, which had been constructed on the Gilmanton side of the channel the preceding autumn.

Native fishermen recount that the shad make their rushing at the Weirs about June 1, and that this run lasts for about two weeks. Through the use of the weir and nets, tons of fish were acquired by the ahquedaukenash.

Ahquedaukenash (Aquadoctan), a Sokoki name meaning the "Weirs," was one of the largest Indian villages in New Hampshire and continued to be a permanent

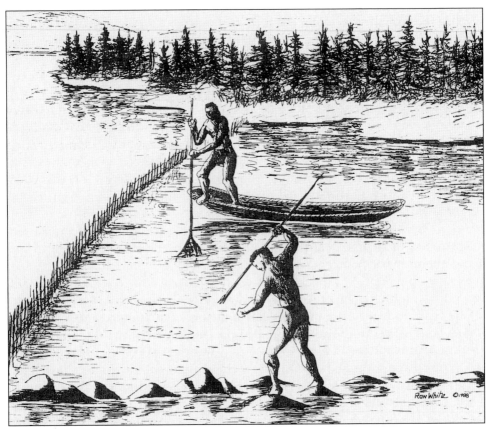

FISHING AT THE WEIRS. This early sketch by Ron White illustrates the Native American system for the gathering of shad in the waters of Lake Winnipesaukee.

one until the spring of 1696, when the few remaining families, with two young English prisoners, left their homes at Aquadoctan to join the Pequaket tribe on the Saco River near what is now Fryeburg, Maine.

The Aquadoctan village site extended along the north bank flanking the channel for more than a quarter of a mile and along the lake front a quarter of a mile beyond the present railroad station. The total length of the site was more than a half mile, but it wasn't all occupied at one time. The land on the south side of the channel rose abruptly and was too steep for "wigwam" sites, but many artifacts have been found around that location above the bridge, where the land is flat. Local lore tells of a pine tree standing on the shores of the Winnipesaukee River, on which was carved a canoe with two men in it, supposed to have been a mark of direction to those who were expected to follow. Another was a tree in Moultonborough, standing near a carry-place between two ponds. On this tree was a representation of one of their expeditions. The number killed and the prisoners were shown by rude drawings of human beings, the former being distinguished by the mark of a knife across the throat.

Over 10,000 artifacts have been collected from the Weirs area alone, and they may be viewed in collections at Concord, Manchester, Hanover, and Laconia, New Hampshire, as well as in the Peabody Museums at Salem and Cambridge, Massachusetts.

The name Winnipesaukee itself has caused much controversy among authorities. There are many meanings of this name, but the two most popular definitions are "the Smile of the Great Spirit" and "Beautiful Water in a High Place." In Abenaki language, "Ogee" means the great spirit and "Winni" means smiling. "Winnipesogee" has an English translation meaning the "Smile of the Great Spirit." Another translation is "Auke," meaning a high place; thus, "Winnipesaukee" translates into "Smiling Water Between Hills."

This lake is steeped with Native American lore; however, the following seems to gather more attention than most. This tale comes from the small village of New Salem, presently known as Meredith, one of the many hunting grounds of the Winnipesaukee tribes.

According to the legend, Ahanton, who was respected for his warlike courage in his tribe, had a daughter by the name of Ellacoya. She was a fair maiden known far and wide who was unable to have a suitor because of her father's dislike for them. It was because of these rumors that the young chieftain south of the lake, by the name of Kona (the Eagle), decided to test his skill and win the hand and heart of this maiden.

Dressed in full costume, the young brave arrived at the encampment and immediately won the heart of Ellacoya. Unbeknown to her father, who had traveled from the camp, the young brave wooed the young maiden for several days. When he returned, Ahanton was full of rage to all present. With a sharp cry, he made an attack on the young brave Kona for daring to woo his daughter and knowingly take advantage of his absence.

Ellacoya, possessed with great love for Kona, thrust herself between the two angry men and pleaded for the life of Kona, telling her father of his display of courage when he fearlessly entered the village. Ahanton, being an admirer of courage and bravery, admitted his haste, whereupon Kona asked for the maiden's hand and was proudly granted the request by the great warrior. Many celebrations were held throughout the region and many feasts enjoyed.

A few days after the wedding, a canoe party accompanied the couple halfway across the lake. While traveling across the peaceful waters of the lake, a dark cloud concealed the rays of the sun and a threatening storm began to turn the water black. Just at that moment, when the party was ready to turn back for safety, the sun shone through, guiding the two lovers safely to the other side of the lake. "Here," cried Ahanton, "is the Smile of the Great Spirit."

The Native Americans told their tales of bygone days with lowered voice, each myth fraught with the fantasy of nature's solitude, and each legend bordered with a fringe of the silver foam of spirituality. Their nations may vanish, but through legends and lore, their legacy lives on to enhance the heritage of this country.

3. THE FIRST SETTLERS

The development of our early American colonies required a permanent commitment on the part of individual settlers to the land and the expectation of trade in colonist-produced commodities. It also required the replication of something approaching normal European society. Once these principles were established, the settlers would spread over the land with a rapidity no one anticipated. And these farmers, taking over land and fencing in their rectangular plots to be held in perpetuity, threatened Native American life in ways far more fundamental than any soldier could.

Within a decade, thousands of settlers to this new land joined the few hundred already on America's East Coast, on territory formerly occupied exclusively by Indians. Neither European immigrants nor natives realized how fundamentally incompatible their land-use patterns were. The Native Americans combined intensive agriculture with hunting and gathering, and native lifestyles required a large amount of land and the abundance of species. The colonists' desire for land for themselves and their young, the magnet that drew them, required dividing up the land into plots and forbidding access by others. The European domesticated animals, set free to fend for themselves in the forests, competed for the nuts and berries on which the natives relied. The most vulnerable varieties died out from the livestocks' repeated cropping, and wild animals retreated from the frontier of settlement. Not only were the region's wild food supplies devastated, but the colonists' pigs rooted up the Indian cornfields and gardens, so the natives were doubly impoverished. Humans and animals spread European diseases that killed many Native Americans. In all these developments, the arrival of the European farmers, despite their peaceful intentions, created far more havoc than the warlike soldiers.

The theory of the British government, shared by the colonists occupying New England soil, was that the absolute, ultimate title of the land was in the Crown and that the sole right of acquiring it by purchase or by actual conquest was in the

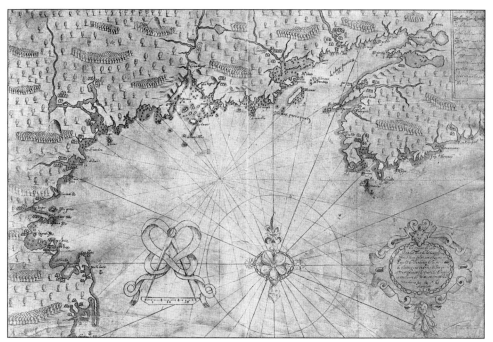

MANUSCRIPT MAP OF THE NEW ENGLAND COAST. This map, drawn by Champlain, details the features of the New England coast in 1607–1608.

Crown or its grantees. This principle was strictly carried out as soon as the general court could take charge of the land policy in the several colonies. However, during the earlier period, there were a few divergences from this theory, and many town proprietors derived their right to the soil primarily from direct purchases from the Native Americans.

An act in 1702 ordered that when land is granted by the General Court, such townships alone have the power to purchase from the natives and that all other purchases are illegal. It also stated in the general laws and archives that "All land in this government are holden of the King of Great Britain as the Lord of the Fee: and that no title to any lands in this colony can accrue by any purchase made of Indians . . . without the allowance or approbation of this assembly."

Later, the purchase rights in every colony became a matter of secondary importance as far as the legal title to land, and the number of proprietors who owned their creation to the Indian purchases gradually ceased to grow until this method disappeared from the New England land system altogether.

The development of New Hampshire is an intricate drama with many tales of triumphs, struggles, and conflicts. The state's early history unfolds, briefly, as follows: the first settlement at the mouth of the Piscataqua and on the shores of Great Bay, their growth into towns and their union under the jurisdiction of the Massachusetts Bay Colony; the formation of the Royal Province of New Hampshire; the woeful conflict with the Native Americans and the French; the

MASON AND GORGES. This nineteenth-century woodcut depicts Mason and Gorges intently studying the naming of their provinces. (NHHS Collection.)

inroad onto the province of the Scotch-Irish and the spread of Massachusetts settlers up the valley of the Merrimack and Connecticut Rivers; the contest of the inhabitants with the Masonian proprietors; the role of the people of the province in achieving national independence; the formation of an independent state government; the compact settlement of the state and the growth of manufacturers, railroads, and cities; the participation in the Great Rebellion; the change in the laws, habits, and customs of the people, together with some account of those men who, in the different generations, have guided and directed the destinies of the people in church, state, and municipal affairs. Here is a story of an evolution of many people fresh from the laws and prejudices of the Old World and their time.

New Hampshire, one of the New England States, has an area of 9,336 square miles, being bound on the north by the Province of Quebec, on the east by the State of Maine and the Atlantic Ocean, on the south by the Commonwealth of Massachusetts, and on the west by the State of Vermont, the Connecticut River being the boundary line. The state's shape is that of a triangle with 100 miles at its

base and 185 miles in length. About one-sixteenth of the surface of the state is covered by water, the largest being the gem of the Granite State, Winnipesaukee.

On August 10, 1622, King James granted "the Province of Maine," bounded by the rivers Kennebec and Merrimack, to Sir Fernando Gorges, "the father of English colonization in America," and Captain John Mason, who had been governor of Newfoundland. Their first colonists came over in the spring of 1623 and upon arrival divided into two parties. One settled on Odiorne's Point in the town of Rye and the other 8 miles up the Piscataqua on what they called "the Neck," now included in the city of Dover. In 1638, a third colony settled on the Squamscott, where Exeter is now located. These two gentlemen jointly received the grant of territory from the Crown which included all the land between the Merrimack and Sagadahock Rivers, from the ocean to the Great Lakes of Canada.

A business known as the Laconia Company was established to survey the Mason and Gorges Patent. It is interesting to note that the Gorges family was from Greece and the Laconia Patent was named after Laconia in Sparta, which was the district from whence he came.

The design of the Laconia Company adventurers was to seize upon and augment to their own profit the rich peltry traffic of that vast region, then in the hands of the French and Dutch. It was believed, in the absence of accurate knowledge of the interior country, that Lake Champlain (then called the Iroquois) could be reached from the New England coast by a journey of about 90 miles, and that only a narrow distance separated it from the head waters of the Piscataqua

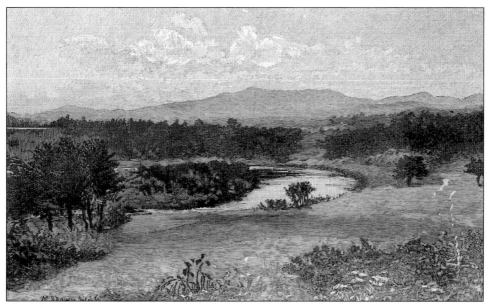

TYPICAL PASTORAL SCENE ALONG THE MERRIMACK RIVER. *The first settlers of the Lakes Region traveled up the Merrimack River to reach the western portions of Lake Winnipesaukee.*

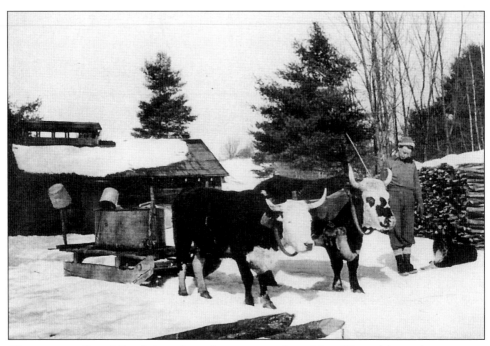

GATHERING SAP. Like their early settler ancestors, these New Hampshire natives are seen here in the 1940s gathering sap by an oxen team during the maple sugar time.

River. Under this delusion, the Laconians hired the buildings which had been put up several years before by David Thomson at the smaller mouth of the Piscataqua, and established there, under command of Captain Walter Neale, a factory, or entrepôt, as a basis for their magnificent design upon the New York lakes.

Captain Jonathan Carver recorded the following in his published work *Travels Through the Interior Parts of North America in the Years 1766, 1767, and 1768:*

> In November, 1629, a large tract of land, situated in the present State of New York around Lake Champlain, had been granted by the Grand Council to Sir Ferdinando Gorges, Captain John Mason and seven other associates. This province was named Laconia, because of the great Lakes therein. A vast tract of land that lies between the two lakes (Lake Champlain & Lake George) and Lake Ontario, was granted in the year 1629 by the Plymouth Company, under a patent they had received from King James I to Sir Ferdinando Gorges, and to Captain John Mason, the head of that family, afterwards distinguished from others of the same name by the Masons of Connecticut. The countries specified in this grant are said to begin ten miles from the heads of the rivers that run from the east and south into Lake George and Lake Champlain; and continuing from these in a direct line westward, extend to the middle of Lake Ontario; from thence, being bounded by the Cataraqui, or the

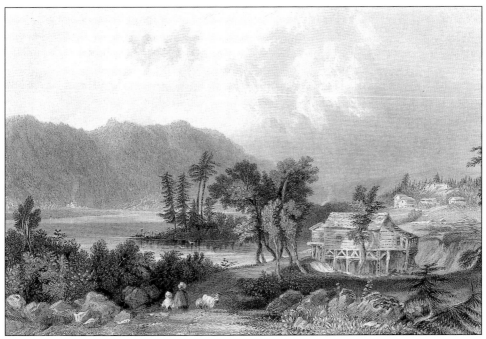

A SAWMILL AND LOG CABIN, MOULTONBORO, 1836. Early settlers established homes, mills, and various industries that grew into thriving communities along the lake's shores.

> River of the Iroquois, they take their course through Montreal, as far as
> Fort Sorrell, which lies at the junction of this river with the Richelieu;
> and from that point are inclosed by last-mentioned river till it returns
> back to the two lakes.

State historian John N. McClintock in his 1889 work, *New Hampshire History*, wrote the following:

> The charter of the Massachusetts Bay passed the seals on March 4,
> 1628–29, thus antedating Mason's patent of New Hampshire as well as
> both the Piscataqua River Grants. If the Massachusetts construction of
> their charter should prevail, then all the patents on the river would be
> swept away; and the whole of that region would fall by prior title into
> the hands and jurisdiction, and neither Mason nor Hilton could have
> offered any effectual opposition.

In that same year (1629), Gorges and Mason divided their holdings, the latter taking as his share the country between the Piscataqua and Merrimack Rivers, which he named New Hampshire in honor of Hampshire in England, his old home. Apparently, Mason did not rely on these early grants, but put more reliance in a grant he received on April 1635. This covered the land between the

Merrimack River and the Piscataqua River for a depth of 60 miles from the mouth of the rivers. His last grant was ratified and confirmed by the Crown on August 19, 1635.

Among other things, it was assumed by early colonists that the Merrimack River continued westward. No one had yet discovered that it made a right-angle turn to the north a few miles inland. This circumstance caused a border dispute between Mason and Massachusetts. This dispute was settled in 1741, giving New Hampshire land west of the Merrimack.

However, over a hundred years before this resolution, Mason had died suddenly in 1635 at the age of 49 while making final arrangements to send supplies and men to the New Hampshire settlement on the Piscataqua. Dr. Jeremy Belknap, in his *History of New Hampshire* (Volume 1, 1831), noted, "But death, which puts an end to the fairest prospect, cut off all the hopes which Mason had entertained of aggrandizing his fortune, by the settlement of New Hampshire. By his last will, which he signed a few days before his death, he disposed of his American estate to his heirs." The estate in America at that time was valued in the inventory at 10,000 pounds sterling.

Dr. Belknap also cited the following from files of the Massachusetts Superior Court:

> The Massachusetts planters viewed Mason as their enemy, because he, with Gorges, had privately encouraged some persons whom they had censured and sent home, to petition against them as disaffected to the government; and had endeavored to get their charter set aside, to make way for the scheme of a general governor. . . .
>
> Four distinct governments [including one at Kittery on the north side of the river] were now formed on the several branches of Pascataqua. These combinations being only voluntary agreements, liable to be broken or subdivided on the first popular discontent, there could be no safety in the continuance of them. The distraction in England at this time had cut off all hope of the royal attention, and the people of several settlements were too much divided in their opinions to form any general plan of government which could afford a prospect of permanent utility. The more considerate persons among them, therefore thought it best to treat with Massachusetts about taking them under their protection. The government was glad of an opportunity to realize the construction which they had put upon the clause of their charter wherein their northern limits are defined. For a line drawn from east to west, at the distance of "three miles to the northward of Merrimack river and of any and every part thereof" will take in the whole province of New Hampshire, and the greater part of the province of Maine, so that both Mason's and Gorges's patents must have been vacated. They had already intimated their intention to run this east and west line and presuming on the justice of their claim, they readily entered into a negotiation with the

ENDICOTT ROCK MONUMENT. This monument has been a recognizable presence in the channel of Weirs Beach since 1892.

principal settlers of Pascataqua respecting their incorporation with them. The affair was more than a year in agitation, and was at length concluded by an instrument subscribed in the presence of the general court in 1741.

In 1651, the inhabitants of Strawbery Banke petitioned for a survey of the boundaries "for the establishment of a court and for the protection against the heirs of John Mason." In 1652, Captain Simon Willard and Captain Edward Johnson were appointed commissioners by the Court of the Massachusetts Bay Colony, under the direction of Governor Endicott, to determine the northernmost part of the Merrimack River and ascertain the northern boundary of the Bay Colony. They, in turn, employed John Sherman of Watertown and Jonathan Ince, a Harvard College student, to determine the latitude of "Aqueductan," a name given the Merrimack River where it issues out of Lake Winnipiseogee (Winnipesaukee). On August 1, 1652, they found the latitude was 43 degrees, 40 minutes, and 12 seconds, besides those minutes which are to be allowed for 3 more miles north which runs into the lake.

After selecting this given point, at the mouth of the Weirs Channel, the following was chiseled upon the boulder present: "EI S.W. / W.P John / Endicott / Gov. / Is II / Commissioners / EJ [Edward Johnson] SW [Simon Willard] / JS [John Sherman] JI [Jonathan Ince]."

This boulder remained unknown until 1833, when it was discovered by workmen engaged in enlarging the channel at Weirs Beach. As the markings had

ENDICOTT ROCK
MONUMENT. Before
the Weirs Beach was
extended and land
filled in around the
monument, this
wooden walkway
provided visitors with
the means to view the
rock, located inside the
granite enclosure.

been worn by the elements, the state legislature appropriated money to have the rock raised and surrounded with safeguards against destruction.

The State of New Hampshire did not, however, until 1892, make this monument completely protected. Today, one finds a structure of granite enclosing this monument. In the fall of 1892, the Honorable E.P. Jewell of Laconia related the following in a memorial address dedicating the Endicott Rock:

> It was most probable at this time that no white man had ever approached the lake nearer than a point three miles north of the "forks" of the Merrimack at the Franklin Falls. The difficulty of navigating the river and small lakes to Winnipesaukee at that time is evident from their estimate of the distance from Franklin to the Weirs. That a sailboat was used appears from the commissioner's account. Whether or not a sailboat reached the lake at that time must remain a matter of conjecture. The Native Americans navigated the river and lakes from Aquadoctan [The Weirs] to the sea with very large canoes, and had "carrying-places," as they were called, where the canoes were taken out and carried past the falls. It is not improbable that the trouble of getting up the river from Franklin was on account of difficulties incident to the sailboat.
>
> Upon their arrival at the lake, they found a well-shaped boulder, exactly at the head of the Winnipesaukee River, seemingly inviting attention, upon which it was decided to carve the inscription making an enduring record of the visit, forming a mecca for unborn generations

who would come this way to enjoy the specticle [*sic*] of the beautiful lake and the North Country

Here was an Indian village, then, and many of the children had never seen a pale-face. We are unable to state when the Indians left their village at Aquadoctan, but it is well known that Isaac Bradley and Joseph Whittaker were taken captive by the Indians at Haverhill, Massachusetts, in the fall of 1695, and were held at the lake all winter. They escaped the following spring, and after nine days in the woods arrived safely at Saco, on the seashore. Since discovery, the waters of the lake have been controlled by the dam at Lakeport, so that the surface of the rock has been covered a great portion of the time. It was found that the water and ice were rapidly obliterating the inscription.

In October, 1880, casts were made by two Italian artists of Boston, Signori Lunchini and Caporoni, one of which is preserved in the rooms of the New Hampshire Historical Society, in Concord; one was given to the Massachusetts Historical Society, and a third to the Proprietors of the Locks and Canals of the Merrimack River, whose office is in Lowell, Massachusetts. Several others are said to be in existence. But while the inscription was quite well defined, and to prevent further destruction, the Legislature of New Hampshire, September 7, 1883, and August 23, 1885, made appropriations and the State appointed commissioners to insure the preservation of the rock.

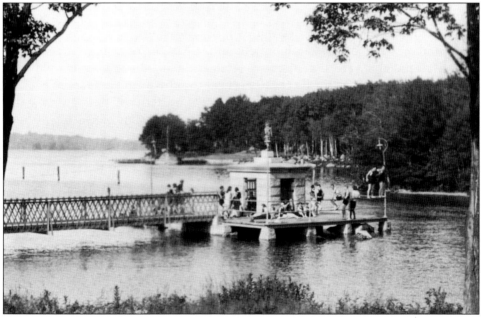

ENDICOTT ROCK MONUMENT. Seen here in the 1930s, these summer bathers are enjoying the waters surrounding this historic landmark.

4. THE PORT TOWNS

Nestled within the small bays and coves of the lake may be found the quaint villages that make the Lakes Region so famous. It is easy to see why this area is so popular: standing atop any elevation in the region one may command a magnificent view and from the many cottage sites, one may experience the surrounding enchantment of the wooded hillsides and rugged wilderness.

The hardships of life for the first settlers were considered severe, even for the most adventurous. As one reminisces about the early settlements in the Lakes Region, one should travel up the dirt road and across the brook to what must have been a small village. Here, the traveler discovers the tokens of an early settlement that once flourished, but had died out with time, leaving only a few farmers and their families, who only had a slight hold on the past by memory or inheritance. They lived and died here, but little trace is left of them—how they came and how they went. A select few of the present occupants can trace their ancestry back to the Revolutionary War times. They came from the seacoast and settled among the mountains and valleys, on the river shores and by the banks of the lake. If one were to ask them why they ventured here, the answered would surely be, "The land is cheap."

On the back side of the Ossipee Mountains, overlooking the great expanse of Lake Winnipesaukee, there had been such a settlement and there a school district within the memory of the living. The ruins of the old schoolhouse has been removed, and only the cellar-hole remains, haunted by the reminisces which will always cling about this deserted house of human experience. The homely vestiges of the pioneer's cabin breathes out the same spirit of desolation that exhales from the crumbling walls of heritage.

And so are all places where houses have stood—the foundation only to be left, like the chair from which the aged tenants rose and traveled to their graves. It is strange what trifles can inspire us with that touch that makes us as one. Close to one of these holes is a small ring of stones piled one upon another, the upper sides

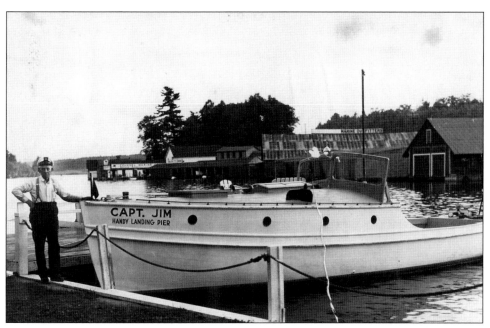

CAPTAIN JIM IN THE WEIRS CHANNEL, 1949. The port towns along Lake Winnipesaukee possess a distinct New Hampshire charm in both its people and its setting.

overgrown with moss, while beneath they were laid there—doubtless, a playtime relic left by the first children of the mountainside.

Whatever it was, the oldest dwellers in the settlement remember this small stonehenge looking mossy-gray with the age of their children, as it does now. Few of the solid ancestral edifices of the region have outlasted this small enclosure of loose stones, half in irony and half in tender sentiment. Time will test the results of man's painful labor, but leaves the careless work of childish fingers untouched.

The few remaining inhabitants have led uneventful lives, startled only by such incidents as the eruption of a hedgehog into a villager's kitchen during breakfast, or the sliding of a cow off a steep incline to a premature death; perhaps the capture of a bear strewing waste in the back house. Their isolation bred self-sufficiency by the solitude of a wilderness wall. Something of the awe that pervaded these lonely hills has crept into their expression, as when they say of the sound that rushes down through the high forest before a storm, "The mountain is roaring," or of a strange echo that steals up from under the frozen floor of Winnipesaukee in midwinter, "Hear, the lake groans."

Some settlements did survive and flourish however; and here is where the most hardy lived and prospered. Eight townships border Lake Winnipesaukee: Alton, Center Harbor, Gilford, Laconia, Meredith, Moultonboro, Tuftonboro, and Wolfeboro. These towns lie in two counties, Belknap and Carroll, the dividing line of which passes in a general direction from southeast to northwest through the middle of the lake.

ALTON BAY, 1880s. Travel connections by train and boat made this an important bay.

The following town sketches detail a brief history, description, and formation of these communities and their limitless variety of land and water uses.

ALTON AND ALTON BAY

Alton and Alton Bay are located at the southern extremity of Lake Winnipesaukee. The first European settlers to embrace this area were the French traders and possibly English scouts who used this territory as a natural protection from the Indians while enroute to Canada and the northlands.

On December 8, 1726, a town named "Coulraine" was incorporated and granted to residents of Londonderry. Coulraine began at the northeasterly corner of Rochester at the Salmon Falls River and ran on the Rochester headline for 8 miles; then northwesterly half a point northerly, making it approximately 12 miles by 10. Its grant lapsed, for these proprietary tracts had to have a certain number of inhabitants dwelling on them by a certain time in order that they may become legal towns. On October 20, 1737, "the Town Corporate of Kingswood" was granted to six people of Portsmouth; this charter also lapsed, for they failed to claim their land.

The present boundaries of the town were finally divided among the proprietors in September 1764. Many were probably settlers who had come after the close of the French and Indian Wars, and others, possibly friends of John Wentworth, the last of the Royal Governors.

The question at this time was "Would this new town of New Durham Gore go the same way as the proprietary colonies of Coulraine and Kingswood?" Many felt that the Gore was destined to become a good-sized village. Families from New

Durham, Rochester, Salmon Falls, and Dover later moved to this settlement and purchased lots. The first to erect a frame dwelling was Benjamin Bennett, who constructed a house in 1773 in the vast expanse of wilderness—the present Alton–New Durham line.

These early years were devoted to becoming an established community in this "their newly found homeland." The early families quickly bonded together in mutual protection and self-preservation in order "to form a community." So, these families resolved to form a town and decided that there were enough people to warrant a town meeting. This meeting was held at the home of Timothy Davis upon Mount Prospect on March 26, 1777, probably during midwinter, outside the cabin of a man who carried a great deal of importance in the community.

Although meetings were held as early as 1777, they were not recorded until 12 years later, in 1789, which was held at the "Dwelling house of Joseph Roberts, Esq." The attending members voted "that Joseph Peirce Esq., be desired and Employed to collect all minutes of records and votes which have been passed and transacted since meetings were held in this place by and under the Authority of the Laws of the State and enter and record the same in the Town Book of Records, also to record all the Accounts with or Against the town in the Selectman's Book of Records."

On May 5, 1794, the community members voted that "This place called New Durham Gore be Incorporated." In the original petition to the state legislature, the name of Roxbury was suggested. This document contained the names of 66 men. The first-generation settlers had passed into middle age, and their children now had votes, as well as wives and families of their own.

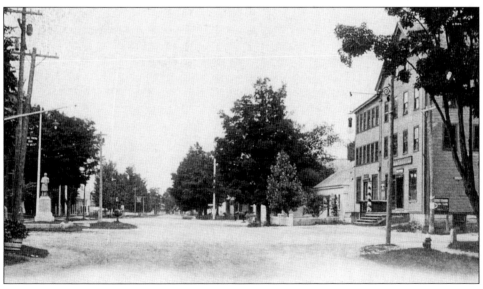

ALTON'S MAIN STREET, EARLY 1900s. Beautiful maple trees lined Main Street, and the Civil War Memorial is visible on the left.

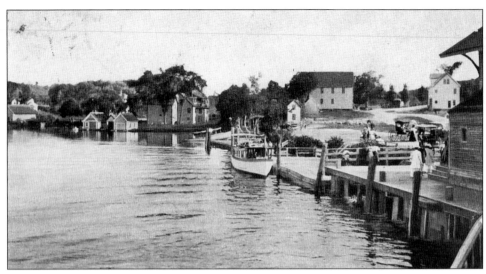

ALTON BAY, 1911. This early steamer awaits its summer visitors for a midday sail up the bay.

Before Alton was finally incorporated, eight petitions were sent to the legislature. After the first two petitions, the name "Roxbury" was abandoned, as the governor stated that another of that name had already been incorporated by the legislature.

As far as records indicate, the name "Alton" was derived from a town of the same name in England from whence ancestors of many of the town's original settlers had come. Eventually, the town grew, and as it prospered, small taverns, inns, and general trading stores were established to meet the needs of the people and travelers. In all probability, the Cocheco House was operated as a tavern, lying at the crossroads of a stagecoach route to Gilmanton, which in turn connected onto those destined for the White Mountains and Canada. This community was also a general stopping place for travelers about the state. In an article dated December 6, 1794, the selectmen of New Durham Gore gave Thomas Bennett their "Consent and Approbation to keep a Public Tavern in said Gore for the term of one year from the date, provided that the said Thomas Bennett provisions and Liquor for the Entertainment of the Traveler and also to keep in good order the said Public House" (town records dated 1777).

On June 16, 1796, the House of Representatives signed the bill approving the incorporation of the town. Thus, the dreams of many citizens had at last materialized. The bill was written into the town record book on March 13, 1797, when the incorporation took effect, even though Alton officially became a town on June 16, 1796, with the signing of the bill by the governor. This meeting of the new town was held in the dwelling house of Benjamin Bennett, which was most fitting, as the Bennett House was the prelude to all frame dwellings erected in Alton.

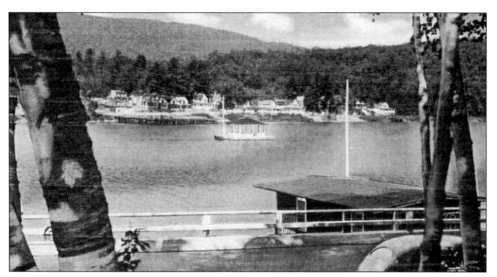

THE ALTON BAY BANDSTAND, 1930s. This majestic wooden structure, one of the few aquatic bandstands in America, is a prominent symbol of Alton Bay's unique heritage.

Alton Mountain was another of the early thriving villages in the township. The land was arable and enormously productive, perhaps the most fertile land to be found within the present confines of the community. To settle a homestead on the mountain meant many long hours of hard labor for the entire family. Most all of the settlers were, of course, farmers, and each had his own lots and farmland. These stalwart families cut into the most impenetrable forest, dug out stumps, planted, harvested, and cared for livestock. In the first quarter of the nineteenth century, there were no idle hands.

The town grew; roads and rangeways were laid out. Between 1838 and 1840, four of the most important existing roads were completed and many others planned, and partially cut out and widened as the need became apparent.

During the 1840s, town boundaries were renewed and adjusted with neighboring towns. Thus a regular pattern may be obtained in the way the town lines were surveyed and re-surveyed. It is no wonder that the settler was never sure where his land began and that of his neighbor's property left off. Several times Alton lost a few acres of land to every town surrounding it as they all, with the exception of Gilford, were fused before Alton. Gilford consolidated in 1812, having previously been known as the Gunstock Parish of Gilmanton. The latter was incorporated in 1727 and originally encompassed all or parts of Alton, Gilford, Belmont, Northfield, Tilton, and Laconia, east of the channel. Wolfeborough was incorporated in 1770; Barnstead in 1727; part of Alton having been annexed in 1842; New Durham in 1762, having previously been known as Cocheco Township.

By 1840, the population of the town had increased by a considerable number from the date of incorporation, a few more than 40 families. The center of

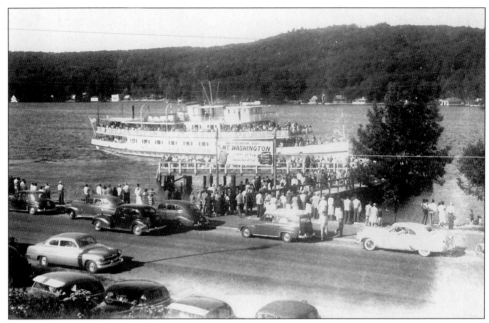

ALTON BAY, 1940S. The famous steamer Mount Washington *is seen here docking at Alton Bay on one of its many excursion trips across the waters of Lake Winnipesaukee.*

population remained at East Alton until the middle of the century, when the railroad brought it closer to its present location. In 1839, a charter was granted to the Dover & Winnipesaukee Railroad to build tracks from Dover to Alton Bay, a total of 29 miles. The charter lapsed, but eight years later another was granted under the name of the Cocheco Railroad. By 1848, tracks had been laid as far as Farmington and a year later were completed to the destination at Alton Bay. The Town of Alton granted the Cocheco Railroad rights to cross the Meredith Road near the Winnipesaukee House on December 31, 1850, and on February 15 of the next year, the present campground land was deeded to the line by John Barker, owner of numerous sections of the town.

The first depot was built at Alton Bay in 1850. It burned four years later and another was soon built. Several other stations were erected in and around the Alton area, including the Main Station at Alton, the Loon Cove, and the Glendale Depots. With the coming of the iron horse, goods and mail no longer needed to be transported by oxcart, but could now be carried by rail up to the Lakes Region, put on horseboats, and transported to Wolfeboro, Melvin Village, and Center Harbor at the northern tip of the lake.

In 1872, a new steam side-wheeler at Alton Bay was launched, which was christened the steamer *Mount Washington*. This vessel was built by the Boston and Maine Railroad, which used an extension of her rail service on Lake Winnipesaukee. She was longer, faster, and considered by many the most beautiful side-wheeler ever built in the United States.

On November 4, 1906, the station house at the Bay was destroyed by fire, taking with it the boardwalk and the verandah. That same night, the Box-shop on Oak Hill and the Wentworth Mills on the River Road were also burned. Local reports state that this arson was done by a crazy man named Greene, for some unexplained reason of retribution against the town, by burning three of the most prominent landmarks of the community and with them much of its heritage and tradition.

The trains to Alton Bay continued to operate until July 9, 1935, a span of 85 years, when due to the decrease of passengers and the increase of automobiles in the region, the trains were halted forever. This was quite a loss to the community, especially for the then-thriving tourist industry.

Like most communities in the Lakes Region, farming and logging were the first attempts for livelihood. As time passed, other industries entered the communities. In the section of town called East Alton, a large granite quarry was mined for many years, but due to greater competition from other quarries in neighboring states, the company was forced to cease operation.

During the past 100 years, many changes in industry and lifestyles have taken place around the Lakes Region—Alton and Alton Bay are no exceptions. Today, its growth has centered its industry on tourism, a magnetic gateway for Central New Hampshire's lakes and mountain and a thriving family resort.

CENTER HARBOR

In October 1763, Moses Senter of Londonderry came to the head of Lake Winnipesaukee to survey some wild land for the government, bringing with him his friend, John Beane. Senter pointed to a hill in the distance covered with autumnal crimson and remarked with awe, "See that Red Hill!" The name "Red

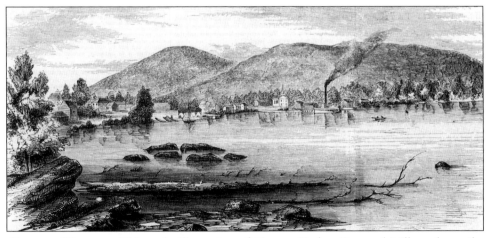

CENTER HARBOR. *This early illustration of Center Harbor Bay and Village shows the village's picturesque setting against the dramatic backdrop of Red Hill.*

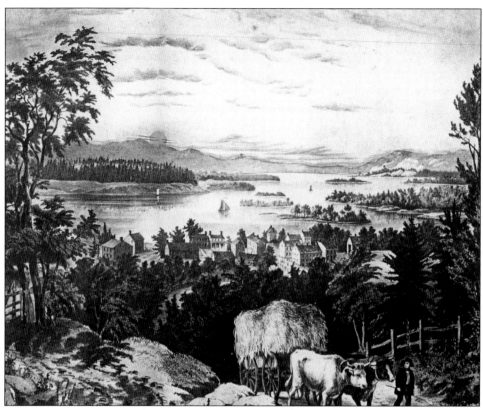

CENTER HARBOR IN THE MID-NINETEENTH CENTURY. Seen here in a vintage Currier and Ives print, Center Harbor served as a halfway station for stagecoaches running from Concord to Fryeburg, Maine.

Hill" has stuck to this day. Senter and his friend were so charmed with the area that they were determined to make a settlement here, and they built a log house on the shore of the lake.

The history of this northernmost port, as a corporate town, dates back to December 17, 1797, when it was set off from New Hampton. For several years, previous to the incorporation of the town, the locality of the present village was known as "Centre-harbour." Since Moultonborough Harbor was east and Meredith Harbor west, this was the center harbor, and according to many citizens, the town's name proceeds from this reasoning.

The first petition for its incorporation was made in June 1788, signed by Benning Moulton and 50 others. This petition, however, was not granted, and in 1797, a second petition was presented to the General Court, which was granted, and the town incorporated on December 7, 1797.

The village of Center Harbor is located on Lake Winnipesaukee and entertains a charming view of the lake, as well as the neighboring hills and mountains at the foot of the White Mountains. This gracious resort town also borders on beautiful

Squam, Waukewan, Kanasatka, and Winona Lakes, all of which command magnificent views of both lakes and mountains in Central New Hampshire.

On the grounds of Camp Pinelands stands the Whittier Pine, intimately associated with the gentle Quaker poet who immortalized New Hampshire and Lake Winnipesaukee. Here it was, that, sitting under it mammoth branches and looking out over beautiful, island-dotted Squam Lake, John Greenleaf Whittier composed such timeless lyrics as "Summer of the Lakeside," "The Wood Giant," "The Hill-top," and many others. Both Winnipesaukee and Squam have felt the pull of the poet's oar as he rowed about, fishing.

Much has been written about John Greenleaf Whittier in the White Mountains (Bearcamp Valley), but little has been expressed concerning his many visits to Center Harbor. During the 1880s, poet Whittier loved to travel from West Ossipee to Center Harbor and Holderness to spend part of his summer at the Asquam House on Shepherd Hill, a spot that his sister, Elizabeth, and he discovered long before it became a popular summer resort and which he described in "The Hill-Top." From the hotel, he wrote to Annie Fields describing "Such a sunset the Lord before never painted." It was while he was on one of his vacations here that he heard of the death of Longfellow. Taking a volume of his friend's poems belonging to Mrs. Martha Nichols, he wrote on the fly leaf some verses beginning with these lines, "As clouds that rake the mountains here / We too shall pass and disappear."

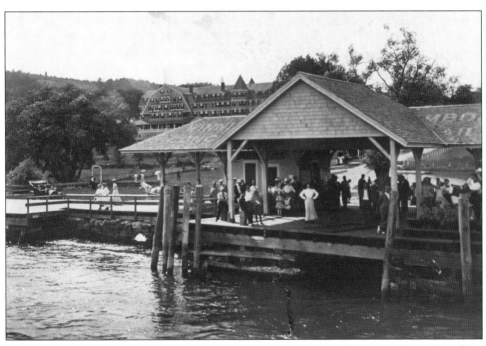

CENTER HARBOR DOCK, 1905. *An expectant crowd awaits the arrival of another of the lake's many vessels. The Colonial Hotel is visible in the background.*

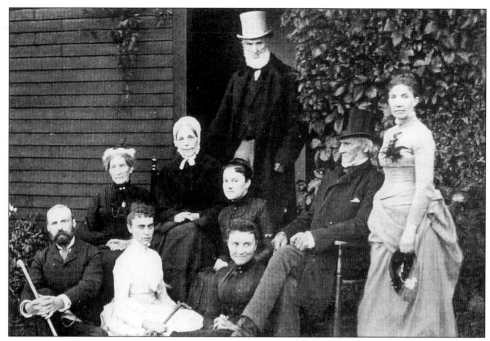

JOHN GREENLEAF WHITTIER AND FRIENDS. The poet Whittier is standing in the doorway in this 1885 portrait taken at the Sturtevant Farm.

At the homestead of Mr. and Mrs. Henry Sturtevant on Sunset Hill in Center Harbor (Route 25b), Whittier would spend much time with friends. Sometimes, on his way to the Sturtevant Farm, he would stay a few days at the old Senter House, a very prominent hotel in the village.

One of his friends gave an interesting interview to the *Portland Transcript* in which he said, "One evening at Sturtevant's we were talking of the immense pine we had seen in the pasture and Mr. Whittier said he had just written a 'little ditty' about it. His cousin Gertrude asked if he would not let us hear it, and without hesitation he read his noble poem 'The Wood Giant.' Since then the tree has been known as 'the Whittier Pine.' "

Another noted tree stands on the crest of a high ridge called Garnet Hill, to the west of the road leading up to Sunset Hill from the village. Pious Deacon Sturtevant named it Old King Saul after the king who, according to the Bible, "stood head and shoulders above his brethren." Prior to this, it had been known as the Pilot Tree because its great height made it a guide for the boatmen of Lake Winnipesaukee.

The Wood Giant has an impressive girth. Mrs. Henry Sturtevant told Judge Frederick W. Fowler of Laconia that she and Lucy Larcom, standing on opposite sides close to its trunk, were just able to touch fingers together by reaching as far around the trunk as possible. Under this enormous tree, Whittier and his friends spent many happy hours.

It was on a matter connected with the great pine that Judge Fowler met the poet. He had taken a picture of the Wood Giant, which he showed Whittier, who gave him permission to use it with the recently published poem. "It was while I was engaged in photography in Center Harbor in the summer of 1885 that I learned that Mr. Whittier was a guest at the Sturtevant Farm on Sunset Hill, and I was anxious to get a picture of New England's Quaker poet, especially as his poem about the great pine on the farm had just been written," Judge Fowler wrote.

Whittier studiously avoided publicity, and the young photographer might have had difficulty in accomplishing his purpose if Mrs. Sturtevant had not come to his aid. Saying that she wished a picture of all the guests at the farm as a reminder of the happy summer they had spent together, she asked Whittier as a special favor to join them. He naturally agreed, and was unobtrusively placed in the center of the group. This gentle conspiracy resulted in a photograph which is still one of Fowler family's most prized possessions.

When Judge Fowler was asked how he remembered Whittier, he replied, "I was most impressed with his wonderfully expressive and penetrating dark eyes, deep set under heavy brows, and his modest and unassuming manner." These dark eyes have been described elsewhere as "flashing," and it is said that they were characteristic of the Bachiler family.

During his failing years (after 1891), Whittier's eyes allowed him to write very little, and it was difficult to talk with him because of his deafness. The famed poet

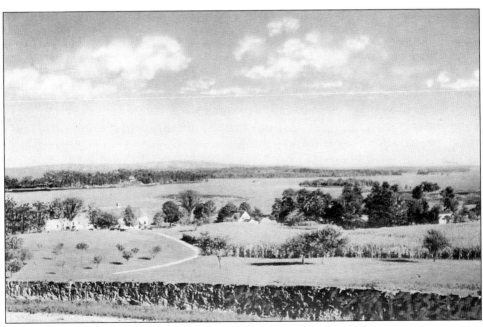

CENTER HARBOR, 1920. Lake Winnipesaukee is visible in the distance from this breathtaking view on Garnett Hill.

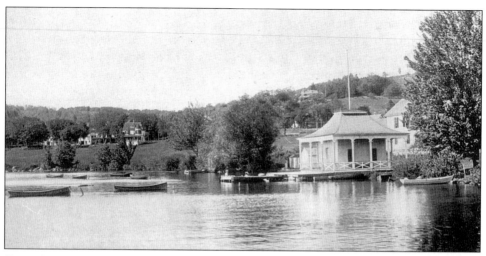

BOAT LANDING AT CENTER HARBOR BAY. Center Harbor is not only a port of many past steamers on the lake, but also serves as the winter home for the M.S. Mount Washington.

still arose at five o'clock in the morning and walked about the grounds of the Elmwood Inn in Wakefield, Massachusetts. He enjoyed visiting the swallow-haunted barn of the inn, and at sunset walked out near the great barn where he could see the western sky.

In the summer of 1892, Whittier was eager to go to Center Harbor, but the trip was considered too tiring for a man of his age and health. Instead, he went to visit his friend Sarah A. Gove at Elmfield, her beautiful home on Hampton Hill, 7 miles from his home in Amesbury. Whittier died at Elmfield early in September 1892. The village bell in Hampton Falls tolled the knell of his passing. As his body was carried to his home in Amesbury, the church bells of the border towns of Seabrook and Salisbury took up the refrain.

His grave overlooks the river that rises in his beloved New Hampshire mountains. His affection for them was expressed in a letter written to Grace Greenwood in 1886: "I spent last summer among the New Hampshire hills, as I have done for several years. Nature never disappoints me."

From 1873 until 1939, the old side-wheeler *Mount Washington* made daily trips to these public docks, and its successor, M.S. *Mount Washington*, continues to use Center Harbor as its winter port. Today, Center Harbor has become one of the most popular summer resorts at the northern tip of the Lake Winnipesaukee.

GILFORD

The beautiful village of Gilford (Gunstock Parish) is located at the base of Gunstock Mountain, part of the Belknap Mountain Range, on the west side of Lake Winnipesaukee. To properly examine the historical development of Gilford, one must first look at its original township—the Gilmantown Charter. On May

20, 1727, His Majesty's Provincial Lieutenant Governor Wentworth signed the Gilmantown Charter for the establishment of a town of some 85,000 acres (133 square miles), about one-third of what was later to become known as Gilford. The first boundaries of the this large town included the present Gilmanton, Belmont, Gilford, Lakeport, and that part of Laconia south of the Winnipesaukee River.

During the first few years following Gilmantown's settlement, the inhabitants identified the territory as the "Lower and Upper Parishes," which described the two major sections of the town for future ministers who would reside in these districts. The Upper Parish included the future town of Gilford, Belmont, and selected sections of Laconia, Lakeport, and the Weirs south of the Winnipesaukee River. The future Gilford, which would include territory along the river, and later became part of the city of Laconia, took the name "Gunstock Parish."

Due to the size of the town and the long distances it took to travel to town meetings, a petition was presented at a town meeting in 1792 to set off the "Upper Parish" as a new town, but this was rejected. In 1811, the town agreed to appoint a committee to describe the boundary line of "Gunstock" to be set off as a new town. In 1812, the Gilmanton town meeting voted down the petition to set off the Gunstock Parish as a separate town. The bill was read three times during that year before it was finally enacted and sent to Governor Plummer for his signature. On

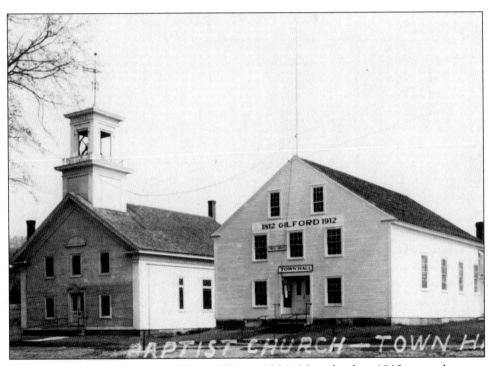

THE BAPTIST CHURCH AND TOWN HALL, 1914. Note the date 1812 upon the town hall's upper sign, for the year 1812 marked the official separation by the state legislature of Gilford from Gilmanton.

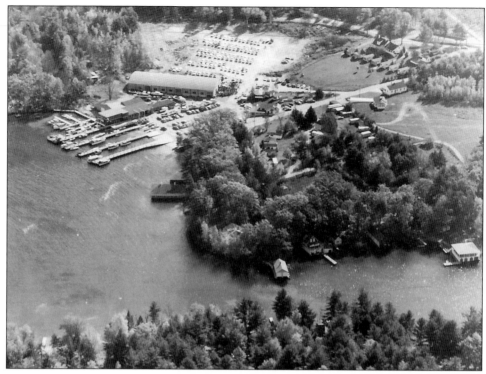

AN AERIAL VIEW OF GLENDALE BAY IN GILFORD. Glendale Bay is a busy port and harbor and serves as the main office for New Hampshire's Department of Safety, Marine Division, which patrols Lake Winnipesaukee.

June 16, 1812, that part of Gilmanton, so-called "Gunstock," was cut off. The new name of "Gilford" was selected, taking its name from a Revolutionary battlefield, that of Guilford Court House in North Carolina.

Through the course of the nineteenth century, Gilford witnessed many changes in its size and boundaries. From the original 133-square-mile area, under the auspices of "Gilmantown" in 1772, Gilford was reduced to 39 square miles by 1893. The "Bridge," or Lake Village, was part of Gilford until 1874, when it separated from Gilford and merged with Laconia. Another change occurred in 1851, when eight farms adjacent to Sanbornton Bay on Lake Winnisquam and the Winnipesaukee River were annexed to Gilford from Gilmanton. The Belmont township was created out of the remaining northwestern acreage of Gilmanton. In 1893, Lakeport (Lake Village) joined the city of Laconia, completing its separation from a rural setting to its urban suburbia. These changes in boundaries had an enormous effect upon the town of Gilford, tax-wise and otherwise.

Over the past 200 years, the town of Gilford has grown from an agricultural community to a very prosperous resort town, attracting many out-of-state visitors to the mountain ski resort chalets and their large expanse of shore property on Lake Winnipesaukee.

LACONIA

The name Laconia commemorates the famous Masonian Grant that "the council established at Plymouth, in the County of Devon, for the planting, ruling and governing of New England, in America . . . [did grant unto Captain John Mason] all the lands between the rivers Merrimack and Sagadahoc, extending back to the great lakes and rivers of Canada, and this was called Laconia." The present city of Laconia is of comparatively recent origin; it was incorporated in 1855, but the towns from which it was formed are among the oldest in this portion of the state. Its heritage is identified with Native American legends and covers a period of such importance in our country's history that a study of it is as interesting as a romance. The territory which makes up Laconia was taken from Meredith and Gilford, thus the details of its early history properly belong to the histories of those towns and that of Gilmanton, from which Gilford was formed.

Laconia was destined to become a city, taking its foremost place among New Hampshire's centers of population and wealth for the Lakes Region in Central New Hampshire. Laconia is bounded on the north by Meredith; on the east by Long Bay (Lake Winnipesaukee) and Gilford; on the south by Belmont; and on the west by Great Bay, or Lake Winnisquam, and Belmont. Practically all municipal businesses of the town, except that done during the summer season at Lakeport and the Weirs, is concentrated in the Laconia Village Business District.

What is presently the Laconia Business District was formerly known as Meredith Bridge. The development of Meredith Bridge may be gained from the

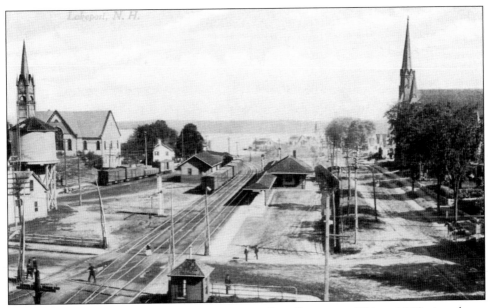

UNION AVENUE LOOKING TOWARD PAUGUS BAY, LACONIA. *This c. 1900 view shows early Laconia and its complement of churches and railroad tracks.*

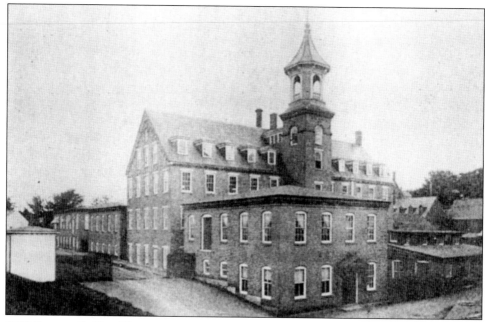

J.W. BUSIEL & CO. HOSIERY MILLS. Known today as the Belknap Mills, this structure is listed on the National Register of Historic Places.

fact that, in 1813, there were only 34 houses and some of these were shanties. No wagons were to be seen on its street, and the mail was frequently carried on horseback from Concord to Center Harbor.

Great progress was made during the next 30 years, as is seen in the following from an 1842 article in the *Belknap Gazette*:

> it appears that there was at that time an extensive printing establishment in the village, together with three cotton mills, one woolen mill, one grist mill, several saw mills, manufacturers of shingles, clapboards, sashes and doors, a large tannery and lesser industries, besides ten stores, two apothecaries, one watchmaker and jeweler, two physicians, two barbers, five lawyers, three clergymen, three new churches, one academy and three taverns. The first saw mill was built at the Weirs in 1766 by the proprietors of the township. The first settlement was made near the head of Round Bay.
>
> The first cotton mill in Laconia, one of the first in the country, was that built by the Meredith Cotton and Woolen Company, which held its first meeting July 1, 1811. The first machine shop was opened in 1808 by Daniel Tucker, who carried on business successfully until 1832.
>
> A paper mill and carding mill were built in 1800. A bell foundry was established in 1810 by George Holbrook, who had "served his time" with Paul Revere of Revolutionary fame. The Granite Hosiery Mills

were established in 1847 followed by the White Mountain Mills established in 1853, and, at first, manufactured hosiery yarn only, but, in 1855, the production of hosiery was began. This was soon followed by the incorporation of the Gilford Hosiery Company in 1864.

From the early 1800s to the present, the city of Laconia has become very prosperous, bringing it to prominence as a center of commerce in the heart of the Lakes Region. Of these enterprises worthy of mention is the Laconia car shops, under the management of the Laconia Car Company Works. Under the leadership of the Honorable Frank Jones of Portsmouth, both president and principal owner, the company served as the largest single industry in the city of Laconia, and one of the largest, most important, and most widely known in the state.

The original Laconia car shops were started by Charles Ranlet in 1848, and it was first known as the C. Ranlet Car Manufacturing Co. In 1849, Joseph Ranlet was taken into partnership, and the firm name became known as the Ranlet Car Company. This partnership continued until the death of Charles Ranlet in October 1861. The following year, the surviving partner, Joseph Ranlet, formed a partnership with the Honorable John C. Moulton, continuing the business under the name of the Moulton & Ranlet Car Company. In January 1865, another company was formed under the name of the Ranlet Manufacturing Co., the members of the concern being John C. Moulton, Joseph Ranlet, and Perley Putnam, who continued in business until April 20, 1878, at which time Ranlet retired.

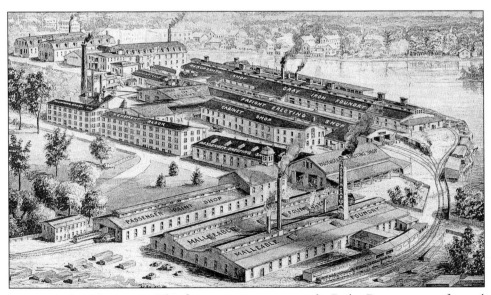

LACONIA CAR COMPANY. *This famous car company, run by Perley Putnam, manufactured a wide variety of rail cars.*

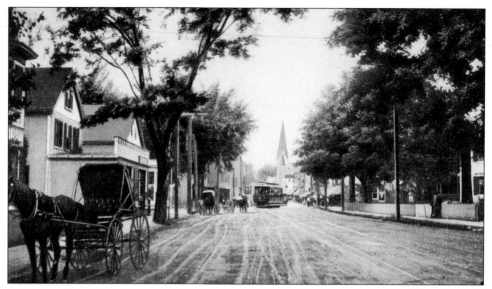

LACONIA'S MAIN STREET, 1908. This early postcard of the "City of the Lakes" shows an interesting variety of modes of transportation, from the horse-and-buggy to the street trolley.

In 1882, the company was reorganized under the corporate name of Laconia Car Company, with Moulton and Putnum still serving as the principal owners. In 1889, Moulton sold out his interest in the corporation to his partner, Perley Putnum, who carried on the car building industry, principally alone in its ownership and management until 1897, when the entire property passed into the hands of the Honorable Frank Jones and his associates.

The new corporation, chartered under the name of the Laconia Car Company Works, was organized on February 25, 1897, and the board of officers of the corporation at that time were as follows: Frank Jones (president), E.H. Gilman (treasurer), and directors B.A. Kimball, C.F. Stone, and Dennis O'Shea.

The original plant was comparatively small with cheap wooden buildings and old-fashioned machinery. But the wooden buildings gradually gave way to more substantial structures of brick, equipped with the latest machines in every department. The plant covered 7 acres of land in the very heart of Laconia, and a large proportion of this property was covered with the foundries, woodworking shops, setting-up shops, painting shops, storehouses, etc., including the immense four-story brick structure devoted to the malleable iron foundry industry, which was operated in connection with the car construction business.

When the car plant was started, nothing but freight cars were manufactured, but afterwards, facilities were added for turning out all kinds of passenger cars, and the Laconia car shops soon won a national reputation for building first-class cars of every description. During the turn of the century, the introduction of electric railroads in all parts of the United States had developed and the Laconia car shops had become very involved in the construction of electric streetcars.

In the manufacturing of all styles of electric cars, this concern achieved a reputation second to none in the United States, and the handsome and substantial products of the Laconia shops could be seen upon the trolley lines of Boston, New York, and, in fact, nearly all the large cities of the United States. The demand for electric cars appeared to increase and there was evidence of a great future in this branch of the business. Being so, the electric car construction department was pushed to its full capacity. The car shop employed about 500 men.

The Boston office at 50 State Street was the general headquarters of the corporation and the office of the treasurer and manager. Peter Walling, formerly connected with the Boston and Maine Railroad as a master bridge constructor, served as the superintendent of the plant at Laconia. Nearly all the foremen in the various departments, and in fact a large proportion of the employees, were men who had grown up in the car-building business.

From a small concern employing less than 100 men, the Laconia Car Company had grown to require almost a regiment of employees in its shops, and its capacity had increased from a few rough freight cars per week to a palatial modern passenger car per day.

The end of the electric cars came gradually as the automobile outgrew its classification as a "rich man's toy," and in 1923 the Laconia Car Company completed its last order for rail or trolley cars. The company continued in existence, with management and custodial personnel, until the early 1930s, but it did not make a recovery. On August 9, 1925, the last official trolley run of Laconia Street Railroad was made and buses replaced the electric cars.

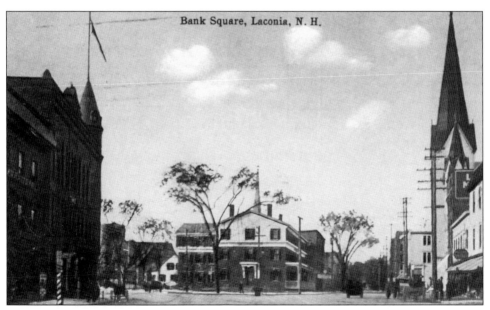

LACONIA'S BANK SQUARE, 1914. Tranquil as it appears, with its opera house, churches, and stores, Laconia remains the "hub" of the Lakes Region.

As industry grew in the community, so also did the services that made Laconia a magnet to the area. The first financial institution was the Meredith Bridge Savings Bank, incorporated in 1831, and is still in existence under the name of the Laconia Savings Bank—the change of name was made in 1869. The first deposit was received in March 1832, and the facilities have expanded over the years, due to its excellent management and the public's confidence in the institution.

For obvious reasons, Laconia's Fire Department should, by no means, be left out of this history, for the existence of this department renders both life and property more secure.

The erection of a cotton mill in 1813 made it advisable, if not imperative, to provide some adequate means for the extinguishing of fires, and after considerable hesitation and long debate, the first engine was bought and housed in specially built quarters on Mill Street, the site later to become the Belknap boarding house. The engine company was ready before the engine had been provided, the company having been incorporated in 1814 as the Meredith Bridge Engine Company. This "tub" was destroyed in 1855 after 40 years of service, and its destruction was a distinct gain to the town, for the engine was a most primitive affair. The original engine had no suction hose, but took water from a tank attached to the machine. This tank was filled by using leather buckets, with which the engine was provided. When in active service, the scene must have been both lively and sometimes comical, for one gang of excited men would be hurriedly bringing water from some adjacent well, spring, or stream, while another would

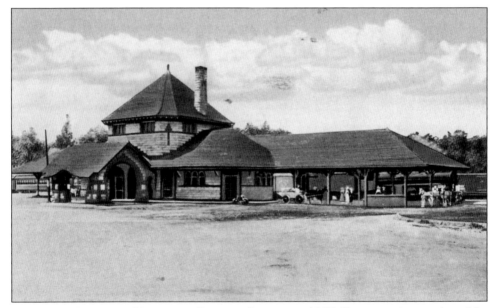

RAILROAD DEPOT AT VETERANS SQUARE, LACONIA, 1917. Due to an increased need for passenger service in Laconia, the Concord & Montreal Railroad Company built this railroad passenger station, which was dedicated and opened on August 22, 1892.

WINNIPESAUKEE RIVER AT LACONIA. This river is a major outlet for the waters of Lake Winnipesaukee to reach the Merrimack River.

be working the brakes for all they were worth and trying to outdo the water carriers by exhausting the supply faster than they could replenish it.

In 1834, the Meredith Bridge Hose Company was organized for the purpose of utilizing force pumps, one of which was located in the cotton mill yard, and the other on the opposite bank of the river on Mill Street. The year 1849 witnessed the purchase of "Torrent No. 2," and the formation of a company to "run the machine."

Both machine and company were destined to achieve local fame, for in those early days, the engine companies of any city or town were representative (volunteer) organizations, and more interest was taken, and more pride felt in their performance, than even baseball can elicit today. The firemen served for the pure love of it, and many a stalwart young man worked with enthusiasm at the brakes or during the headlong dash to the burning building. This outlet providing for his bubbling-over spirits was an asset for the town, as well as creating a more useful member of the community.

The first steam fire engine was purchased in 1875, and the fire apparatus was greatly added to and improved during that year, a new hose carriage and a hook and ladder truck also being provided. The progress made since 1875 has been in keeping with that of the town, and presently, Laconia has a fire department which, in efficiency, discipline, and apparatus, is one of the finest in the state of New Hampshire.

Closely associated with the work of the firemen was the service afforded by the Laconia and Lake Village Water Works, chartered in 1883, with a capital of

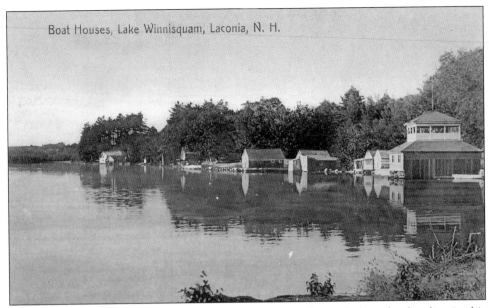

Boat Houses, Lake Winnisquam, Laconia, N. H.

BOAT HOUSES ON LAKE WINNISQUAM, LACONIA. Clustered along the shoreline in this cove, privately owned boathouses shelter the many elegant crafts that sail these waters.

$50,000. The pipes utilized by this corporation were laid in the summer of 1885, and the facilities offered by the company were largely availed of for manufacturing, mercantile, and domestic purposes.

In 1881, the service afforded by the Winnipesaukee Bell Telephone Company was also introduced to the Lakes Region, which included the towns of Lake Village (Lakeport), Weirs, Meredith, Gilmanton, Tilton, and Belmont. This company was incorporated April 23, 1881.

The Laconia and Lake Village Horse Railroad was incorporated in June 1881, and the road was built during the summer of 1882. The first car was operated on Friday afternoon, August 18, 1882. The road extended from the Willard Hotel in Laconia to the Steamboat wharves at Lake Village (Lakeport), a distance of 2.5 miles. The line was of narrow gauge, but the cars were of equal capacity to those in use on standard gauge roads.

The Laconia press merits a much more extended notice than the limited space here provided, for they were well established and had accomplished much in the advancement in local interest as well as the surrounding towns. The first newspaper published at Meredith Bridge was the *Belknap Gazette*, which was established more than 150 years ago by Colonel Charles Lane, who carried on a large printing office and book bindery located on the present site of the post office. In 1843, the *Gazette* was purchased by the Whig party, and the paper changed hands several times later.

The *Laconia Democrat* dates its origin from the establishment of the *New Hampshire Democrat*, the first number of which was printed at Meredith Bridge in

the last week in December 1848 and was dated January 4, 1849. This was the first organ of the democracy in Belknap and Carroll Counties and was considered the best printed in the state.

The *Calvert's Weirs Times and Tourists' Gazette* made its first appearance in the Laconia area at the Weirs in 1883 and was printed weekly until 1898. Since 1992, the *Weirs Times and Tourists' Gazette* continues the original tradition of the *Calvert's Weirs Times* by printing its weekly newspaper for the Lakes Region and beyond, keeping alive the area's special heritage and legacy.

LAKE VILLAGE

The settlement of Lake Village (Lakeport) holds the distinction of being endowed with many names. It has been referred to as the "Upper" Village, this name arising from its position above Meredith Bridge, now Laconia, on the Winnipesaukee River. At another time, it was called Batchelder's Mills, at another Furnace Village, later Slab City, and Folsom's Falls. However, it was around the middle of the nineteenth century that it became known as Lake Village, which took hold as its new name, followed progressively by Lake City, Lakeville, until 1892, when it was referred to as Lakeport. In 1893, Lakeport became part of the new city of Laconia.

Lake Village was originally part of the town of Gilford, and Gilford, originally a part of Gilmanton, thus its history really dates back to the incorporation of that town in 1772. Although Gilmanton was formally incorporated at that date, the actual permanent settlement of the town did not take place until nearly 40 years later, for the country was so overrun by hostile Native Americans and the difficulties to be overcome were so great, that the early colonists were deterred from entering upon and improving their granted lands.

At first, farming practically monopolized the industry of the early settlement, but the country had to be cleared, houses had to be built, grist had to be ground, and some of the many waterpowers in Gilford were soon used to run the first gristmills, sawmills, etc. As Lake Village possessed by far the most valuable waterpower in town, it has been identified almost from the very beginning with the manufacturing history of Gilford.

There were two mills at the Weirs during this early time, one on either side of the Winnipesaukee River, but the power was small and the mills were finally destroyed by the raising of the dam at Lake Village, at which point Abraham Folsom built a sawmill in 1780. Reverend J.P. Watson writes in his *Sketch of the Town of Gilford*, "So great was the volume of lumber manufacturing at Lake Village, and proportionately so in excess of all other pursuits and products, that the place became known best by the current designation of 'Slab City,' and bore that title for a long time."

During the following years, when the "old growth" timber had been nearly exhausted and the lumber industry had greatly diminished, Lake Village (Lakeport) became prominent in connection with the industry of iron, "Furnace Village."

Reverend J.P. Watson also explained the growth of this settlement, "This village has rapidly increased of late years, and is now the rival of Laconia, and by water approaches is even better connected." These two centers of business and population were founded at nearly the same time, but the lower one had decidedly the advantage due to its rapid growth in its business district; all of which contributed to the prosperity and importance of the Lower Village, and were almost entirely wanting in the Upper Village. Due in part to the cooperative efforts of the prominent manufacturers and merchants of one village with the enterprise in the other, these two communities joined together as one. Such firms included the Laconia and Lake Village Water Works and the Laconia and Lake Village Horse Railroad. The Lake Shore Railroad would never have been built had it not been for the cooperation of Laconia and Lake Village. Geographically divided by the river, Meredith on the west and Gilford on the east, Lake Village (Lakeport) saw the western part of its territory ceded to the new town of Laconia in 1855, then to Gilford in 1876, before the village finally became part of the City of Laconia in 1893.

Today, Lakeport, in union with Laconia, has become prosperous in her industry and a center of tourism in the Lakes Region.

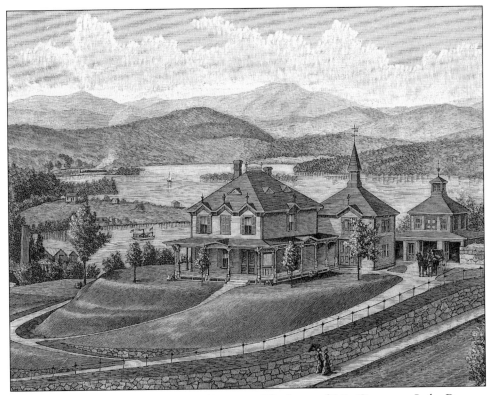

RESIDENCE OF J.S. CRANE, LAKE VILLAGE. *The home of J.S. Crane, on Lake Paugus, possesses a wonderful view of Winnipesaukee and the White Mountains in the distance.*

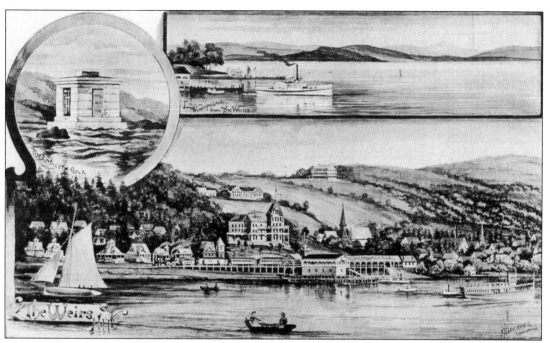

A BIRD'S-EYE VIEW OF THE WEIRS. The Weirs is one of the most visited and celebrated of the port towns of Lake Winnipesaukee.

THE WEIRS

Situated on the verge of Lake Winnipesaukee, along the side of a hill rising abruptly from the water, the little village of Weirs is singularly a summer resort. For many visitors, the Weirs is a paradise for recreation, a terminus for the many vessels that use this major port for daily excursions on the lake.

The Weirs (Aquedoctan) was a home to Native Americans. Originally, a fishing weir was built in the channel at the outlet of Lake Winnipesaukee where they would catch the shad during their yearly migration between the Atlantic Ocean and Canada.

As noted in chapter two, it was in 1652 that the first exploration of Euro-Americans was made to the Lakes Region when a party of surveyors, under the leadership of Captain Simon Willard and Captain Edward Johnson, were appointed by the Court of the Massachusetts Bay Colony, to ascertain the source of the Merrimack River so as to establish the northern boundary of the Bay Colony.

On August 1, 1652, they found the source to be "Lake Winnipiseogee," and so marked the latitude to be 43 degrees, 40 minutes, and 12 seconds besides those minutes which are to be allowed for 3 more miles north, which runs into the lake. Here, they so marked it on a rock at the opening of the Weirs channel, Endicott Rock Monument.

In *Rambles about the Weirs*, Edgar H. Wilcomb writes the following:

> in 1727 a large tract of land was granted by the Province of New Hampshire, under King George of England, to a company composed of 164 persons, 24 of whom were named Gilman, settled in Exeter and vicinity. This grant was later confirmed by the Laconian proprietors, claimants of all the Winnipesaukee lake territory. This territory of the grant was so named Gilman town which encompassed the township of Gilmanton, Alton, Gilford, Northfield, Belmont, and portions of Tilton and Laconia, east of the river flowing from the lake. The property west of this river from the lake southward was encompassed in the later town grants of New Salem [now Meredith] and Sanbornton.

The first known recorded survey of this area was taken approximately between the years 1748 and 1753. This took place in the town of Portsmouth in 1753, at which time, the entire township of Meredith was divided among its proprietors of the town. This plan of Meredith was stated in the records as "A plan of the township called Palmer's Town lying to ye westward of Wenepesioca Pond [Winnipesaukee Lake], in ye Province of New Hampshire, granted to Samuel Palmer, Esq. Surveyed A.D. 1750 and 1753, by Jonathan Longfellow, Surveyor."

Wilcomb continues, "The township is laid out into three divisions. The first division contains one hundred acres to each 'right' and are those lots numbered with red from ye outlets of Wigwamn Pond [Lake Waukewan] downward to ye Wares [the Weirs]." This division included 100 acres of the Weirs bordering upon the shores of Lake Winnipesaukee from the present Weirs to Meredith Village.

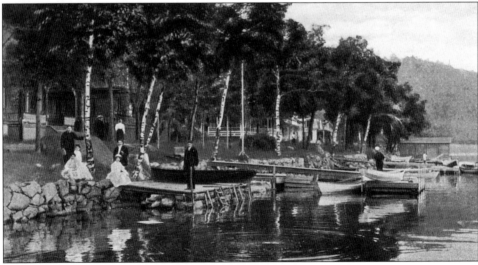

THE SHORE PATH AT THE WEIRS, EARLY 1900s. *Families are seen here enjoying the lake's shoreline, lined with beautiful white birches.*

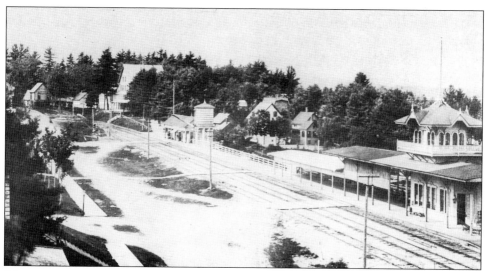

THE WEIRS RAILROAD STATION. Nestled on the western shore among the pine groves, the railroad brought tourism to the Lakes Region.

In 1768, only 17 families were settled in this township, but two years later the population of Meredith had grown to 34 families, being distributed between Meredith Village and Meredith Bridge (Laconia). In 1775, there were 259 residents throughout the township, and in 1855, just before Meredith Bridge broke off from Meredith proper to become Laconia, the population was approximately 3,521.

The first recorded building constructed by the early white settlers at the Weirs is said to have been a fort or blockhouse in 1736 by the surveyors for the town of Gilman town. The fort, located on the east shore of the present canal facing what is now Endicott Rock Monument, was built of hand-hewed logs and stood 14 feet square in dimension. This location is now called Interlaken Park.

What interesting tales could be told of the early settlers as they traveled northward in old stagecoaches, spending their evenings at the local taverns that then occupied and helped develop the Weirs.

The first excavations to open up the channel to navigation were done in 1833 by local residents. During the early days of steamboating, a wharf occupied the east bank of the channel above the bridge, and this was the old landing-place for the fleet of "gundalows," early vessels that plied the water of the lake before the days of steamboating.

In the years 1848-49, the first railroad extended from Concord to Montreal, passing through Laconia and the Weirs. This gradually transformed the settlement from an agricultural center to tourism—the rails of the Concord & Montreal Railroad making travel to the north country easily accessible. This was the time that saw the *Lady of the Lake*, the *Chocorua*, and the *Dover*, some of the first steamboats to ply the water of Lake Winnipesaukee.

The first railroad station at the Weirs was located near the lower railroad bridge, opposite the bridge over the channel. About this time, the steamer wharf was first built, and it was a very primitive affair. Instead of the present incline for passengers, between the railroad and boat landing, there were stairs against the side of the embankment and "tackle" to raise and lower the freight. Eventually, the Weirs became a major port town in the Lakes Region, where connections were established between the railroad and the steamboats.

During the 1870s, the Weirs was especially distinguished by its grove meetings and other assemblages of society organizations, such as religious, temperance, musical, and military bodies. The spacious and handsome groves and buildings of the New Hampshire Veterans' Association, for soldiers of past wars to gather in "reunion," are still very prominent features of the landscape.

Practically all the major changes in the Weirs were caused by fire, such as the railroad station and pier in 1939 and the Weirs Hotel in 1924. Fire had even taken some of the buildings in the Veterans' Grove, which have never been replaced. Before the fire of 1939, the railroad station ran out and over the water with a two-story building on it, as well as a large ice cream parlor on the second floor.

In 1939, three tracks ran through the town itself, the new station was built, and the old spur track was taken out. Through the years, one by one, the tracks have all but disappeared, except for one single track that is the main line from Boston to Lincoln, New Hampshire.

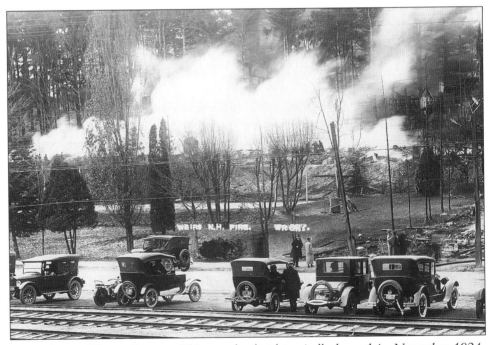

THE HOTEL WEIRS BURNS. *This popular hotel tragically burned in November 1924, along with 12 other landmarks on Lakeside Avenue and Tower Street.*

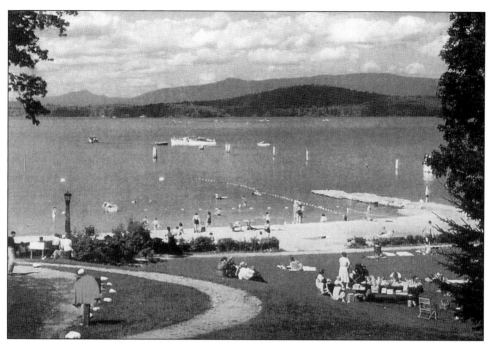

WEIRS BEACH, 1950s. Located next to Endicott Rock Monument, this beach continues to attract crowds of summer bathers to the area.

Over the next 60 years, many changes have taken place, but the town's purpose is still the same—to be a major seasonal attraction for the thousands of tourists who come to Central New Hampshire each year.

MEREDITH

Nestled in the foothills of the White Mountains, on the shore of Lake Winnipesaukee, lies the beautiful settlement of Meredith. A community of superb scenery in the center of the Lakes Region, uniquely clustered with many lakes and rivers, streams and meadows, islands and bays, it is truly the "Latchkey to the White Mountains." Its shore on Lake Winnipesaukee was a favorite resort for Native Americans. Large villages stood on each side of the river, and they prospered by tilling the land and fishing the lakes. Many years before the first European settlers appeared on the scene, dams were built on the rivers for the purpose of catching shad, which swarmed there in the fall. Here, the warlike chief Wohawa called a council to incite the neighboring tribes just previous to the bloody days of 1675, and here, the gallant but ill-fated Lovewell often halted in his raids on the Ossipees. This whole region is rich in legendary Indian lore and heritage.

In 1748, the first settlement, Palmer's Town, was made. It was named for Samuel Palmer of Hampton, who, as a teacher of surveying and navigation, laid

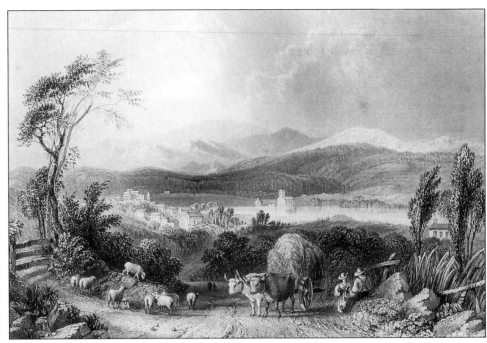

A VIEW OF MEREDITH, 1838. In this sketch by William Bartlett, the White Mountains create a magnificent backdrop for the early rural setting of Meredith.

out much of the land surrounding Lake Winnipesaukee. This was one of the first towns to have a charter granted by the proprietors, and, as most of the lots went to prospective colonists, possibly from Salem, Massachusetts, it was called Salem, which soon changed to New Salem. Not all of them, however, fulfilled the terms of the charter, for only 17 families actually settled in the town. Many of the other proprietors were land speculators who planned to sell their shares at a profit. Prior to 1769, nearly all of the proprietors' meetings were held in Stratham and Exeter, and it was there that plans for settlement were actually voted upon.

Committees were appointed to lay out the township and its divisions of lots, much of which had been completed before the Seven Years' War broke out in 1754. Preparations for settlement were soon resumed by the proprietors of New Salem.

The early settlers of New Salem came by way of the Canterbury Road, and then journeyed to the Weirs area, thus beginning a settlement that is now referred to as the Meredith Parade. Ebenezer Smith and John Eaton were the first two settlers. Log houses were built at the head of what is now Lake Opechee around the year 1766. The first settlers seemed to like the high ground of the Parade; a church, a tavern, the meetinghouse, the cemetery, and a pound were all located here.

Growth of the town was very slow until, on December 30, 1768, a petition for township was reaffirmed and incorporated, and the region was renamed Meredith, after Sir William Meredith, a prominent member of the English

Parliament. The town's growth surged; businesses and farms flourished. However, as with many of the towns in the Lakes Region, continued development was seriously hampered by the Revolutionary War, when many took up arms in defense of their independence. After the hostilities, they turned their attention upon town and civic affairs.

Early settlers in Meredith were men and women of a most sturdy character. They were pioneers of an extraordinary kind, and they took an active part in the formation of the Granite State, stamping their individuality upon its enactment.

Of all the events recorded in the town records, the saddest and most dramatic took place in the unfinished Town Hall at the annual town meeting on March 13, 1855. Approximately 600 to 800 voters were present when suddenly the floor timbers gave way under the weight and threw about 150 persons to the basement. Of those, 60 either died or were crippled for life. Because of this tragic event, Meredith lost a large portion of her territory in July 1855 to the newly formed town of Laconia, and in July 1873, to the town of Center Harbor.

During the 1800s, Meredith was a thriving manufacturing town that housed one of the few linen mills in America. On the banks of the lake could be found a casket factory, which serviced all of New England and much of the East Coast. There have been many industries which have come and gone in Meredith's history. Such industries include the manufacturing of stockings, cotton, woolen and linen textiles, agricultural implements, organs and melodeons, caskets, many wooden products, and numerous others.

The Meredith Shock and Lumber Company was considered the life of the town for many years. It is difficult to overestimate the importance of this enterprise. The company gathered the raw lumber from the surrounding countryside, took it to the lake shore, and from there used powerful little steamers

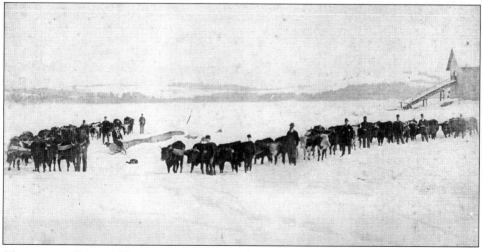

TEAMS OF OXEN, MEREDITH, 1880s. These oxen teams were used to break roads throughout the town. The Shook Lumber Company is visible on the right.

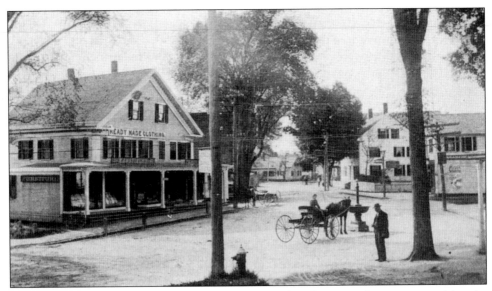

POST OFFICE SQUARE, MEREDITH, 1880S. Found in the center of most communities, the water fountain was a main feature in the town's business district.

to tow the lumber to Meredith. The location of the manufacturing company was where St. Charles Church is now.

The Meredith Mechanics Association was another important industry in the town, which was incorporated in 1859. The property consisted of all the waterpower offered by an adjoining lake call Waukewan in one fall of 42 feet to Lake Winnipesaukee. The complex of the association consisted of three factory buildings, three shops, one store, and three houses.

In 1876, Samuel Hodgson moved from Laconia to Meredith. He leased the power and mills of the Mechanics Association and manufactured mittens until 1877. By that time, Mr. Abel, an associate of Hodgson, had revolutionized the manufacture of knitting good. In 1877, Hodgson began to manufacture stockings in Meredith. He erected new buildings, tripling the capacity of the mills. It became the principal activity in the village. In 1885, the mill employed about 160 operators, most of whom were women. In 1887, the Hosiery Mill burned—this was a terrible catastrophe for the community.

Shortly after, two brothers, Allie Hall and Minot Hall, came to Meredith from Massachusetts. They bought all the property from the Meredith Mechanics Association, as well as the water rights of the old mill. After equipping and erecting new buildings, they purchased flax from Europe and manufactured in what was known as the Meredith Flax Mill, an excellent grade of pure linen. Later, the entire business was acquired by Allie Hall, who then established the Meredith Linen Mill. The mill was located where the Mill Falls Market Place is today.

A third industry worthy of mention was a tannery, one of the first industries in the village. It was established about 1870 by William Fernald and later carried on

by George Badger. It was located on Hawkins Brook, which goes under the road at Prescott Park and enters into the creek. The power was furnished by the flow of the water from the brook.

The present township of Meredith is bound on the north by Center Harbor and Lake Winnipesaukee; north and northeast by Lake Winnipesaukee; southeast by Laconia; south by Sanbornton; and west and northwest by New Hampton. Within its boundaries are many lakes: Waukewan, Wicwas, Winnisquam, as well as Winnipesaukee.

Within the town, there are two villages: Meredith Village and Meredith Center. The business district of the town is located in the village, which is beautifully situated on Meredith Bay, an arm of Lake Winnipesaukee. A major influence of the village's prosperity was due mainly by the growth and development of the Concord & Montreal Railroad, which brought its line from Boston and Concord and continued north, via Meredith Village, and on to the White Mountains and Canada.

The spirit and growth of the community are evident in their many farms and industries, mills and factories, inns and hotels, and enterprises of all descriptions which then sprang up in the Village and the Center, on the neck and the islands. As travel by road, railroad, and boat increased, the town grew in size and importance in the Lakes Region.

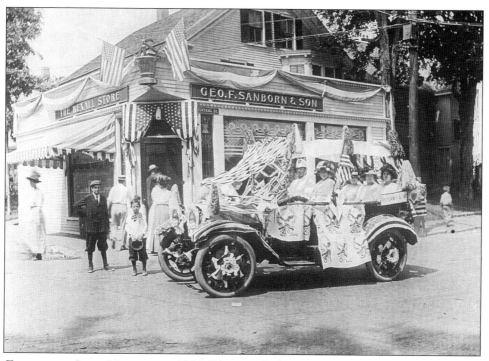

FOURTH OF JULY, MEREDITH, 1915. Photographed on Main Street, this ornately decorated automobile won first prize in the town's parade.

63

MOULTONBORO'S MAIN STREET, 1920. In this view looking east, Tilton's General Store, the Olde Country Store, and the town library are visible.

MOULTONBORO

The town of Moultonboro resides astride the northern end of Lake Winnipesaukee and thrusts its long neck—Moultonboro Neck—down into the lake, giving it a 50-mile shoreline of unsurpassed beauty of that body of water alone. With its frontage of 15 miles on Squam Lake, and that of Kanasatka, Berry Pond, and ten smaller ponds, Moultonboro offers a longer shore line than any other town in the state. Red Hill and the Ossipee Mountain Range rise high above the surrounding countryside, affording slope and a beautifully varied terrain.

Moultonboro was granted by the Masonian proprietors to Colonel Johnathan Moulton and 61 others on November 17, 1763; it was finally incorporated on November 27, 1777. The document was signed in the famous Stoodley's Tavern in Portsmouth and declared to be "for the encouragement and promoting of the settlement of the country," the entire area being described as "near Winnepisseoky Pond."

The town is steeped with American Indian lore. The Ossipee tribe once resided in this vicinity, and some years since, a tree was standing in Moultonboro on which was carved in hieroglyphics, the history of their expedition. Many Indian implements and relics have been found, indicating this to have been once their favorite residence. In 1820, on a small island in Lake Winnipesaukee, a person discovered a curious gun barrel, much worn by age and rust, divested of its stock, enclosed in the body of a pitch pine tree, 16 inches in diameter. On the shore of the lake, at the mouth of Melvin River, a gigantic skeleton was found, about 60 years since, buried in sandy soil, apparently that of a man more than 7 feet tall, the jawbone easily passing over the face of a large man.

Like so many of the New Hampshire towns, whose early settlers included many of the same family name, Moultonboro took its name from a group of its grantees with one common name, Moulton. When one examines the original list, it shows that no fewer than 16 Moultons were included. There were, however, 45 additional grantees not of the name Moulton.

Most of the Moultons came from Hampton under the leadership of Colonel Johnathan Moulton, who received his title through having fought in the Indian Wars. In addition to his land in Moultonboro, Colonel Moulton also received grants in the towns of Cornish, Tamworth, Eaton, Campton, Lisbon, Chatham, Burton, Orford, and Piermont, as well as Huntington and Lunenburg, Vermont. He reportedly also had the entire area of what is now New Hampton deeded to him as Moultonborough Addition by Governor Wentworth in return for his present to the governor of a "fine fat ox."

At the beginning of the Revolution, Colonel Moulton was considered to be one of the richest men in the province, with an estate totaling more than 80,000 acres. In 1775, Colonel Moulton joined the protest against England's taxation of the colonies as colonel of the Third Regiment, a militia force that fought at Ticonderoga. Toward the end of his life, he was affectionately referred to as "General Moulton."

Today, Moultonboro is the home of many fine estates, summer cottages, boys and girls camps, and condominiums that grace the shoreline and mountainsides of this Lakes Region community.

MOULTONBORO'S MAIN STREET, 1925. In this view looking west toward Red Hill, the Olde Country Store, listed on the National Register of Historic Places, appears on the right.

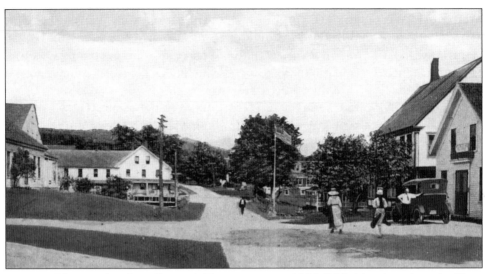

MELVIN VILLAGE'S MAIN STREET, TUFTONBORO, 1931. This historic and scenic village of Tuftonboro was named for David and Eleazer Melvin, who fought in the French and Indian War.

TUFTONBORO

Tuftonboro lies between Lake Winnipesaukee and the Ossipee Mountain Range and comprises Melvin Village, Mirror Lake, Tuftonboro Center, and Tuftonboro Corner. Tuftonboro has the grand distinction of being the only town once having been owned entirely by one man, John Tufton Mason, after whom it was named in 1750. The town was incorporated in 1795.

Mason, a native of Boston, was the great-grandson of Captain John Mason. His wife, Anne Tufton, was descended from William Tufton, who was a descendent of Christopher Tufton, Earl of Thanet and governor of Barbados. The Tuftons were related to the Wentworth governors by marriage.

John Tufton Mason inherited the claim to the undivided lands of northern New Hampshire assumed to be held by Captain John Mason. In 1746, he sold it for 1,500 pounds to a group of Portsmouth merchants who disposed of it under grants made to prospective settlers in the years preceding the American Revolution. The town of Tuftonboro, bordering on Lake Winnipesaukee, was laid out to be 6 miles square, containing approximately 23,000 acres.

One of the loveliest and most peaceful retreats on the shores of Winnipesaukee is Melvin Village, nestled at the foot of the Ossipee Mountains. From a modest and retiring hamlet, it has grown to become a thriving vacation center at the northeastern end of Winnipesaukee. While guarded by the brooding Ossipee Range, across the bay and intervening islands of the lake, the village is graced with a view of the Belknap Range, blue and beautiful in the distance, and always a dominating feature of the landscape.

From the more elevated portion of the village, alluring glimpses of the Sandwich Range and many of the well-known peaks of the White Mountains are enjoyed by vacationers, while the bay itself sparkles like a sheet of turquoise below. It is a Swiss-like scene, lacking only the glaciers and guides, and possesses an air that even Switzerland might envy.

Within the limits of Tuftonboro lies Mount Shaw, the highest peak in the Ossipee Mountain Range, rising majestically to a height of some 3,000 feet above sea level. From the summit, a picturesque view of Melvin Village is seen from the outreaching lowlands near the lake. Its white walls and spires are scattered among meadows and orchard greenery, a contrast with the blue water and the outline of hills unseen: Dopple, Crown, or perhaps Mount Caryl, and the low ranges about Alton Bay at the southern end of Winnipesaukee.

The southern side of the mountain was a favorite resort for the American Indians. Their usual choice of picturesque spots for an encampment may be recognized upon sailing about Melvin Village, or in approaching by the range way, the abrupt mountain-wall behind the farmlands of the village. The precipitous face of Bald Peak, the southernmost summit of the range, forms a background to a most enjoyable landscape.

WOLFEBORO

Wolfeboro is a splendid example of New Hampshire's elegance, charm, and Yankee tradition. It is not just a town bounded by majestic hills and lakes, but rather an experience of the splendor and grace of the old greeting the new; where pride is foremost in retaining a legacy of being the "Oldest Summer Resort in America."

This picturesque hamlet is properly situated on the shore of Lake Winnipesaukee, while the lofty Ossipee Mountains rise in the rear like impregnable walls of a gigantic fortress. Its whole scene presents a view of sublimity and celebration of the true New Hampshire spirit.

Wolfeboro is quite regular in design as compared with most other New Hampshire towns. It has an area of about 36 square miles; its northwestern boundary line being 6 miles in length and separating it from Tuftonboro; its northeastern line measuring nearly 7 miles and separating it from Ossipee; its southeastern line is 7.25 miles long and divides it from Brookfield and New Durham; and its southwestern line is some 5.5 miles in length, about half of it bordering on Alton and the other half on Lake Winnipesaukee.

The original town was comparatively small, the present area of Wolfeboro being the result of various annexations, such as that of the tract of land known as "Wolfeboro Addition," added in 1800; that of a portion of Alton annexed in 1849; and that of a part of Tuftonboro, added in 1858.

The village proper is situated on two beautiful slopes rising from the Bay of Lake Winnipesaukee, and it was in the township that Colonial Governor John Wentworth erected a splendid mansion. According to Benjamin F. Parker's *History*

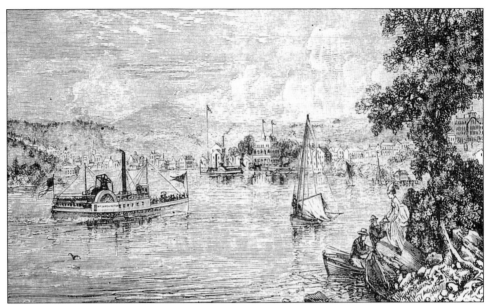

WOLFEBORO BAY, 1880S. This nostalgic view of Wolfeboro depicts the importance of the town's harbor in its everyday life.

of Wolfeborough, 1901, the first proprietors ever to embrace this settlement purchased land for a new plantation from John Tufton Mason patent, so called,

> for the encouraging the Settlement of a new Plantation on the fifth day of October instant Granted and conveyed unto us William Earl Treadwell & Henry Apthorp Merchants Ammi Ruhamah Cutter, physician and David Sewell, Attorney at Law all of Portsmouth in the province of New Hampshire at the Right Estate and Demand of said Proprietors of a certain Tract of Land equal in Quantity to thirty Six square Miles.
>
> The organization of Kingswood, a town chartered by Governor Belcher, October 20, 1737, embracing within its limits a portion of the territory included with the boundaries of Wolfeborough, may now very properly be considered.

This territory, being immense, made up what is now comprised within the limits of Middleton, Alton, and New Durham, and parts of Gilmanton, Wakefield, and Wolfeboro. By the condition of the grant, Benjamin Parker continues,

> the proprietors were each to build a dwelling-house, and settle a family in the town within five years. They were also to build a meeting-house within the same time, and settle an orthodox minister within seven

years. They were to reserve three hundred acres of land for the first
ordained minister that should settle in that town, a like quantity for the
second six hundred acres for parsonages, and three hundred acres for
schools. The proprietors were to pay the government an annual quitrent
of ten pounds of hemp, if demanded, and reserve for it all mast trees.

On November 14, 1759, it was voted "that the township, in honor of the late
renowned and illustrious General Wolf, who was killed in battle before Quebec,
be called Wolfborough." The spelling error in Wolfe's name was transcribed to
that of the town. It was retained in the charter granted in 1770 and continued in
general use. The error that they then made in the spelling of Wolfe's name
caused the town to be known as Wolfborough; however, the name is now
almost universally written Wolfeboro, the ending "ugh" being omitted for the sake
of brevity.

The first known permanent settlers to reside in the town were Benjamin Blake
and Reuben Libby, who arrived during the summer of 1767. Several other families
came to town the following year, and by August 21, 1770, a petition for a charter,
the later being granted, gave them the privileges of township. The original
township was quite small as compared to its more than 28,000 acres today.

Possibly, the most illustrious and zealous promoter of this settlement was John
Wentworth, who was newly appointed by His Majesty George III as governor of

*SCENIC VIEW OF WOLFEBORO BAY. In the distance, the growing town of Wolfeboro unfolds
along the lake's shoreline.*

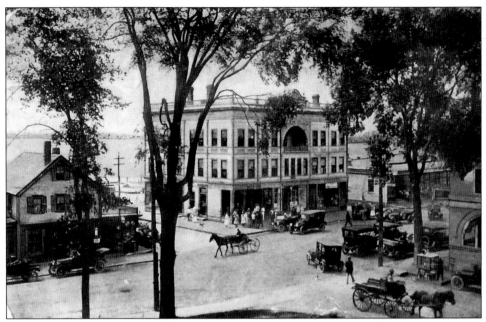

POST OFFICE SQUARE, WOLFEBORO, EARLY 1900S. In the distance is Wolfeboro Bay, where the early steamboats made their daily stops to this resort town.

New Hampshire on August 11, 1766, and also "surveyor of the King's woods in North America." As early as 1768, Governor Wentworth commenced operations of his own lands on the shore of Smith's Pond (Lake Wentworth). It was upon this property that he built a beautiful mansion as his summer resort.

In 1771, the provincial authorities commanded the construction of a road 3 rods wide from the governor's mansion in Wolfeborough, through Tuftonborough, Moultonborough, New Holderness, Plymouth, and Baker's River to Dartmouth College so that the governor could attend the college's first graduation. The ancient map of Kalm refers to this section as the King's Woods.

Wolfeborough, at this time, was still a wilderness, and except where contiguous to Lake Winnipesaukee, it was surrounded by dense forest. There was no territory adjoining it, except that of New Durham, that had any inhabitants, and these men and women lived a great distance from any populated district.

It was no easy task for these early families to induce new people to settle in the town. Only the more courageous were willing to brave the inconveniences and hardships of pioneer life in these woods. However, when the governor of the province had obtained possession of several thousand acres of land in Wolfeboro and contemplated establishing a baronial estate, immigration became more rapid. So encouraging was the outlook that the proprietors of the town deemed it advisable to apply to the governor for the charter.

At no period in the early history of Wolfeboro had the town so encouraging an outlook as in 1774, for at this time there were within its borders some 30 families,

which, although generally poor, were successfully clearing their lands and raising crops. But according to Benjamin Parker's *History of Wolfeborough*,

> More than this, Governor Wentworth, the leading patron of industries and education, had engaged in an enterprise within its limits that bid fair to make it eventually the second town in the province. His operations had thus far been highly conductive to its interest, as he had furnished employment for surplus labor, paying remunerative wages in cash, which was greatly needed by the indigent settlers. Probably more was accomplished on the Wentworth Farm during this than in any preceding year.
>
> Thus closed the year of 1774, and without fear for the future, men of wealth and position have begun to regard it as a place favorable for investment and residence.

The close of the American Revolution found the townspeople somewhat reduced in number. It was quite some time before the community recovered from the effects of the long and costly war, but Wolfeboro progressed and the town records of 1805 indicated that there were 206 taxpayers, 160 of whom paid a tax on real estate and only 9 being assessed for a poll tax alone. An inventory of the town made in 1802 recorded the number of acres of wild land as 40,898; orchard land, 10; tillage land, 262; mowing land, 756; and pasturage, 1,100. Also noted, there were 200 polls, 154 horses, and 971 neat cattle.

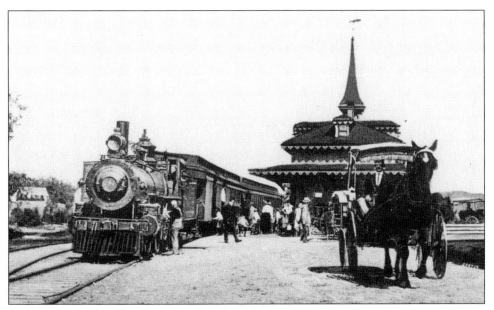

WOLFEBORO STATION, 1912. The Boston and Maine railroad gladly welcomed its many visitors to the Lakes Region.

The first mill, within the town's limits, was a sawmill built by George Meserve about 1769. It was located on Smith's River, and in 1771, it was improved by A.R. Cutter and David Sewall, who added a gristmill to the original plant. As the settlement grew, many more sawmills and gristmills appeared on the landscape, for the numerous waterpower in town provided an almost endless supply and cheaply available. Various manufacturing enterprises have grown in the town, among them a shingle mill, a chair factory, a pipe factory, a cloth dressing establishment, a tannery, a foundry, a woolen factory, etc., but over the years, this settlement has been greatly hindered by destructive fires.

Since then, the manufacture of sawed lumber and box shooks had long been a leading local industry, in addition to the tanning of leather and the manufacture of boots and shoes.

In 1869, the town voted to pay five percent of the valuation, amounting to $3,500, to aid in building the Wolfeboro Railroad, which later became known as the Wolfeboro branch of the Northern Division of the Boston and Maine system. The rail communication to the larger cities south of Wolfeboro opened even more avenues of industry—especially tourism.

As a summer resort and a place of permanent residence, Wolfeboro possesses so many varied claims. Many residents of Boston, New York, and countless other cities make a regular practice of spending the summer months at this resort town, as is evident by the many delightful sites and cottages on the lake shores. No more picturesque spot can be found on the lake shore of Winnipesaukee than that of Wolfeboro's bays, inlets, coves, and channel-way in the village proper. Truly, Wolfeboro is a "Summer Resort of America."

GOODHUE AND HAWKINS, EARLY 1900S. This celebrated, centuries-old navy yard is a Wolfeboro institution, serving now as one of the leading marinas of the lake.

Lakes Region Conservation Trust. This island is considered to be one of Lake Winnipesaukee's finest jewels.

Horse Island is the setting for a strange tale. Many years ago, a summer resident of Center Harbor was transporting his horse to the Weirs by boat when a storm arose, sinking the craft. A rescue party found no trace of the man, but after many days of searching, found the horse living contentedly on this island. The horse refused to leave and finally had to be tied and carried off. On reaching the mainland, the animal soon became ill and died. Many people felt he had pined away his life but would have lived had he been permitted to remain on the island near the spot where his master had perished.

Dolly Island is named after Dolly Nichols, who operated a hand-propelled ferry from Meredith Neck to Bear Island. The story of Dolly Island is not complete without the legend of Aunt Dolly Nichols, who lived on the Mansfield property on Bear Island during the first half of the nineteenth century. Dolly Nichols was the daughter of Ensign Robert Bryant, who is said to have been one of the first settlers on Bear Island and who took part in the Revolutionary War. Dolly Bryant married a gentleman by the name of Joseph Nichols and became the mother of two fine boys and one girl. When at a young age, the boys moved away from the island, the girl died, and Dolly's husband deserted her, leaving her to make her own livelihood.

Aunt Dolly was a character known far and wide in the Lakes Region for selling hard cider and rum to the fisherman. Of no less renown were her muscular feats. She often rowed to the Weirs for a barrel of rum, which she would swing upon her shoulder and carry to the boat. Reaching home, she would pull the barrel into her lap and take a swig. At other times, before leaving the Weirs, she would lift the barrel above her head to drink from it in full view of those on the dock.

AUNT DOLLY. This humorous sketch by Ron White shows the legendary Aunt Dolly hauling a barrel of hard cider or rum to her boat.

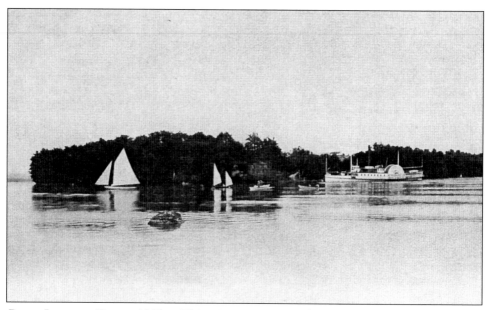

BEAR ISLAND, EARLY 1900s. This picturesque view shows a variety of the lake-going vessels, such as the docked Mount Washington, *around Bear Island.*

There was an area on Meredith Neck called the Cattle Landing. The early farmers in the area brought their cattle to this area to swim them across the channel to Bear Island. At that time, Bear Island was mostly grazing land. One of the mail delivery stops for the U.S. mail boat, Bear Island is the second largest island on the lake, with an area of 750 acres, and it is quite thickly populated—the only island which has its own church. The island has an hour-glass figure; some idea of the size of Bear Island may be gained from the fact that it has approximately 8.5 miles of shoreline. Bear Island received its name from the fact that a bear was once killed on the west side of the island.

According to local lore, during the early settlement of Meredith, two young men by the name of Dockham and Prescott started on the ice for a fishing trip; one had a jack knife, the other an axe. They made their way around the Gulf section on Bear Island. Here, they found a bear hibernating under the roots of a partly fallen tree. The young man with the knife tied the knife to the end of a pole with his fishline and gently prodded the bear with the sharp end until the bear rushed in haste from his comfortable nest. The man with the axe struck him on the head at exactly the right moment and killed him instantly. They cut some small poles and dragged the bear home over the ice. It has been said that this was the bear that gave the island its name.

A major attraction for the summer visitors to Bear Island is the rusty but attractive St. John's Church, located on a hill at the southern end of the island. During the ten weeks of the summer season, Sunday services are given and guest ministers, representing a variety of faiths from across the United States, are

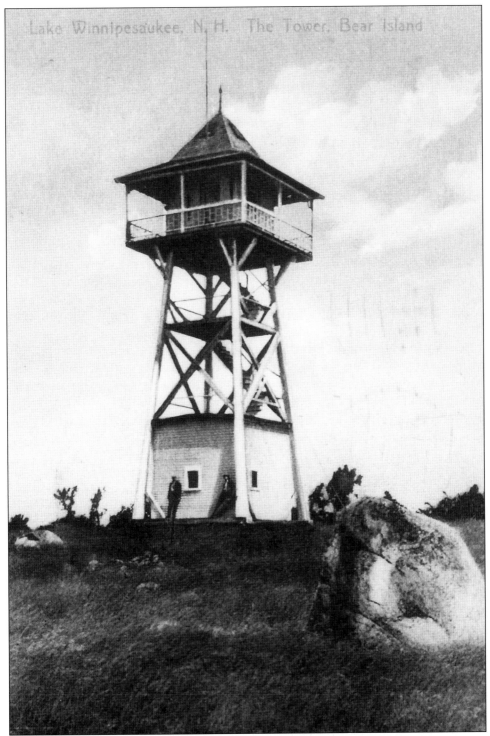

BEAR ISLAND OBSERVATORY TOWER. Built around 1900, this tower was purchased by the Right Reverend John T. Dallas and incorporated into the Episcopal chapel.

invited to conduct services here. The church is unique in the fact that it was built around a 50-foot tower, originally constructed as a fire lookout when the island was less populated and less forested, which offered a 360-degree panoramic view of the island and lake.

Also located on this large island was a fine hotel known as the Bear Island House. This hotel was started as a boarding house by Mr. and Mrs. Leonard Davis in 1879. According to *Bear Island Reflection*, published by the Bear Island Conservation Association in 1989, "The guests at Bear Island House enjoyed hiking, tennis, swimming and boating. Behind the hotel were clay tennis courts and bath houses. It was customary for boarders to stay for weeks at the hotel, which required a large staff to work in the vegetable garden, milk the cows, gather the eggs, roll the tennis courts, run the boats, and, of course, clean rooms and wait on table." The hotel closed in October 1934, and in November of that same year, fire destroyed the fine old establishment. This island was annexed to Meredith on December 30, 1799.

Three Mile Island is 3 miles from Center Harbor and has been one of the summer homes of the Appalachian Mountain Club since the year 1900. Located beside this island is the Hawk's Nest and Nabby's, which hang off the southern shore creating a protected docking and swimming area for the camp.

It is interesting to note that the first permanent camp for the Appalachian Mountain Club was established on Three Mile Island in 1900. This 43-acre island, located at the northern end of Lake Winnipesaukee, is approximately a half mile long and less than a quarter of a mile wide. The island is practically a ledge

BEAR ISLAND HOUSE, EARLY 1900s. This famous boarding house and hotel, established in 1879, accommodated many seasonal tourists and later burned in November 1934.

APPALACHIAN MOUNTAIN CLUB. Here, a few members can be seen enjoying a canoe trip off of the Three Mile Island landing.

rising to a height of about 50 feet with a ridge running north and south in the center of the island. The shoreline consists mostly of stone and gravel; however, there are some fine beaches for bathing. Nestled about the island are several coves and points, namely, Belknap and Chocorua Points, which afford fine views of the mountain ranges that frame the lake. Located on the western end of the island are two swamps, namely Rhododendron and Cliff Swamps, which cover a rather large area; here lovely ferns, shrubs, and plants may be found in their wild state.

In 1899, property on Three Mile Island was offered to the Appalachian Mountain Club (AMC) by Mr. and Mrs. Edson C. Eastman of Concord, members of the AMC. The idea of island property for summer camping was enthusiastically received by the membership. This gift was soon followed by generous contributions, and in a very short time the success of the enterprise soon became realized. Several meetings were held by the trustees of the club and visits to the island property were made so as to ascertain the boundaries of the gift.

According to Laura H. Dudley's *Annals of Three Mile Island Camp* (1942), the trustees did the following:

> [they] selected the southwest corner, marked on the east by a large red oak hanging over the water, and a small strip was added in order to include the whole tree. In the summer of 1900, Mr. and Mrs. Eastman increased their gift by the addition of the southeast corner. Mr. Lawrence [a member of the club] then gave the Club ten acres more, and the remaining twenty-five acres purchased by subscription. The entire island and Little Rock Island thus became the property of the Club.

CABIN ON THREE MILE ISLAND. This cabin was the first cabin built on the island and was used by the Appalachian Mountain Club.

During the first summer on the island (August 1900), construction began. A party of 11 arrived at the island site to prepare the camp. A cookhouse was built, 24 tents and a mess-tent were pitched, and all was ready for its first campers. The season lasted for two weeks under the capable management of Rosewell Lawrence and John Ritchie Jr. During that first season, 40 campers visited the island and enjoyed their outing on the club's new island property.

Soon an appeal was made to raise further funds so as to purchase the remainder of the island and construct a permanent camp. The response was well received, and by the next year (1901), plans were developed for the building of a clubhouse. Amazingly, the clubhouse, a 30-by-40-foot structure built on a ledge, was ready for the 1901 season. The facility served as a central meeting place for the camp, equipped with a reading and writing room, a dance hall, post office, and reception hall, complete with a piazza serving as a dining room.

During the first season, boats and canoes were purchased for the camp, and to house them, a boathouse, two runs, and a float were built. In 1905, a two-story addition was added to the boathouse, and by 1912, a second story to the old section was added. After the season of 1932, this boathouse was torn down and a new structure was built, which housed a large recreation hall and locker facilities. On the front of the house ran a broad piazza for lounging and socializing while watching the bathers and water sports.

Also in Laura H. Dudley's *Annals of Three Mile Island Camp*, she mentions that "In June, 1965, a fire started when a bolt of lightning hit the big pine just to the north of the tennis court knocking the very top of the tree off onto the tennis

court." According to Herb Mattlage's *Three Mile Island Fire* (1982), "There it smoldered for some time and finally fanned into a good blaze. The fire then worked its way to the Rec Hall, dock and canoe house and stopped just short of the Launch House when boys and fire department arrived to put it out."

Camp was scheduled to open on July 3, 1965, so the debris from the fire was hurriedly cleared and a canvas "Pavilion" was constructed on the dock. Quickly, 15 Grumman canoes, 100 chairs, 6 tents, and other necessary items were purchased, and on opening day all was ready to start the 1965 season.

Through its 101 seasons, the Three Mile Island Camp has expanded its facilities to the point where it now has about 50 cabins around the shore with a new central dining and entertainment hall. Parties of 50 or more frequently stay at the camp for varying periods, and in addition to enjoying the aquatic pastimes, indulge in fishing and hiking excursions to the White Mountains. Three Mile Island has successfully furnished its members with a most comfortable summer home for many, and an ideal vacation for many more.

Beaver Island was once willed to Ben Ames Williams and two other authors, who sold it to the late John Sheppard, former president of the Yankee network of Boston. This island is so named for a colony of beavers that still make their homes in the area.

Between One Mile Island and Little Mile Island, so named for they are both 1 mile from Center Harbor, occurred an interesting story. On a foggy Thursday morning, early in the season of 1910, the side-wheeler *Mount Washington* ran aground upon the shore of One Mile Island. There was very little damage done, but she was laid up for several days. A call was made to the Boston and Maine

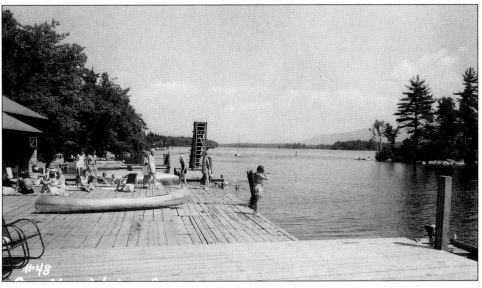

MAIN DOCK, THREE MILE ISLAND. *This scenic view shows campers of all ages enjoying the recreation provided by the Appalachian Mountain Club.*

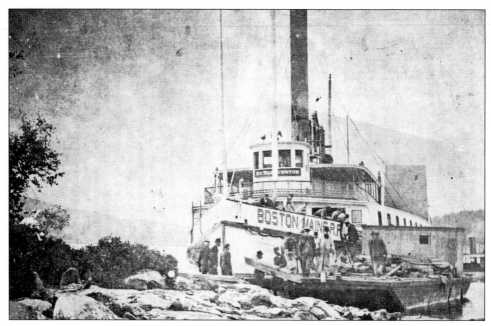

THE WRECK OF THE STEAMER, 1910. The steamer Mount Washington *is seen here run aground on One Mile Island.*

Railroad offices in Boston, the company that owned the vessel at that time. That evening, a wrecker and crew were sent out to the *Mount* from the Weirs. The following morning work began. Throughout the Friday, they labored, but it wasn't until Sunday that she was free to resume her schedule. Not a single plank had been damaged by the accident. Meanwhile, the *Mount's* competitors had not been idle, and by Friday afternoon, posters and handbills began to be seen around the lake advertising, "Grand Sunday Excursion to Center Harbor; See the Wreck of the Steamer *Mount Washington*." Needless to say, the prospective Sunday excursionists were disappointed, for the *Mount Washington* had, by that time, resumed its regular daily schedule.

In 1852, the first boat race between Harvard and Yale was held in the waters at Center Harbor. A Yale University Athletic Association pamphlet describes the race as follows:

> The Yale oarsman had their eyes on the progress at Harvard and, largely through the efforts of James M. Whiton, '53, a challenge was sent to Harvard to "test the superiority of the oarsmen of the two colleges" and a race was arranged for August 3, 1852, at Center Harbor, Lake Winnipiseogee [*sic*]. The training of the men may be inferred from the remark of one of the Harvard crew, that they "had not rowed much for fear of blistering their hands," and there was a pleasing absence of all that childish formality that hedges a race at the present day. The *Oneida* ('53)

came down from Cambridge, while Yale had three boats, the *Halcyon*, manned by the crew of the *Shawmut*, the *Undine*, the crew of which had to be filled out from shore, and the *Atlantic*, hired in New York for the race. So eager were they to race that they had in the morning a try out of the crews and the *Oneida* won; but the real test came in the afternoon on a 2-mile pull to windward from a stake-boat out in the lake. The Harvard boat again won the prize, a pair of silver mounted black walnut sculls; the *Halcyon* was second. Ten minutes was given as the time by the imaginative timekeeper. There was so much fun in the race that the crew thought they would have another go on the fifth; but that day was very stormy and the prize was given to the *Halcyon* as second in the first race. Late in the day the storm lulled, and as a token of respect to the few visitors assembled, the uniforms were brought out, the boats manned, a little rowing indulged in, songs sung, the usual number of cheers given, and all said "Well done." The whole party remained at the lake for a week and left together for Concord, where they parted. Such was the wholesome little regatta of 1852.

Connected to Birch Island by a small, picturesque bridge is Steamboat Island, so named because the steamboat *Belknap*, which was the first steamboat ever to sail on Winnipesaukee, was wrecked here in a storm in 1841 while towing a raft of logs to a sawmill. A stock company built and launched the *Belknap* in 1833. It was a curious craft, the boiler set in brick, drawing so much water that a barge was

THE *STEAMER* BELKNAP. *Launched in 1833, this was one of the first vessels to sail upon Lake Winnipesaukee.*

THE HORNBEAM BRIDGE. *This historic bridge connects Birch Island on the left to Steamboat Island.*

employed to load and unload its cargo. It took two years to build the boat and its launching was a great curiosity. The speed of the craft under good conditions was 6 to 8 miles an hour. The steamer, however, was never a success, and it was a great relief to the owners, when it was wrecked on Steamboat Island in November 1841. Earlier, in 1781, George Sanders of Gilford had offered to buy both Birch and Steamboat Islands for the sum of $40.

The bridge, which connects the two islands, was built in 1933 out of a rare type of wood known as hornbeam, a wood so tough that not even a knife could possibly cut it. The arches supporting the bridge are a natural formation of hornbeam trees.

Long Island is the largest island in the lake, covering 1,138 acres. It is connected to Moultonboro Neck, a part of the mainland, by a bridge which is accessible by automobile year round. Local legend recounts that many years ago the Aquadoctan Indians, who were part of the Algonquins, and their traditional enemies, the Chocoruas, were always at war, fighting for supremacy around the lake. Finally, the battling tribes decided to settle their difference, agreeing that an Aquadoctan princess should marry a Chocorua prince. The Chocoruas set out in their canoes from the northeastern end of the lake and the Aquadoctans launched forth from the Weirs. They met on the lower end of Long Island, where the marriage ceremony took place, bringing peace to the Lakes Region.

During the twentieth century, Long Island had two large hotels called the Island Hotel and Long Island Hotel, a post office, schoolhouse, many well-to-do farms, and the magnificent estate of Doctor F.E. Greene of old "Nervura" fame. When

asked what his medicine was good for, Doctor Greene replied, "It's good for me." This great estate burned only a few years ago.

Known as Becky's Garden, the smallest charted island in the lake is located near Center Harbor. The legend of Becky's Garden has it that an early settler of Center Harbor had several daughters, the loveliest of whom was Rebecca. While her sisters were frivolous and spoiled, Rebecca was a model young lady who beautified the surroundings of her father's home by the care of her garden. One day her father's cattle escaped and laid waste the beautiful garden plot; Rebecca was heartbroken, so her father, by way of consolation, offered her the gift of any one of the numerous islands in the lake which she might care to choose.

Her sisters clamored for the same dowry, and their father finally consented, giving Becky first choice. This caused her sisters to be so envious that Becky decided to choose the smallest island she could find and selected the one which bears her name today, an island that is scarcely more than a brush-covered rock. The other daughters picked out large, verdant islands. The story of Becky's choice traveled far, and a wealthy young farmer in the vicinity became so interested when he heard of the unselfish young maiden that he sought her acquaintance. Finding her an attractive young lady, he wooed and won her for his bride. Thus, Becky's Garden, though the smallest of islands, produced the greatest result.

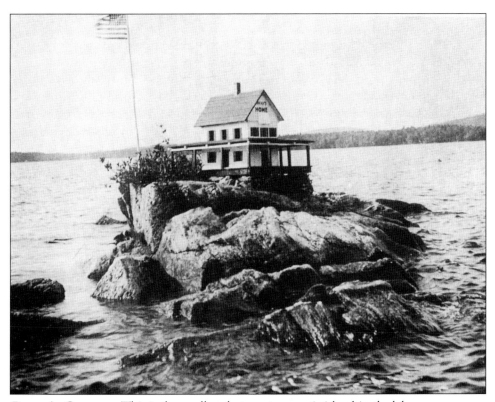

BECKY'S GARDEN. This is the smallest, but most romantic island in the lake.

Lake Winnepesaukee, N.H.,
Among the Islands Green's Basin.

GREEN'S BASIN ISLAND. This early-twentieth-century postcard reveals the pastoral beauty of the island before the Green family built its cottage.

Located at the northern most tip of the lake is an area known as Lee's Mills. The origin of its name came from the Lee family, who established a sawmill and became manufacturers of barrels. Today, the mill is gone; however, steamboats may be found plying the waters of this secluded bay. During the early fall (September), there is a Steamboat Meet, which attracts steamboats of every size and description from all over the East Coast. Many of the vessels reflect an era gone by, but the crafts look as new and bright as if they were built yesterday. Most of the boats are in their original condition and still fired by wood, coal, or charcoal.

Like Lee's Mills, Green's Basin is also located at the northwestern tip of the lake and has retained its primitive atmosphere—quiet, secluded, and extremely peaceful. With a small craft, one may be able to sail into the small coves and narrows where larger crafts cannot navigate. The entrance to Green's Basin is through the narrow gut at Toltec point (check the navigation chart) where the water depth is from 5 feet to 10 feet.

Secluded in the middle of a small bay, which is formed by Cow Island and Tuftonboro Neck, is the Middle Ground Shoal, being .5 mile long and equally as wide.

Cow (Guernsey) Island is a very large island with an area of 519 acres. Immediately after the War of 1812, Captain Paul Pillsbury was sent to Cow Island by its owners, who resided in Dover. There, he erected several buildings including a windmill, and soon became one of the celebrated cattle breeders in the

area. Captain Pillsbury started with only 3 cows, and this number later grew to 40, plus oxen, sheep, and other young cattle—hence the name of the island. After operating the mill for several years, Paul Pillsbury later moved West and is believed to have founded the Pillsbury Milling Company in Minneapolis.

The windmill, the tower of which was made of wood, octagonal in shape, peaked top, solid frame, was used to grind corn. As it was the only gristmill in the Lakes Region during those early days and water transportation was easier than over the dusty roads, it attracted customers from around the Winnipesaukee area. In 1831, a gentleman by the name of Captain Price stopped his ship at the Island of Guernsey in the English Channel and was so impressed with the quality of cattle he saw there, that he bought a bull and two heifers, brought them to Boston, and sent them to Cow Island. These animals had to swim the last half mile of their journey to their new island home where they became the predecessors of the enormous dairy industry centering upon that breed.

August Shannon wrote that her father moved his family to the island in 1866 to manage the farm. At that time there was a quaint old house of six rooms and a hallway, a large barn, hog house, and the gristmill. The "L" of the house, which served as a kitchen, had originally been the pilot house of the steamer *Red Hill*, one of the first steamers that plied the waters of the lake. This mill is no longer there; however, a reproduction of that mill may be found on the northern shoreline of Cow Island.

Winter Harbor, a part of the town of Tuftonboro farther inland, was so named because a loaded boat, destined for Moultonboro, was forced to seek shelter there and was frozen in and remained during the winter. The towns of Wolfeboro and

COW ISLAND. *This early image of Cow Island, or Guernsey Island, shows a gristmill on the right and Leon Shepherd, standing in the doorway of the house.*

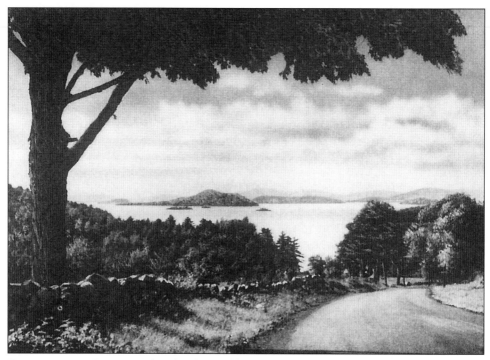

RATTLESNAKE ISLAND. The island is visible, rising 390 feet above the lake, in the center of this view overlooking Roberts' Cove.

Tuftonboro Necks stretch out to one another from the north and south creating this harbor; it is well protected from the prevailing northwesterly winds. Just beyond, down a long cove, is the low building of the Libby Museum, built in 1912 by the late Dr. Henry F. Libby of Boston; it has a collection of indigenous fish, birds, animals, and Native American relics.

Rattlesnake Island is one of the largest islands in the lake and has the highest elevation, rising 390 feet above lake level. Lying along the axis of the lake, the 2-mile-long island thrusts steeply upward, whereupon the view of the entire region may be seen. It features quiet tree-lined glens and bold plateaus cast in giant granite slabs heaped upon each other. Rattlesnakes were actually found on the island—in fact as late as the 1940s. The skins and remains of some of these snakes can be seen at the Libby Museum in Wolfeboro.

The most striking feature of this island, however, is the panoramic view of the mountain ranges as seen from the summit of the island. To the north, the mountain range closest is the Ossipee Mountain Range, topped by Mount Shaw at 2,975 feet above sea level. To the left of the Ossipee Range is the Sandwich Mountain Range, the foothills to the White Mountains. To the left of the Sandwich Range is the Squam Mountain Range, and to the immediate left rests the Belknap Mountain Range. The two highest peaks are Mounts Gunstock and Belknap, rising 2,384 feet above sea level. Looking southeast and to the right of

Wolfeboro Bay, one may see Copple Crown Mountain, rising 2,100 feet above sea level. To the right of Copple Crown and to the southwest is the 5-mile-long arm of the lake known as Alton Bay. To the right of Alton Bay is picturesque Mount Major, a part of the Belknap Mountain Range, rising 1,784 feet.

There is a quietness on Rattlesnake Island's shore. The sky, with jagged lines of steely blue, softly cuts all around the mountains. The sun sparks a blaze thick as stars upon the glassy diamond wrinkles of the water, and the steep of the hills inspires rest and dream.

Diamond Island was once the sight of a large hotel known as the Diamond Island House. This hotel was moved across the ice in the 1870s to become a part of the famous New Hotel Weirs, which was destroyed by fire in 1924. During the heyday years of steamboating on the lake, this island was one of the stops for the steamers. Early history indicated that James Ames Jr. purchased the island, which lay off his mainland farm, in 1824. Later, in 1865, it became the property of the Winnipisseogee Lake Steamboat Company.

Jolly Island has a very interesting history. Originally, the island was designated as Lot. No. 9 (which included Jolly, Locke's, Round, Birch, Mark, and Mink Islands) and was owned by the Masonian Proprietors. In 1837, George Saunders of Gilford offered to buy this lot of island (Birch and Jolly) for the sum of $40. On April 23, 1846, Joshua W. Pierce, relative of John Ringle, a representative to the Masonian Proprietors, sold "Foley Island so called in right No. 9. 28-1/4 Jno Rindge Marked No. 9. near the south end of Bear Island" to Winborn A. Sanborn.

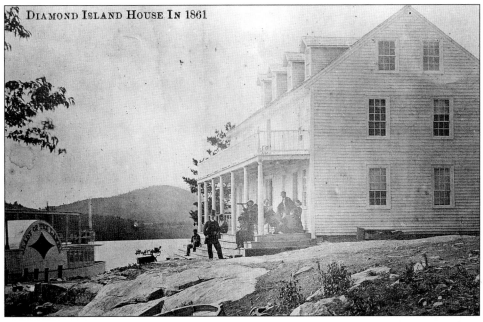

DIAMOND ISLAND HOUSE IN 1861

DIAMOND ISLAND HOUSE, 1861. An early gathering of people enjoy the lake's scenery from the front porch of the hotel. A docked Lady of the Lake *is visible on the left.*

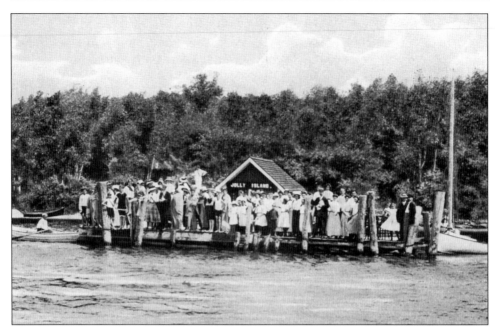

JOLLY ISLAND DOCK, 1930S. These locals are seen waiting on the island's dock for the delivery of the mail.

In the book *Jolly Island: One Hundred Years (1893–1993)*, published by the Jolly Island Centennial Committee, the following history is provided:

> Winborn A. Sanborn was a very interesting person. He was born in 1810 and grew up on a farm in Gilford. Throughout his lifetime he went from job to job but always came back to Winnipesaukee. For a while he sailed on an East India trading vessel, but in 1833 he was back on the Lake as captain of the *Belknap*. After two years of that he decided to travel out West, but he returned and resumed command of the *Belknap* for a few seasons. After a spell as a "country trader" in Alton Bay he went to Boston to study machinery, and became an engineer on a harbor steamer. He was back in 1851 superintending the construction of the *Dover*, which was being built at Alton Bay, and became its first captain. He continued to live at his farm in Gilford. He was one of the stockholders of the *Lady of the Lake* and in 1863 became its captain. He left in 1869 to pursue interests in Florida, but in 1878 he returned and continued as captain of the *Lady* until his death in Florida in February, 1882. In 1880 he conceived the idea of building a hotel at The Weirs. A hotel was moved from Diamond Island, and enlarged. For a while it was known as Hotel Sanborn, but most of the time it was known as Hotel Weirs. Winborn served several terms as a New Hampshire State Representative.

The property was conveyed to Winborn's daughter, Ellen, whether at the time of his death or earlier still needs to be determined. Ellen was married to Captain John S. Wadleigh, who became the commander of the *Lady of the Lake* in 1885 and continued as such until the *Lady* was retired in 1893. Captain Wadleigh's family was among the early pioneers in Meredith.

What use was made of the island throughout these ownerships is uncertain. It is quite likely that it was used for grazing as was common during the nineteenth century. The rocky terrain would appear to discourage farming. On October 27, 1891, Ellen Wadleigh sold Jolly Island to Charles S. David. In 1892–93, descendants (nine in all) began to settle on Jolly Island, until today when it has become a very beautiful island with many fine cottages clustered around its shore.

Locke's Island is said to be the first island inhabited by the early settlers during colonial times. In 1829, this island was known as Smith's Island, after landowner John P. Smith. Later, Daniel Blaisdell, owner of the island for eight years, sold it along with his mainland estate to Daniel Locke in 1837. During this period, the island passed through two more generations of Lockes and became a seasonal pasturage for sheep, cattle, and retired horses. During the early twentieth century, like so many of the islands in the lake, shoreline property began to develop with many summer cottages gracing its landscape.

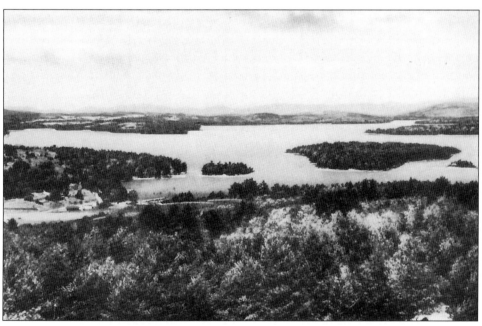

GLENDALE AND LOCKE'S ISLAND. This view, taken from Belknap Point, displays one of the most picturesque settings on the lake.

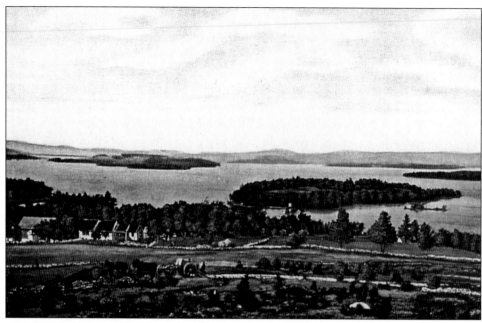

GLENDALE BAY, 1930. In the distance is Locke's Island and the within the bay's waters rests the steamer Lady of the Lake.

Located near Locke's Island is the busy port and harbor of Glendale. This .5-by-.75-mile-long cove is one of the best protected on the lake—being exposed by a few degrees of the northeast wind. The depths in the harbor's navigable waters range from 10 to 15 feet. Glendale is the home of the New Hampshire Department of Safety, Marine Division, which patrols the lake, keeps navigational equipment in repair, and is an aid to boaters in distress. This department has complete jurisdiction over all lakes in the state of New Hampshire.

On the bottom of Glendale Bay rests the hull of the old *Lady of the Lake*, one of the oldest and most active steamboats on the lake. When she was retired, the hull was filled with stone, and in the process of being towed to her final resting place off from Governor's Island, she rebelled and sank in 40 feet of water in Glendale Bay. She remains there today over a large boiling spring, and skin divers, who visit her, say that her hull is still in perfect condition.

Timber Island is one of the largest undeveloped islands on the lake. Originally known as Wentworth Island, it was the right of Masonian Proprietors Peirce and Moore, who sold it in 1822 to John P. Smith of Gilford. This 135-acre island is now protected by the Lakes Region Conservation Trust against future development.

Governor's Island is the fourth largest and one of the most famous islands on the lake. It was originally part of the old Gilmantown Grant, which included the present town of Gilford. The first John Wentworth, acting in place of the absent colonial governor, signed the grant on the condition that he would receive 500

acres and a house lot on Governor's Island. The island remained in the hands of the succeeding governors until it was united to the State of New Hampshire during the Revolutionary War. Forty years afterward, the island was purchased by Eleazer Davis, one of Gilford's early settlers, and given to his rebellious son, Nathaniel, to keep him busy and out of trouble. The elder Davis's efforts proved successful, for his son settled down, and before long the prosperous settlement of Davisville sprang up on the island.

During Davis's tenure of the island, it was called Davis Island, but through succeeding generations, it fell into disrepair and fire eventually ruined the old Governor's Mansion in 1870. Ten years later, the island was acquired by Stillson Hutchins, a prominent politician and publisher from the District of Columbia, who rebuilt the old mansion and improved the island. About this time, Governor's Island became the resort of numerous celebrities, and many splendid social events were held there. Just prior to the First World War, Governor's Island was the summer home of Baron Speck von Sternberg and the staff of the German Embassy. Development of this island has continued, and it has become a very beautiful and exclusive colony.

Governor's Island truly has a very colorful history, for, unlike all other towns in the Winnipesaukee Lakes Region, Gilmantown was granted and chartered as a town by the Province of New Hampshire, while Governor Shute, the King of England's appointee, was in power during the colonial period. All other town grants were made by the purchasers of the old Mason grant as noted in chapter three. When the Gilmantown grant was made in 1727, Governor Shute was in England, and the first John Wentworth, lieutenant governor, was acting governor and signed the grant and charter of Gilmantown. One of the conditions was that "500 acres and a houselot" should be reserved for the governor and an equal reservation was to be made for lieutenant governor, both reservations to be on the southerly "shore of Winnipisiokee Pond."

Governor Shute never returned to his office in New England and never claimed his reservation, which was laid out for him by the proprietors of Gilmantown in the present Intervale section of Gilford, a short distance southeast of Governor's Island. The island itself was reserved for acting governor Wentworth, at his own request. But as nothing was done in the way of development of this region for approximately 40 years after the Gilmantown grant was established, the island remained in its natural state until the third Governor Wentworth (also an appointee of the King of England) came into office as governor of the Province of New Hampshire.

Governor John the Second, as he was called, also received the appointment of "surveyor of the King's woods," including all the territory about the lake. "Kingswood" was the first name given to this vast tract of the northeasterly side of Lake Winnipesaukee, in which he acquired a large reservation on the north shore of Lake Wentworth, embraced in the Town of Wolfeboro, where he established a temporary summer capital. Governor John Wentworth the Second immediately became interested in the development of the entire Winnipesaukee

region, thus initiating the first survey of the lake and its islands, which induced the development of roads and settlements.

Aware that his uncle, Governor John the First, had been granted Governor's Island, he applied for a transfer of the grant to himself, for the purpose of establishing here a magnificent permanent summer capital. The validity of the first governor Wentworth's title to the island was not clear, there being simply an entry concerning the reservation upon the records of the Gilmantown proprietors, and it appearing that both the grantee and the town had abandoned their claims. The claimants of the Masonian "rights" were disposed to include the island within their remaining "holdings." The matter of title was not completely settled until 1772. In that year, the purchasers of the Masonian grant and rights succeeded in establishing their claims, and then became the admitted owners of all ungranted territory in the Lakes Region (including all the islands in Lake Winnipesaukee). They passed the following measure, dated July 29, 1772, and signed by the proprietor's clerk, George Jaffrey, giving Governor John Wentworth the Second a clear title to Governor's Island:

> Whereas, there is an island lying in the westerly part of Winnipisiokee Pond which has heretofore been called, distinguished and known as Governor's Island, not severed to the particular right of an proprietor, and as His Excellency John Wentworth, Esq., has greatly encourage and promoted the settlement of the lands about said pond, by his improvements and cultivation in Wolfeborough, and from the personal respect borne said proprietors to His Excellency, it is considered and therefore voted that all the right, title, interest and estate of said proprietors of, in and to the said island in Winnipisiokee Pond, called, distinguished and known by the name of Governor's Island, be and hereby is granted to His Excellency John Wentworth, Esq., his heirs and assigns forever. A true record, attest.

Governor Wentworth was in possession of the island three or four years, until dispossessed by the colonists, when it seems to have reverted to the State of New Hampshire during the Revolutionary War. However, during his brief ownership of the island, he had the island surveyed and partly laid out, in accordance with his elaborate plans, including a road leading up to the site of the former colonial mansion. Although it is not known whether the governor planned and partly built on this fine old structure, and the outbuilding that stood until about 1870, it seems unlikely that the later owners would have erected such an imposing and expensive estate.

Meredith Bay is located at the foothills of the White Mountains and is sometimes referred to as "the Latchkey to the White Mountains." It is here that the road splits to either the east or west side of the White Mountains. Pinnacle Hill, part of Meredith Neck, is so named because of the fine views of both the Weirs and Meredith Village from the summit of this hill.

Before the early settlers came to this area in the 1700s, the area around Meredith Bay was a favorite resort for the Native Americans, for they hunted, camped, and fished along these shores during the summer months. From these early camping sites, many Indian relics and burial grounds have been discovered and preserved. Today the shoreline is clustered with many fine summer and year-round homes.

Along the shoreline are the railroad tracks that connect the Weirs (Laconia) to Meredith Village. In 1848, the Boston, Concord & Montreal Railroad opened its line north from Concord to Laconia, Meredith, and eventually all the way to Montreal. From the 1850s, this marked an important development to the growth of the Lakes Region's industry and resort centers in the White Mountains.

On September 15, 1900, just above the Weirs, the worst freight wreck that ever happened on the White Mountain Division of the Boston and Maine Railroad occurred. Two men were killed and four trainmen were seriously injured in the middle-of-the-night collision. Two locomotives were demolished and 20 to 30 freight cars and their contents were piled up into a confused heap on the track. The trains came together with a terrific force just above the pumping station at the

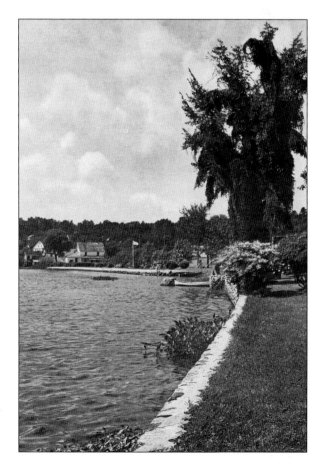

CLOUGH PARK IN MEREDITH BAY. This park is located near Meredith Village. The rocks that make up the wall were collected from around the globe.

97

Weirs. A confusion in the orders issued to the crew of the extra freight train was believed to be the cause of this collision. Some remains of this wreck may be found in the lake just off shore at this point.

At the tip of Meredith Bay lies the beautiful settlement of Meredith Village. A community of superb scenery, in the center of the Lakes Region, it is uniquely clustered with many lakes and rivers, islands, and bays. The foot of the lake was an ideal resort for the Native Americans. Large villages stood on either side of the rivers, and they prospered by tilling the land and fishing the many lakes. Meredith was considered to be one of the best farming towns in the state. The old side-wheeler *Mount Washington* made daily stops at these public docks during the turn of the century. Today, the *Mount Washington* continues the tradition and makes Meredith a regular port-of-call.

6. Railroads and Steamboats in Motion

The first recorded type of craft to be used on the lake during the times of the early settlers was a peculiar model of sailing vessel. These early sailboats were called gundalows. In retrospect, one may believe, from factual information available to their appearance, that these crafts were as picturesque as anything that has navigated on the lake. The gundalows were flat-bottomed and frequently planked with hewn timbers to ensure safety in case the craft was accidentally run on the rocks. A few were round at both bow and stern, an unusual piece of construction for the time, achieved by fastening blocks of timber together with wooden pins, then hewing the bow and stern to the shape desired. There was a stout railing around the sides. These boats were among the safest ever to operate on the lake, with no record of anyone being lost by accident and no person drowning or being injured who was in any way connected with its service. Motive power was from one to two sails; a few boasted of having a jib. All had two long oars, or "sweeps" as they were called, located at the stern of the vessel. These were used for steering, and in calm weather, a procedure resembling sculling was resorted to for propulsion. Either method was slow, and a 25- or 30-mile trip often required two or three days. In an unusually good wind, a speed 6 or 8 miles an hour was possible. The sweeps resembled the propelling implement of the gondola, which accounts for the unusual name of these boats.

All gundalows carried cargo between Alton Bay, Meredith, and Lake Village (Lakeport). The early roads had a marked influence on Winnipesaukee navigation, an influence that was to continue until the thousands of summer visitors to the Lakes Region came in their cars over a modern systems of interstate highways. Other similar roads extended from the seacoast towns to the interior communities. Thus, supplies for the Winnipesaukee region first came to Alton Bay by a team or stage. Likewise, first commercial passengers on the lake generally embarked at this port. Gundalows did not advertise to carry passengers, but did a limited business at 50¢ for a first-class passage on the deck of the boat. There was

but one rule for passengers, and a promise to obey it was required as a boarding credential: no interference with the crew.

Gundalows characteristically had two captains, one who officiated on one way of the trip, while the other took command on the return trip. Friendly rivalry prevailed between the captains, in matters of time required for the journey and the ability to direct the entire course of the boat through any contingencies that might arise without asking help from the captain who was off duty.

These crafts were picturesque, but uncertainty of wind and weather, which necessitated resorting to laborious manpower, inevitably spelled their defeat. One other type of craft was destined to navigate Winnipesaukee known as a horseboat, an old combination of scow, team, and treadmill. Credit for conceiving and constructing the first horseboat is given to a man named Patten, who was a resident of Manchester, New Hampshire.

Patten, even in those days, had the attributes of big business, and in looking over Winnipesaukee and its craft with an eye to the future needs, foresaw a good income to the man who could build a boat that would transport freight and passengers without regard for the weather. Scow-shaped crafts seemed, at the time, the only type for inland water navigation.

Getting his idea for the waterwheel, Patten figured that some type of wheel, pushing and turning the water on each side of the craft, could propel it fast enough to improve on the gundalow, if a reliable motive power were attained. Patten finally hit upon the idea of a mechanism similar to a treadmill, located near the stern of the boat, with a horse walking the treads and thus turning the side-wheels.

Accordingly, Patten set upon his project with great enthusiasm, selecting the best timber from Governor's Island. The materials were hauled to Meredith, where construction of a 70-foot craft was started. Patten changed his plan slightly as the building began, rounding the bottom of the hull to make the boat faster and more maneuverable in the water. With the completion of the hull, Squire John V. Barron of Lake Village and Captain David Parsons had an inventive turn of mind and set up the treads to accommodate three horses. Trials proved this impractical, and two horses were finally used. The sweeps of the gundalows were retained, but only one was used, as an immense rudder. This oar, or rudder, was frequently operated by foot power by a man who sat on a high seat where he watched the horses and guided the craft's direction by moving the rudder. The horses were led into the elevated structure, and the weight of the steeds on the tread inclined the "laggs" to move. At the proper time, the captain and steersman released a brake, and the paddle-wheels started to turn.

Horseboats soon replaced gundalows, and these crafts remained in service until after the arrival of the steamboat, for they were used to carry wood for the boilers of many of the early steamers, and some even remained in operation until the late 1880s.

Even the more reliable horseboats did not fill the navigational needs of Lake Winnipesaukee. Sixteen years passed after the *Cleremont* sailed on the Hudson

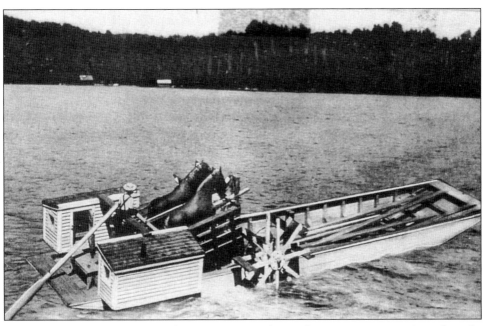

LAVALLEE'S HORSE BOAT. These unique vessels, used to transport a variety of goods, operated on the lake between 1878 to 1890.

River before a corporation was formed at Lake Village to build Winnipesaukee's first steamboat, the *Belknap*.

The half century following the close of the war for American Independence may be called the stagecoach era, and the ever-popular and prominent question before the people was the building of new roads and the improvement of the facilities for travel and moving merchandise. The waterways, the aboriginal courses of travel, naturally became the maritime ways of transportation, but these served their purpose only in certain sections. Their lines of transit were too arbitrary to meet the needs of the growing population in general.

In the closing years of the nineteenth century, four great state roads known as "turnpikes" were chartered and built at considerable expense. These roads were satisfactory as far as had been expected of them, but with all the outlay and endeavor, the journey to Boston, or any of the seaport communities, then the hub of business, was a tedious and expensive undertaking.

In the midst of these earnest efforts toward benefiting the inhabitants of the state, a strange whistle awoke the silence of the Merrimack Valley and proclaimed the coming of a new power, which was to relegate the jaded stagehorse to the mere peaceful pursuits of life. This newcomer was the iron horse.

The successor to the stagecoach was the steam railroad. New England may be considered a pioneer of steam for transportation. The first application of steam to locomotion was made on the Connecticut River by a Mr. Morley of Orford, New Hampshire, whose experiments predate those of Robert Fulton. The first steam

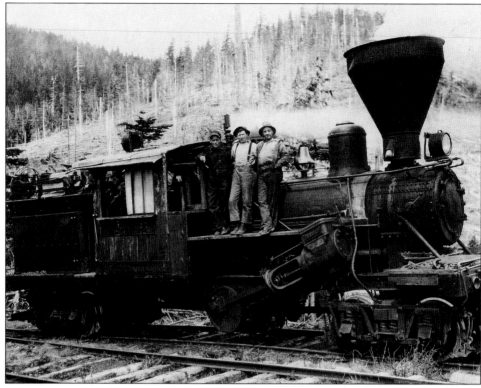

THE SANDWICH NOTCH LOGGING TRAIN. The nineteenth century saw the advent of railroads, which transformed the Lakes Region both economically and socially.

engine was built by Nehemiah S. Bean of Gilmanton, New Hampshire. Sylvester March of Campton, New Hampshire, invented the cogwheel railroad system and built the Mount Washington Railroad.

During the early 1800s, the growth of the textile industry and an increasing population brought about the need for better transportation of raw material to New England's manufacturing centers. In 1830, a project was proposed to build a railroad between Boston and Lowell, a distance of 26 miles. On June 24, 1835, the Boston & Lowell Railroad was opened for service.

The Boston & Lowell was considered the first and principal link to what was known as the great Northern Route. From Lowell, the line was continued by the Nashua & Lowell Railroad. This line then extended by the Concord Railroad along the Merrimack Valley to Concord, New Hampshire, and then by the Northern Railroad to the Connecticut River in Lebanon. From there, it continued through Vermont to connect with the Montreal Railroad, a distance of 326 miles from Boston. In addition to these extensive lines with the Boston & Lowell was the Boston, Concord & Montreal Railroad, which proceeded from Concord, New Hampshire, and throughout the White Mountains, connecting with the Grand Trunk and the Portland & Ogdensburg Railroad.

On August 8, 1848, the Boston, Concord & Montreal Railroad between Concord and Meredith Bridge opened—an important development to the growth of what is now Laconia. In the following year, the road was extended to Lake Village (Lakeport). This event marked one of the largest celebrations these towns in the Lakes Region had ever seen.

In 1839, a charter was granted to the Dover & Winnipesaukee Railroad to build tracks from Dover to Alton Bay—a total of 29 miles. The charter lapsed, but eight years later another was granted under the name of the Cocheco Railroad. By 1848, tracks had been laid as far as Farmington and a year later were completed to Alton Bay.

In 1847, a charter was granted to build the Lake Shore Railroad between Laconia and Alton Bay. This 18-mile road was established to connect the Cocheco road, on the eastern side of New Hampshire, with the old Boston, Concord & Montreal Railroad at Meredith. Due to the lack of finances, this construction was postponed for over 40 years, leaving the original charter to expire. Finally, in 1883, the charter was granted and left in the hands of Charles A. Busiel and his associates. In 1887, both the Concord Railroad and the Boston and Maine offered to build the Lake Shore Line. In June 17, 1890, the Lake Shore Railroad was opened by the Concord Railroad Corporation, connecting Alton Bay to Lakeport.

The Cocheco Railroad played an important part in the race for supremacy on the lake with the Concord & Montreal Railroad during these early days of transportation. The Cocheco Company, who had also built the steamer *Dover*, was

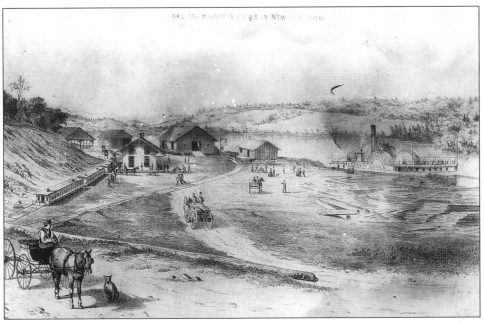

ALTON BAY RAILROAD AND STEAMBOAT STATION, 1868. Alton Bay possesses one of the longest and most distinguished reputations as a port for shipping and trade on the lake.

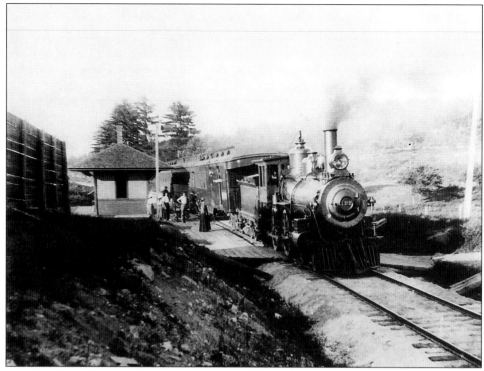

GLENDALE STATION, 1897. A small crowd of onlookers is standing by the steam train No. 122 of the Lake Shore Railroad, which began operation in 1890.

an intense rival of the Concord & Montreal. The Weirs was a forbidden port to craft operated by the Dover & Winnipesaukee, which had taken over the Cocheco in 1863, as Alton Bay was off limits to the boats of the Concord & Montreal. The race was finally won by the Dover & Winnipesaukee Railroad after the construction of the steamer *Mount Washington* in 1872, and the line was taken over by the Boston and Maine in an attempt to consolidate its lines in outlying districts.

In *Illustrated Laconian* (1899), the following information was recorded: "A mammoth canon [*sic*] was located near Horse Point, on the shore of Lake Winnisquam [*sic*], and when the special train came along, a salute was fired, which was the signal for ringing the mill bells and the church bell of the Old North Church. There was an immense throng of people waiting at the depot to welcome the Iron Horse." The train was named *Old Man of the Mountain*.

The importance of the railroads in New Hampshire cannot be fully estimated in considering the many forms of development that have fallen to its material progress. Their influence had been felt in every section of the state, and where stations were established, the population had gravitated. Towns and villages that were few in number had become centers of industries. While wealth, like the currents of the state's rivers, was attracted to the waterfalls, the source of power,

it was left for the railroads to foster the hum of spindles, the rumble of looms, the tap of hammers, each being symbols of public prosperity. Where the iron horse had not penetrated, silence had fallen on the scene and natural resources were left to waste. And not only did the manufacturing and business interests depend on the railroad for their welfare, but the portable mill of the most remote lumberman, the summer home in the mountains, the many industries of the state, all were affected by the railroads.

Railroads flourished through the late nineteenth to the early twentieth century, but as time passed, interstate highways were improved and the trains became replaced by the automobiles. The trains to Alton Bay continued to operate until July 9, 1935, but with the decrease of passenger service hastened by the prolific number of automobiles, the trains ceased operations—a great loss to the area. With the growth and development of the steam locomotive throughout the state came the advent of the steamboats for lake travel on Lake Winnipesaukee.

During the nineteenth century, competition between the railroad companies did much toward improving boating on Winnipesaukee. If one were to compare the old dirt roads that connected the towns and villages of the Lakes Region, it is easy to see that water travel was fast, convenient, and an accepted means of transportation for decades. Railroad stations were a common sight on every public

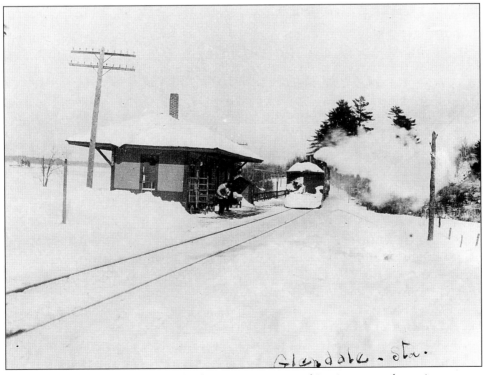

GLENDALE STATION, 1920s. This locomotive is seen making its way to the station across a snow-covered landscape.

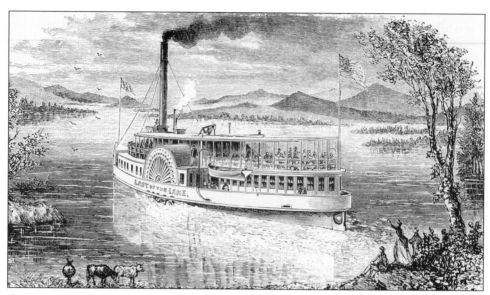

STEAMER LADY OF THE LAKE. *Depicted in this 1880s sketch, the famed steamer provided elegant transportation for countless natives of the area and visitors to Lake Winnipesaukee.*

dock throughout the region, where trains would transfer passengers to one of the railroad-owned steamboats for the next jaunt. All these towns were laced together by boat lines and smaller crafts connecting between the islands and smaller communities. On any day, one could find more than a dozen steamboats throwing soot into the air as they carried passengers and freight to all points throughout the Lakes Region of New Hampshire.

One of the first steamboats, the *Belknap*, measured 96 feet long and 33 feet wide. This vessel was powered by a steam engine salvaged from an old sawmill. The boat made her launching at Lake Village (Lakeport) in 1833. With a few mishaps, she made her maiden voyage on schedule and continued to operate on the lake for eight years, until a cold October day in 1841, when the lake witnessed its first shipwreck. A nor'easter was making its approach and the *Belknap* was sailing out of Center Harbor towing a raft of logs that apparently slowed the vessel down to a speed of approximately 3 miles an hour. It was somewhere between Six Mile Island and Birch Island that a gale struck the old boat. She was unable to make headway with the heavy load, and the *Belknap* swung onto the rocks of a small island, smashing its bow. It sank almost immediately. The machinery was later salvaged, but the hull still remains on the bottom of the lake near what is now called Steamboat Island. This wasn't the only steamer, but after the *Belknap* made her last voyage, all early steamers were either destroyed or worn-out, and steam boating on the big lake came to a standstill for many years.

The population in the Lakes Region grew, and the railroads were quickly making their way across the countryside. Mid-century saw the construction of the famous *Lady of the Lake* and the development of marine transportation on Lake

Winnipesaukee. William Walker of Concord and Benjamin Cole were the prime movers in the building of this fine boat. The *Lady of the Lake* was built in Lake Village (Lakeport) in June 1849 by the Winnipesaukee Steamboat Company. It was a large craft of 125 feet and completely designed for commercial lake travel. Many thousands of people gathered to witness the launching of this vessel, and 400 rode with her on the maiden voyage, which traveled from Lake Village to the Weirs, Center Harbor, and Wolfeboro.

The Weirs was on the line of the Concord & Montreal Railroad, whose tycoon, B.A. Kimball, foresaw, with the success of the Winnipesaukee Steamboat Company's *Lady*, huge profits from commercial navigation of Winnipesaukee. Consequently, the *Lady of the Lake* soon passed into the possession of the railroad. With the change of ownership, W.A. Sanborn became its captain.

At this time the *Lady* had no rival, and business boomed for the rail company. This was difficult for the competitor, Cocheco Railroad Company, to withstand. The Cocheco Railroad served the southern half of the lake and could easily see its business going under via the competition of the Concord & Montreal side-wheeler, so at Alton Bay, they ordered the construction of a new vessel to be called the *Chocorua*. There developed a strong rivalry on the lake between the *Lady of the Lake* and the *Chocorua*, for this was home territory for the Concord & Montreal system. The battle was on, and the lake saw the division of two domains, each under a different name: one being Winnipesaukee, the northern half of the lake, and the other Winnipeseogee, the southern half. The first was legally adopted by the New Hampshire Legislature in 1931. The captains, being loyal company men, usually gave the "Full Ahead" when the two met on a parallel run from Center

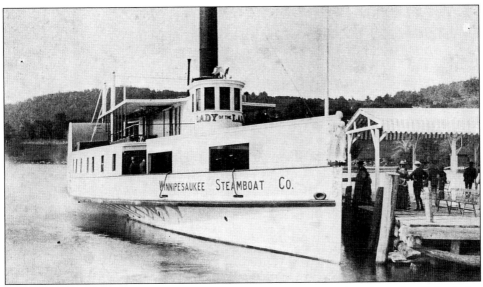

STEAMER LADY OF THE LAKE. *Seen here docked at Center Harbor, the* Lady of the Lake *was built by the Winnipesaukee Steamboat Company and launched in 1849.*

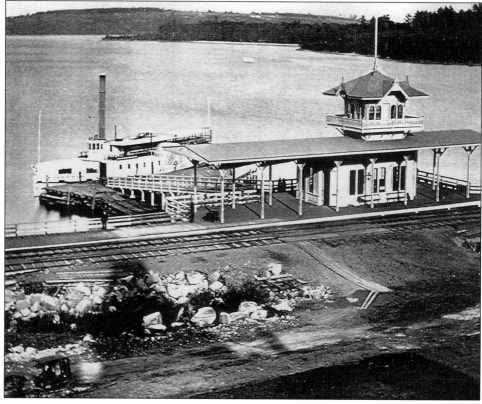

STEAMER LADY OF THE LAKE, *1880s. The vessel is seen here docked at the Weirs Railroad Station. Governor's Island is visible in the distance.*

Harbor to Wolfeboro. On such races, both the passengers and crew cheered for their favorites, but it was unquestionable that the *Lady* was the better vessel and could outrun the rival craft without really trying.

It wasn't too many years later that the lake witnessed the launching of another craft, the *James Bell*. In comparison, this was a luxurious steamer outfitted with the latest comforts and gave both companies competition. Not fancied by this second rivalry, the Boston and Maine Railroad Company, which had already purchased the Cocheco system, purchased the *James Bell* and discontinued it as a passenger vessel. This was a desirable move for the Boston and Maine, for they docked the *Bell* at the Weirs, which was home territory for the Concord & Montreal, and it showed a profit from excursion trips and moonlight cruises. Even though the *Bell* didn't have a chance as a commercial vessel, it did acquire the honor of being the first tourist boat. Although the *James Bell* gave a boost to the Boston and Maine, Captain Wiggins of the *Chocorua* was still no match for the *Lady*.

During the competition years between the railroad companies (the *Lady of the Lake* and the *Chocorua*), the Boston and Maine decided to build a larger, faster, and more beautiful boat than ever before seen on Winnipesaukee. Famous

shipbuilders along the Atlantic seaboard were consulted, with Smith and Townsend of East Boston finally being selected. Plans went forward, the construction site at Alton Bay was selected, and there began the building of the steamer *Mount Washington*, named after the greatest mountain in New Hampshire. This vessel was to become the largest steamer to ply the waters of Lake Winnipesaukee and would outlive her builders, her competitors, and three generations—a variable Winnipesaukee tradition, as famous a side-wheeler as was ever launched in America.

The finest of oak and pine was selected for the *Mount Washington*. Her length of 178 feet was slightly greater than the renovated *Chocorua*, but her 49-foot beam and draft of 12 feet far exceeded her predecessors. The engine was 450 horsepower and its cylinder had a diameter of 42 inches. The cylinder stroke was 1 of 10 feet; low pressure boiler of 39 feet long; a single-cylinder engine with a 42-inch bore developed 450 horsepower. The engine was built by William Wright & Company of Newburgh, New York, producing 24 r.p.m. with a steam pressure low of 30 to 25 pounds. Her tonnage was 510. True to the tradition of saltwater seamen, the steering wheel in the pilothouse was rigged in such a way that turning it to starboard would swing the vessel to port.

During the early days of the *Mount*, the following crew members were employed: Augustus Wiggins, first captain; Harry L. Wentworth, purser and second captain; Alonzo Leighton, chief engineer; Fred Leach, engineer; John M. Lovett, pilot; and Mrs. Elizabeth Ferry, food services. It is interesting to note that part of the pay was a stateroom for sleeping and three meals per day. The *Mount Washington* made her first trip on July 4, 1872, with Alton Bay, Meredith, Center Harbor, Long Island, and Wolfeboro on her schedule of ports.

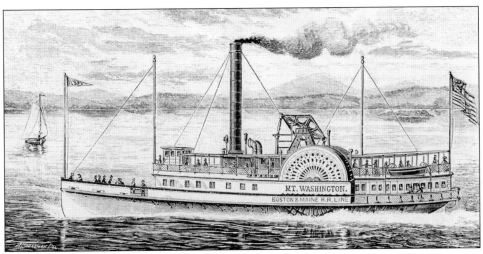

STEAMER MOUNT WASHINGTON. *The famous side-wheeler, seen in this 1890s artist's rendering, was constructed by the Boston and Maine Railroad Line to accommodate the growing need of travel on Lake Winnipesaukee.*

In *Winnipesaukee Voyage*, Howard F. Greene wrote the following of his trip:

Even though the *Mount* outclassed the *Lady of the Lake*, their rivalry continued unabated for 18 more years. The captain and crew of the *Lady* pushed themselves even harder in their efforts to regain some of their lost business, until, by 1890, the vessel ran three round trips a day from June 4, until October 20. She began her day's work at 5:30 a.m., sailing from Wolfeboro to Long Island, Center Harbor, Bear Island, and the Weirs. Arriving back at Wolfeboro at 10:30 a.m., she sailed immediately on her second trip, which finished at 3 p.m. The third and last trip of the day, started at 3:30 and finished at 7:30 p.m. a fourteen hour day for captain and crew, not counting the time involved in firing up in the morning and cleaning up at night. Even with all the efforts of the great *Lady*, she could not withstand the losing battle against the *Mount Washington*, and she made her last voyage in September 1893, after which she was retired to Glendale Bay and later destroyed by the owner. The *Mount* was left alone and crowned the "Queen of the Lake."

With the launching of the *Mount Washington*, the *Chocorua* was retired from service and used only for special parties; however, in 1875, it was finally dismantled in a cove just back of the steamboat landing at Alton Bay.

Captain Wiggins was the first captain of the *Mount* in 1872, followed by Harry Wentworth. In 1908, Herbert A. Blackstone took command and remained in

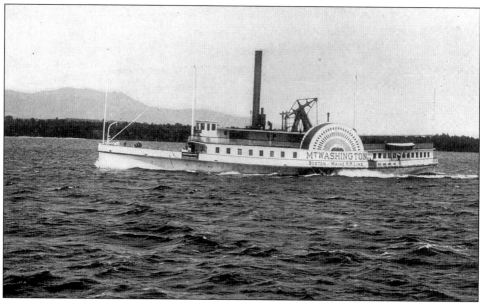

STEAMER MOUNT WASHINGTON. *The much-celebrated vessel is seen in action on Lake Winnipesaukee's waters.*

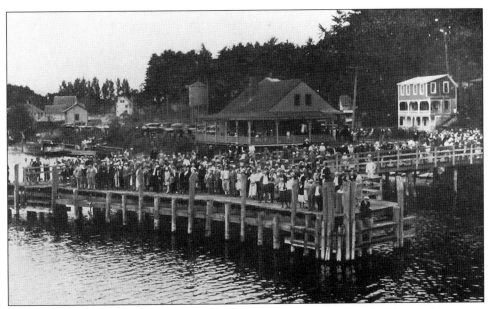

ALTON BAY, 1928. A large crowd of anxious onlookers awaits the docking of the steamer Mount Washington.

charge for 13 years. The *Mount Washington* enjoyed some of its best years under Captain Blackstone's command.

During the days of the *Mount* and the *Lady*, another type of steamer, which was driven by a screw propeller, made its way into the lake. There was no question that it was more efficient than the larger boats, even though it could not compete with the big side-wheelers when at full speed. The main purpose for these smaller crafts was for the tourist business, which was becoming very popular in the region.

The first screw-driven steamer, the *Mineola*, was launched five years after the *Mount Washington*. The launching took place at Lake Village (Lakeport), where hundreds gathered from all over New Hampshire to witness the christening of this first screw-driven vessel, which claimed it could reach speeds of 10 miles per hour. The skeptics could not swallow this claim, for the screw propeller was still unproven; on her maiden voyage, it reached 10.5 miles an hour.

The most famous of the screw-propelled vessels was the *Maid of the Isles*, built at Wolfeboro in 1877, at a cost of $16,000. Wolfeboro locals maintain that the *Maid* won a race against the *Mount* in one of the many races between the early steamers.

Eventually, time took its toll, and the *Maid* saw the end of her career at Center Harbor, when a group of Independence Day pranksters set the *Maid* on fire. This seemed to be the turning point for all boating on the big lake, for in 1893, the Concord & Montreal Railroad system ceased; the *Lady of the Lake* made its last voyage; and the Boston and Maine was faced with competition from the automobile. With road improvement and the development of the interstate

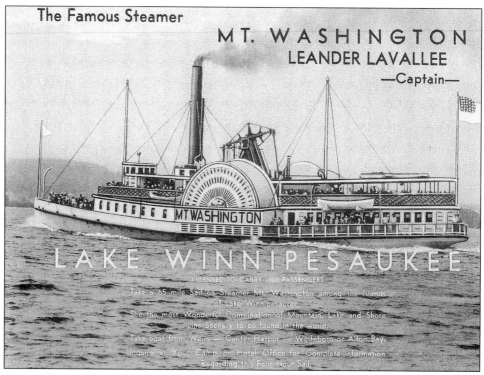

The Famous Steamer

MT. WASHINGTON
LEANDER LAVALLEE
—Captain—

MT WASHINGTON

LAKE WINNIPESAUKEE

LICENSED TO CARRY 1000 PASSENGERS

Take a 65 mile Sail on Steamer Mt. Washington among the Islands
of Lake Winnipesaukee.
See the most Wonderful Combination of Mountain, Lake and Shore
Line Scenery to be found in the world.
Take boat from Weirs — Center Harbor — Wolfeboro or Alton Bay.
Inquire at Your Camp or Hotel Office for Complete Information
Regarding this Four Hour Sail.

MARKETING MOUNT WASHINGTON. *This is an advertisement for Captain Leander Lavallee's passenger service on the lake.*

highway, more people were traveling by auto, and the commercial value of the steamers began to cease. By the end of World War I and the signing of the Armistice, the steamers, as commercial transportation, were on a downward trek.

In 1922, the Boston and Maine Railroad sold the *Mount* to Captain Leander Lavallee for approximately $3,000. This ended an even half-century under the service of the railroad. The vessel prospered for the next several years with Captain Lavallee as its skipper. In 1932, Captain Lavallee sold the *Mount* to Sidney Baker of Lakeport, and Captain Baker operated the steamer with some success during those Depression years. In the year 1935, Captain Baker sold the *Mount* back to Leander Lavallee, who resumed operations as before.

On December 23, 1939, a little after 8 p.m., a wood stove in the Weirs Beach Railroad station overheated and live sparks flew onto the wooden floor, starting a fire that engulfed the station in flames. Fred Moore, a local hotel owner, noted the fire and promptly notified the fire department.

The *Mount* was docked at the Weirs for the winter during the time of the fire, and Captain Lavallee made every attempt to save her, but his efforts were fruitless—the *Mount* was lost! The following morning, only smoldering wreckage and iron ruins remained. The approximate appraisal of damage to the *Mount* and railroad station was $75,000, and the vessel was only partially insured.

After the fire of 1939, Lavallee began his search for a new vessel that might replace this old side-wheeler, which had serviced the lake for 67 years. "To build a new one," Lavallee said, "would cost in the vicinity of a quarter of a million dollars." His search took him all over New England and the East Coast until he finally spotted the old side-wheeler *Chateaugay* at Burlington, Vermont, on Lake Champlain. Here stood the iron-hulled steamer, built in 1888, staunch as the day it was launched. At the time that Lavallee looked it over, it was being used as a clubhouse by the Burlington Yacht Club.

Gambling all on the faith that 150 miles that separated the two lakes could be overcome, Lavallee signed a contract to purchase the *Chateaugay* for $20,000. Thus began the insurmountable task of dismantling the superstructure and transporting the hull to Lakeport, New Hampshire. The hull was the only part of the vessel wanted for the new *Mount*.

Now began the financial strain of such a project. To this aim came the aid of several interested state businessmen, who believed in the project and gave financial assistance to Captain Lavallee. Such people included James R. Irwin of the Weirs, who contacted many others for their support. Finally, the services of John G. Alden, Inc., Boston, were secured for the construction and design of the hull. Mr. Colley drew up the plans for the new boat and the task of transporting the hull to Lakeport.

On April 3, 1940, they finally cut the hull into 20 sections, loaded them on flatcars, and carried them overland to New Hampshire, where they began reassembling, welding, and building the new superstructure. Captain Lavallee insisted that the propulsion be by steam engines. This presented additional problems, for engines of this type were no longer manufactured. After much searching, an old steam yacht named the *Crescent III* was found in the New York

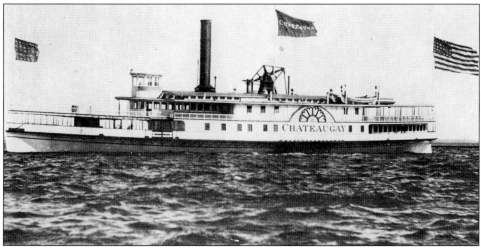

STEAMER CHATEAUGAY. *This side-wheeler from Burlington, Vermont, was purchased by Captain Lavallee to replace the damaged* Mount Washington.

CAPTAIN LEANDER LAVALLEE. Seen here at the helm of the local mail boat, Captain Lavallee was a prominent figure in the lake's navigational and cultural heritage.

area and was bought for the amount of $25,000. The *Crescent III* was a 140-foot craft built in 1920. After they installed the boilers, engines, propellers, and shaft, the launching date was becoming a reality. By this time, the entire Lakes Region was feeling the pulse of excitement for the launching of the new *Mount*. What appeared at one time to be the end of the *Mount Washington* had become a believable beginning for the region.

Paul Blaisdell wrote the following in his *Three Centuries on Winnipesaukee*, 1975:

> Throughout the hectic days of construction, the task would have been hopeless without the enthusiastic cooperation of many individuals and officers. Byron and Carl Hedblom of the General Ship and Engine Works spared no effort to speed the day of launching, and to them must go much of the credit for the completion of the ship. The State Public Service Commission met on short notice to clear problems relating to its jurisdiction and keep things moving. Three crews worked in eight-hour shifts, and at any time of the day or night Captain Lavallee or James Irwin might be seen at the shipyard, ironing out problems with the engineer. It was a gigantic undertaking, accomplished in a true Yankee fashion.
>
> At the cost of approximately $150,000, New England has the S.S. *Mount Washington*. To speak of her as New England's ship is done

advisably, for she takes the place of a gallant craft which won the hearts of thousands. She is looked upon as a part of New England rather than as the exclusive child of New Hampshire. Truly she is the pride of Lake Winnipesaukee.

On August 12, 1940, Lakeport witnessed the launching of the S.S. *Mount Washington II*. Thousands upon thousands of spectators gathered to watch the launching of the new *Mount*. The *Laconia Evening Citizen* reported the following: "Launching of the steamer *Mount Washington II* was one of those occasions which comes to a community but once in a lifetime. Probably 20,000 saw the twin screw, all steel ship glide into the water of Lake Paugus at 1:03 yesterday afternoon." The boat was christened by Dorothy Irwin, University of New Hampshire freshman and daughter of vice president and general manager of the Steamship Mount Washington Corporation, James R. Irwin.

The waters of Lake Paugus, and later Lake Winnipesaukee at Weirs Bay, were dotted by more than 500 private boats of all descriptions, from canoes to handsome cabin cruisers; ship bells rang and whistles tooted as the *Mount* started on its 4-mile trip to its birth at Weirs Beach. That evening, after the *Mount* arrived at the Weirs, men worked day and night in preparation for its trial run, which was only a few days away.

The day finally came for its trial run, which was made around Governor's Island, and the resulting run found more work to be done on the engines. Carl and Byron Hedblom from General Ship went over the vessel that night, and the next time she went out, it made good time.

It wasn't long after the *Mount Washington II* was in commission when, in 1942, bankruptcy occurred. After bankruptcy, the Coast Guard acquired her engines for war service and the boat was laid up until the end of hostilities. However, that was not the end, but rather a new era of boating, for after World War II (1946), the *Mount* was put back into service, and today the *Mount Washington* is recognized as a pleasure vessel and landmark, the pride flagship of Lake Winnipesaukee, which provides its passengers with the natural beauties of both the lake and mountains.

STEAMER MOUNT WASHINGTON II, *1940. Thousands of spectators came to see the launching of the new vessel.*

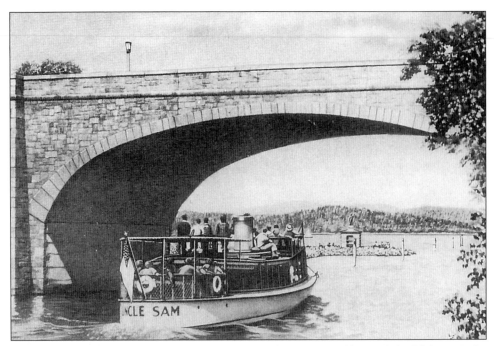

UNITED STATES MAIL BOAT UNCLE SAM. *This recognizable symbol of life on Lake Winnipesaukee is seen passing under the Aquedoctan Bridge at the Weirs.*

"RFD No. 7, Laconia, New Hampshire." This was the address first established in 1892, when the first mail boat was put upon the lake. In the year 1916, an act of Congress made this the only floating post office on an inland body of water in the United States, and it has remained so to the present.

The original steamer to transport mail to the island on the northern half of the lake was called the *Robert & Arthur*, built in 1892, followed by the *Dolphin*, built in 1894. The third mail boat was the original *Uncle Sam*, built in 1906 for Mr. Seabury of Long Island, New York. The vessel was 65 feet long, had a 14-foot beam, drew 7 feet of water, was capable of carrying 100 passengers, and was equipped with a single screw engine. In 1945, this boat was converted from the traditional steam to the new diesel-type engine and kept its franchise on the lake until 1961, when it was retired.

During the years 1932 to 1933, the mail was carried by the *Marshall Foch*, Captain Edward Lavallee's personal boat, after which the original *Uncle Sam* retained her claim to the mail franchise. In 1962, *Uncle Sam II* made its appearance on the lake, after a laborious overland travel from Portsmouth Navy Yard. This 72-foot vessel was a converted Naval PT boat, which had a beam of 20 feet, a draft of 6 feet, weighed 80 tons, had a top speed of 15 miles per hour, and was capable of carrying up to 150 passengers. On March 23, 1963, under the dual ownership of Vernon Cotton and Allan Perley, she slipped through the water on her maiden voyage to continue the mail service of the northern islands. Postmaster Edward

Lavallee prepared the mail, luggage, etc., right on board the vessel, thus giving it the continued, honorable distinction of being the only floating post office in America.

In 1969, the mail franchise was placed with the *Sophie C*, a modern 76-foot tourist boat under the ownership of the Winnipesaukee Flagship Corporation, Weirs Beach, New Hampshire, and continues to deliver mail as it did over a hundred years ago.

UNITED STATES MAIL BOAT UNCLE SAM II. *This converted PT boat is seen on its way to Lakeport from Portsmouth in Depot Square in Laconia.*

117

7. SUMMER CAMPS

The modern summer camp movement has been contributed to by many, but the organized camp is essentially an educational institution. As such it was originated and has been developed by educators, those who were concerned with the lives of the young and their training for adulthood.

The first organized summer camp that presented practically all the best features of what summer camping is today was that of Ernest Balch, opened in 1881 and continued until 1889. But there were unknown to Balch others before his time who took boys into the open wilderness during the summer months.

Ernest Balch started his camp as a result of deliberate planning to meet a particular need. All the essential features of the organized camp were worked out by him at Camp Chocorua. Moreover, his camp was maintained continuously on the same site for nine years, and as a result of its influence, other camps were established that followed his practices and many of his old campers later established camps of their own. That is, Balch not only put into execution a carefully thought-out educational plan, but he established a school of imitators and disciples who followed his practices and out of which has come the organized summer camp as the lake knows it today.

Regarding Camp Chocorua, Balch wrote the following:

> I first thought of the boys' camp as an institution in 1880. The miserable condition of boys belonging to well-to-do families in summer hotels, considered from the point of view of their right development, set me to looking for a substitute. That year and 1881, I had thought out the main lines of a boys' camp. That year, also, with two boys, I made a short camping trip to Big Squam. In 1881 I occupied and bought Chocorua Island.
>
> It is hard now to distinguish invented ideas from those acquired by experience. Certainly we began with several important ones which

GREEN'S BASIN SUMMER CAMP. *This summer camp, owned by the Green family, was the first built in the Basin.*

persisted in the structure of the camp during the nine years of its active life.

The first theory was that there should be no servants in the camp; that the camp work must all be done by the boys and faculty. Another was that the boys must be trained to master the lake. So a systematic and complex plan was thought out to provide safety for the boys and teach them swimming, diving, boat work, canoeing and sailing.

Minor activities were singing, the choir, acylyte [*sic*] work, the library, carpentry, chiefly building, law court, contracting companies, baseball, "The Golden Rod," camp paper, correspondence with home, pillow fights, water fights, liberty day without rules, stories, charity, fishing, cooking, examinations, races, land sports, cruises. The division of work in a crew, the management of a crew by the boy "Stroke," was always amusing to watch.

The reception of the camp idea by educators and schoolmen was so negative at the beginning that it puzzled me and made me doubtful. Professor Wentworth, the great "Bull" Wentworth of Exeter, was an exception. He did not visit the camp but he did ponder the ideas I put before him and understood them. Moreover he thought them sound. All the other teachers I talked to were perfectly calm and not the least appreciative.

119

JUNIOR LODGES AT CAMP IDLEWILD, 1950S. Established in 1892, this camp was located on scenic Cow Island.

> Then came Armstrong, welcome as good water in a dry land. He had made a distinguished place by original work at Hampton and elsewhere. He was not, I gathered, regarded as a regular by Schoolmen. He did not stop at phrases. He lived at Camp Chocorua for weeks and studied both the theory and practice. He proclaimed his opinion and wrote it in generous words. Articles in magazines and books followed. Camps grew, the legend began, culminating in the interpretation of American Private Schools.

Balch in the foregoing reflected on the cool attitude of schoolmasters toward the small camp. With their slow response, conservative as always, they saw nothing of value in so radical an innovation. It remained for General Armstrong and Mr. Frissell of the Hampton School and a few other open-minded men to espouse the cause and preach the doctrine of the summer camp.

Through correspondence with Balch, the Reverend Nichols, inspired with the same idea, opened a camp for boys in 1882 at Stow, which he called Camp Harvard. This camp was later taken over by Dr. Winthrop T. Talbot, a son of Dr. J.T. Talbot, then dean of the Boston University Medical School, who, in 1884, moved it to Squam Lake, where it was known as Camp Asquam.

Louis D. Bement, editor of the *Camping Handbook, Summer Camps*, 1931, wrote the following of Camp Asquam:

> The camp was situated on sloping ground well up from the shores of Squam Lake near Holderness, N.H., and commanded a beautiful view of that picturesque lake with its islands and the surrounding mountains.

There were four buildings; a combination dining hall and cook shack, the director's cabin and two dormitories. These latter held some twenty bunks lined up against the two side walls, while at one end there was a large fieldstone fireplace.

Down on the shore of the lake was a boathouse which held some five or six rowboats of the Adirondack type, as canoes were considered too dangerous for boys in those days.

All the work of the camp with the exception of the cooking was done by the boys . . . Mornings were given over to camp work and swimming. After dinner there were baseball, tennis, rowing, and short hikes. Occasionally there would be an all day hike planned. Some botany was studied and, in a very elementary way, zoology. As a final end-up for the summer there came the hike through the Presidential Range.

For more than ten years the camp was successfully continued until Dr. Talbot's failing health necessitated its closing and the site has since been used for private purposes. Some of the assistants, trained by Dr. Talbot, soon established camps of their own, which attained success. Dr. Shubmell, who had been an assistant of Dr. Talbot's in 1903, split off from Dr. Talbot, taking some of the boys with him and a short distance south, on Little Squam Lake, and established Sherwood Forest Camp, which he continued until 1910. On this same site, Dr. John B. May, who had been a camper and councilor under Dr. Shubmell, in 1914 established Winnetaska Canoeing Camps, which were continued by him until 1928.

In 1886, two years after Dr. Talbot's camp was established, Edwin DeMeritte opened Camp Algonquin, a few miles east which was operated as a private camp for boys. Camp Idlewild on Lake Winnipesaukee was opened in 1892 by John M. Dick, who had some training in a YMCA camp at Plymouth, Massachusetts.

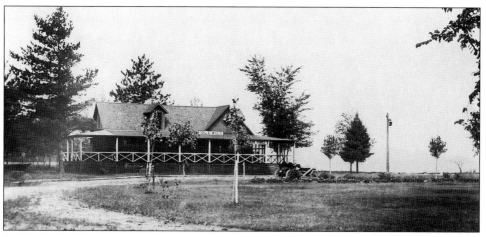

MAIN LODGE AT CAMP IDLEWILD, 1914. Camp Idlewild served as a private boys' camp for over 60 years on Cow Island.

121

CAMP WYANOKE, 1949. Campers are seen enjoying the lake's waters at this camp near Wolfeboro.

So out of the influence of Balch's idea there had grown up, within a few miles from Chocorua in the succeeding 14 years, a whole brood of successful camps that followed the practices he had established. And, moreover, these camps have transmitted their influence far and wide.

While Ernest Balch had in the back of his mind the founding of a monastic order, it had to prove itself a success before anyone became bold enough to suggest that what was good for the boys might be equally good for their sisters. As early as 1892, a girls' camp was established by Professor Fontaine at his natural science camp called Camp Arey, thus establishing just claim as the first organized camp for girls.

In 1900, Mrs. Oscar Holt took some girls as summer boarders in a small cottage, the "Redcroft," on the shore of Newfound Lake. After two years she decided to entertain only small boys and thus originated Mowglis, the pioneer camp for young boys.

The year 1902 was significant in the history of girls camps. Laura I. Mattoon, a teacher in a private school of New York City, then established Camp Kehonka in Wolfeboro on the east side of Lake Winnipesaukee. At this period in time it was considered a startling thing to do, to take reputable New York girls in their teens and young women into the woods. It scandalized some of the good schoolmistresses to hear that she let girls run around in the broad daylight in bloomers. In the same year Miss Munoz established Pinelands at Center Harbor.

Family camps have become increasingly popular in the Lakes Region. In addition to the Appalachian Mountain Club's Three Mile Island, two more camps worth mentioning, which have been in continuous operation for more than 100 years, are Sandy Island Camp and the Geneva Point Center.

Sandy Island, possibly the only YMCA camp for young adults and families in the country which has been in continuous operation for over 100 years, is located near the middle of Lake Winnipesaukee. Walter Jones's *The Sands of Time*, published by the Boston YMCA, 1998, relates the following:

> In March of 1899 a committee from the Boston Association visited Lake Winnipesaukee, situated in the foothills of the White Mountains. After crossing over the ice to inspect the 66-acre island, the Association leased it from the owners, Walter A. and Agnes E. Brown, at an annual rental of $100. Sandy Island was a part of the estate of the Brown family who had settled on Long Island in 1821.

Due to its magnificent location and composition of the island, it was only appropriate that it be named Sandy Island. To the northeast lies the Ossipee Mountain Range; to the southwest, the Belknap Mountain Range; and to the north, a fantastic view of the Presidential Range in the White Mountains. The island is well endowed with pine groves, sandy beaches, and sheltered coves for fine boating, bathing, and total relaxation. Appropriately, the first prospectus was captioned "Spring and Summer Days: How and Where to Spend Them," and the camp was described by the Boston YMCA as "a summer resort for young men

SANDY ISLAND CAMP. This vacation camp for young adults and families was operated by the Boston YMCA and was the first co-educational adult camp in the country.

working on small salaries and receiving short vacations where they could enjoy healthfully and economically their summer outings."

During the early years of the island's development, the camp was rather primitive and rugged. However, this enterprise became so successful that the Boston Association bought the island in 1900. The first buildings to be constructed were a combination dining room and social hall and two dormitories that could house 50 campers. By 1905, a boathouse was built on the north shore and further additions to the dormitories were constructed so as to accommodate more campers.

During the first 25 years, the camp continued to expand its facilities. First the dining hall, known as "Alhambra," was enlarged to include a second floor for sleeping quarters and a screened-in, open-air dining hall. A row of tents was established along the shore, which could accommodate from 8 to 12 campers. Later, after the acceptance of women campers, the larger tents were replaced by cabins suitable for family units, each commanding a vista of the lakes and mountains.

Today, Sandy Island is a family camp under the general supervision of the Camping and Outdoor Recreation Branch of the Boston YMCA. A Camp Committee, composed entirely of campers, acts as an advisory group which makes recommendations to the Camping Branch Board relative to policies and major projects for the island camp.

Walter Jones also mentions the following of the camp's purpose and natural advantages:

> The camp is not, and never has been, a venture for profit. Any surplus is ploughed back into improvement of the island's facilities. Sandy Island is a truly cosmopolitan camp. It appeals alike to the young and the middle-aged; the business man, and the student; the housewife and the secretary; the athlete and the individual of sedentary habits. And there is seldom a season when distant countries are not represented and enlightening contacts afforded with visitors. On Sandy Island every man is a brother. It is the sole air of the sponsorship to minister to body, mind, and soul and in its modest sphere to promote the larger Brotherhood of Man.

<div align="center">

Beautiful Isle of Sandy
Set in a sea of blue
Raising our hearts so grandly
Moulding us into friends true
Working, playing
Life is just what you make it, boys
Friends and good cheer
Await you here
Beautiful Isle of Sandy.

</div>

INN AT GENEVA POINT CAMP. This inn was once the site of the Roxmont Poultry Farm, but now serves as a Christian Conference Center on Moultonboro Neck.

Since 1919, Geneva Point has attracted thousands of people from all over the country. Located on the southern extremity of Moultonboro Neck, it has become a place where its visitors may relax and communicate with their creator, and feel re-created in body, mind, and spirit, as a family in one.

This property extends into the northwestern area of Lake Winnipesaukee, called Moultonboro Neck, and it was here that Dr. Jared Alonzo Greene purchased several hundred acres for the purpose of raising cattle, horses, and poultry. Early maps designate the property as "Roxmont Poultry Farm."

In 1896, the Roxmont Poultry Farm ceased operations and the property was converted into an inn for the growing tourist industry in the Lakes Region. But World War I brought tourism to a halt, so the real estate was sold for $30,000 to the International Sunday School Association in 1919. This was the beginning of a long and prosperous building program for the Geneva Point Center.

At this time, there were 236 acres, but because of some sales in intervening years, there are presently just under 200 acres. The central property, with all its buildings, has been maintained; however, some buildings have been moved and a few have been replaced with more modern structures to meet the changing needs of the times. The basic beauty of the center has been retained, and for thousands of people it has become a place of spiritual reflection.

The International Sunday School Association (ISSA) was primarily a grassroots lay movement that later formed the International Council of Religious Education. Many ordained clergy cooperated, but did so as individuals, not as representatives

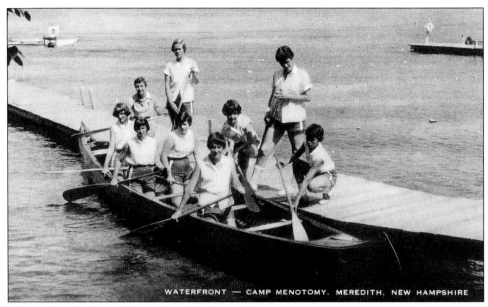

WATERFRONT — CAMP MENOTOMY, MEREDITH, NEW HAMPSHIRE

CAMP MENOTOMY. These young ladies are enjoying the camp's beautiful waterfront. This popular girls' camp was located on Meredith Neck.

of their congregations. The association brought together Sunday school officers and teachers from many denominations and organized them into local, county, state, and national units.

From the years 1922 to 1950, the International Council of Religious Education had title to the property, and managed it through a Geneva Point Administrative Committee. As the camp grew, improvements were gradually made to meet the needs of the growing community. Campers and staff stayed in the inn and some of the cottages that were on the original farm property. There were also tents with wood floors. Electricity did not reach the inn until 1926, and then only for the kitchen, dining rooms, and meeting rooms. Kerosene lamps were used in all of the sleeping quarters.

Until 1930, the largest meeting place was the old chicken house of the Roxmont Poultry Farm, which could accommodate only 150 persons on a level floor.

According to a reminiscence of Dr. Erwin Shaver in 1947, he wrote, "The first chapel services were held in the Chicken-coop—a conglomerate structure with rain-stained and whitewash walls; the floors were part board, part dirt, and the original exits for the poultry still preserved! If one wanted to support the argument that the spirit of reverent worship can be had under the most ugly and incongruous surrounding, here was irrefutable evidence."

Eventually, a new chapel was dedicated on August 5, 1930. It was a white, two-story structure with four white columns across the front porch. There was a stage and auditorium, plus six classrooms. Later the two on the second floor were

opened to permit a balcony into the main auditorium, and two on the first floor were opened to enlarge the auditorium.

In 1950, the National Council of the Churches of Christ of America was formed and the International Council of Religious Education (ICRE) became the Division of Christian Education of the new council, and brought with it the property at Lake Winnipesaukee. This Division Unit Committee, comprised of representatives of all the denomination cooperating in the division, elected the Geneva Point Committee, which, in turn, administered the camp on behalf of the division.

Geneva Point has become a resource for many as a center for conferences and leadership training laboratories. In recognition of this increasing role, and to more accurately identify its function, the name was officially changed to Geneva Point Center in 1966. Because the center was continuing to grow, particularly for its youth, there was a need for more adult housing. In 1966, the Lake View Lodge was built, which provided ten double bedrooms. In 1981, another complete ten-bedroom facility was constructed and was dedicated to Dr. Emily V. Gibbes in honor of her years of service as associate general secretary for the National Council of Churches.

From the very beginning, Geneva Point has emphasized the quality of family camping and has become a lasting pride of the center, thus alumni reunions are an annual affair that bond the center as a family camp for a total Christian community.

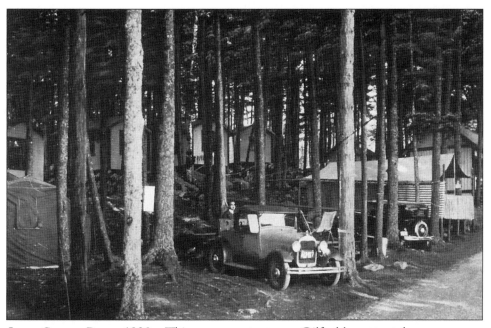

LAKE SHORE PARK, 1920s. This summer retreat near Gilford has attracted many campers and bathers over the decades.

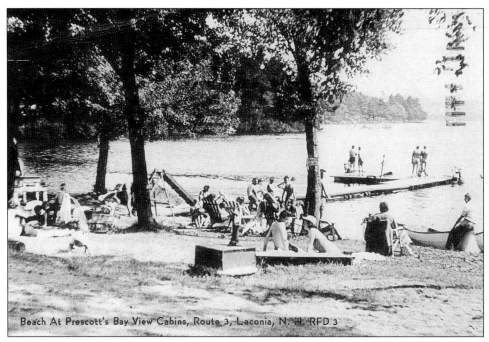

THE BEACH AT PRESCOTT'S BAY VIEW CABINS, 1955. These summer bathers are enjoying the waters of Paugus Bay near Laconia.

During the 1930s, there were as many as 72 established camps in the Lakes Region. This number has grown to include many specialized camps today. The Lakes Region may take just pride in the distinction that the first organized summer camp for young people was established here on the shore of its lakes. The following is a list of summer camps by location and year of establishment.

LACONIA
Camp Arcadia (1909), Lynnholm, and Camp Samoset (1915)

WEST ALTON
Mishe Mokwa (1913), Kabeyun (1924), Sherwood Forest (1930), and Birch Hill Camp (1930)

WOLFEBORO
Wolfeboro Camp (1910), Camp Wentworth (1923), Camp Kehonka (1902), Camp Owaissa (1919), Camp Wyanoke (1909), Camp Wildwood (1928), and Camp DeWitt (1924)

TUFTONBORO
Camp Boycroft (1922), Camp Idlewild (1891), Camp North Wood (1930), and Camp William Lawrence (1926)

MOULTONBORO
Camp Iroquois (1915), Camp Tecumseh (1903), Camp Winaukee (1920), and the Byron Lodge (1914)

CENTER HARBOR
Camp Bonheur (1925), Camp Winnicut (1927), Camp Pineland (1902), Camp Asquam (1915), Singing Eagle (1922), and Camp Wokondah (1909)

MEREDITH
Camp Anawan (1913), Camp Wotanda (1925), Camp Passaconaway (1909), Camp Waubanaki (1923), and Camp Kuwiyan (1910)

ASHLAND
Little Squam Lodge (1929)

HOLDERNESS
Camp Wachusett (1903) and Camp Aloha Summer School (1904)

The following are camps still in existence today on Lake Winnipesaukee.

ALTON BAY
Camp Kabeyun, Camp Brookwoods (Chestnut Cove), Camp Deer Run (Chestnut Cove), and Camp Alton

TUFTONBORO
Camp Belknap and Camp Northwood

MOULTONBORO
Camp Winaukee, Winaukee Island Camp (Black Island), Camp Robindel, Geneva Point Camp, Deepwood Lodges, Camp Tecumseh, KOA Campground, Arcadia Campground, and Camp Iroquois

MEREDITH
Camp Nokomis (Bear Island), Camp Lawrence (Bear Island), and Camp Menotony Girls

8. Landmarks and Legacies

Literally thousands of visitors come to Central New Hampshire every year just to ride the famous cruise ship *Mount Washington*, a true landmark and legacy on Lake Winnipesaukee. This vessel provides her passengers with the natural beauties of the lakes and mountains which make the region so famous. Like the old side-wheeler, it makes daily stops at the port towns of Center Harbor, Wolfeboro, Alton Bay, Weirs Beach, and now Meredith. It is only appropriate to look closely at her continued legacy and heritage as the flagship to boating on Lake Winnipesaukee.

Since the 1940 launching of the *Mount Washington II* in Paugus Bay, many changes have occurred to this fine vessel. At the conclusion of World War II, several marked changes in her motor and physical appearance took place. In the spring of 1946, under the supervision of Douglas Brown and Carl Rossler of General Ship and Engine Works, and owners Carl and Byron Hedblom, the vessel underwent conversions, namely two added 615 horsepower Enterprise diesel engines, which added 30 tons to its weight and 100 tons of concrete for ballast. In order to install these engines, two 35-ton chain hoists were used to lower these engines in place; this was quite a feat. All steam equipment was removed and changed to electrical power, including the steering plant and propellers. For better visibility, the wheelhouse was moved from the second deck to the third.

In the summer of 1946, the *Mount* was inspected and licensed by the Public Utilities Commission under the laws of the State of New Hampshire, and it made its first voyage in August of that year under the command of its new captain, Bryan K. Avery. For better than 40 years, Captain Avery served as the *Mount*'s moving force for the Winnipesaukee Fleet and a legend in his own right.

In 1948, the boat deck was removed and a section of the new third deck was replaced and remodeled for the purpose of carrying passengers, thus providing better visibility of the lake for its passengers. It was on October 31, 1982, that the most extraordinary task was undertaken by the Winnipesaukee Flagship

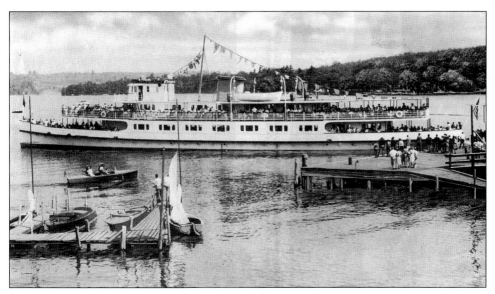

LEAVING THE WEIRS BEACH, 1946. The M.V. Mount Washington *went unused during the World War II years, but resumed its daily passenger schedule after the conflict's resolution.*

Corporation: the 205-foot *Mount Washington* was hauled out of the water on the marine railway at the company's shipyard and winter headquarters in Center Harbor to expand the vessel.

Hundreds of friends and family of the company thronged to the shipyard to witness the separation. Prior to the ceremonies, the actual cutting had been made just forward of the engine room bulkhead. A prefabricated hull section, to be set in place by a large crane, would extend the vessel's length to 230 feet. Several other prefabricated pieces, which make up the various sections of the deck housing and main body of the ship, would be put into place, fully enclosing the interior of the ship.

The bow of the vessel was connected to a gear reduction winch and was pulled ahead 28 feet on a rolling platform that supported the forward section of the ship. The actual power supply was through a sheave and cable, and a winch drum of a crane. This was the first time the *Mount*'s hull had been cut since it was brought overland in 20 pieces from Lake Champlain in 1940.

During the entire operation, Byron Hedblom, former owner of the *Mount*, rejoined the company to supervise the construction of the new 24-foot expansion. His career in shipbuilding with the General Ship and Engine Works in East Boston, Massachusetts, spanned both the Depression and World War II eras, constructing tankers, tugboats, and "Liberty Ships." After Hedblom sold the company in 1972, he retired, moving to Arizona. When the Winnipesaukee Flagship Corporation decided to expand the *Mount*, Hedblom was called to do the design and architectural supervision. At the age of 78, Hedblom met the task set before him with the comment, "Every job's a new challenge."

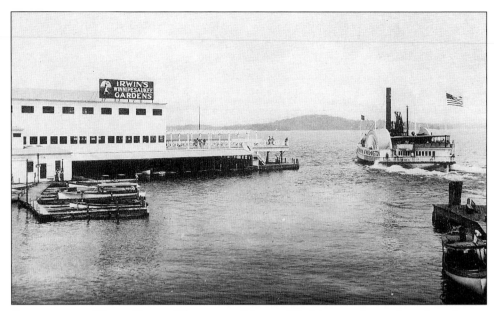

LEAVING THE WEIRS DOCK. The steamer Mount Washington *is seen here departing on one of its many 65-mile daily trips around Lake Winnipesaukee.*

The actual separation took but a few minutes, but the exhilaration felt by the crowd and crew members of the corporation mounted with every moment of the bow's movement forward. The separation maneuvers were under the supervision of Byron Hedblom, Scott Brackett, president of the corporation, and Captain Robert Murphy, vice president in charge of operations for the corporation. Much credit must be given to the master ship fitters, Murray Ryder and John Pettengill, who skillfully refitted the addition of the vessel.

Just six months after she was separated into two sections and lengthened by 24 feet to a total of 230 feet, the *Mount* was ready for re-commissioning. With the sound of the ship's horn and the traditional breaking of a bottle of chablis across the bow, the M.S. *Mount Washington* was re-commissioned and launched in a ceremony held at the shipyard in Center Harbor on Saturday morning, April 30, 1983. Despite the inclement weather, nearly 1,000 spectators attended the festivities and cheered as the *Mount* was slowly lowered into the lake by the marine railway.

Scott Brackett presided at the ceremonies, along with Commissioner Gus Gilman from the Department of Resources and Economic Development. The Reverend Dr. Philip Polhemus offered a prayer for the re-commissioning and for a smooth sailing of the vessel. Mildred Beach, executive secretary of the Lakes Region Association, had the honor of re-christening the ship. Also present for the re-christening was Governor John Sununu.

During the next few weeks, the crew busily worked on her completion and interior facelift, giving her a fresh paint job, newly designed lettering, custom-

made draperies, and new wall-to-wall carpeting throughout the interior of the ship, creating a gracious and nostalgic atmosphere.

With the new lengthening of the ship, new docks had to be installed to accommodate her additional size. Docks at Wolfeboro and Weirs Beach were redesigned. Having changed her tonnage and length, it was most appropriate to change her name from motor vessel (M.V.) to motor ship (M.S.) *Mount Washington*.

During the spring of 1986, the corporation went through a transition of ownership, thus new interior changes to the vessel were made as well as the construction of the port facility at the Weirs. In 1999, new docking facilities were set in place at the Meredith Town Docks so that the *Mount* could make Meredith a scheduled port-of-call for the 2000 season.

Today, the M.S. *Mount Washington* continues to sail the waters of Lake Winnipesaukee as the largest, proudest, and sleekest ship in New Hampshire. Under the direction of President Edward A. Gardner and General Manager James Morash, the *Mount* commands the lake as the Flagship of Winnipesaukee.

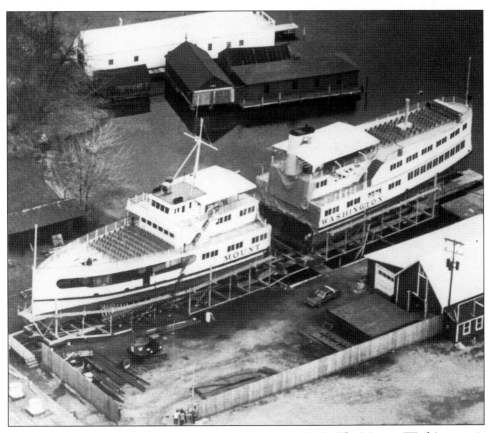

REPAIRING AND EXPANDING THE FAMOUS VESSEL, 1982. The Mount Washington *is seen here under construction at Center Harbor to increase its length from 205 feet to 230 feet.*

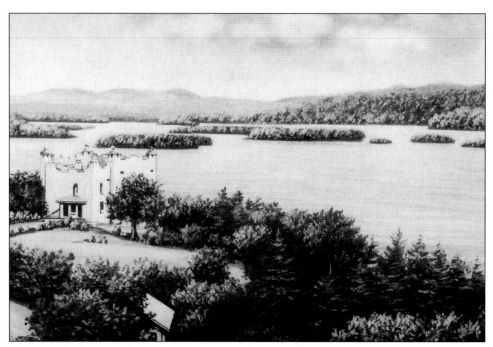

KIMBALL'S CASTLE. From this scenic standpoint, the lavish residence commands an impressive view of the Forties, a collection of islands near Gilford.

It was in 1897 that Benjamin Kimball, president of the Concord & Montreal Railroad and the Kimball and Wright Wheel Mfg. Company of Concord, hired an architect to built his castle on Locke's Hill overlooking Lake Winnipesaukee in Gilford.

In the early 1920s, Samuel L. Powers of Boston wrote the following of Benjamin Kimball:

> Many years ago Mr. Kimball made his first trip up the Rhine River in Germany. As he sat upon the steamer's deck, viewing the vine-clad slopes on either side of the river, he finally came into view of the castles built by the Barons of the Middle Ages. It was then that the thought came to him that he would like to build a castle similar to those, upon the promontory which he owned on the southern bank of Lake Winnipesaukee; so he made a landing, secured an architect, and arranged with him to make plans for a castle, which stands today some seven hundred feet above the lake on the brow of Locke's Hill. That castle is an exact reproduction of the one that he selected upon the banks of the Rhine.
>
> My belief is that the most joyous hours of his life were those spent during the summer seasons at this New Hampshire castle. I have seen Uncle Ben many times sitting in a large chair upon the broad verandah

looking out through the arches at the view before him. On one occasion he said to me, "Where in the world can you find a more superb view, one that has greater diversity of scenery, than the one that lies before us?" It is a remarkable view, seven hundred feet below were the sparkling waters of Winnipesaukee, dotted with its hundreds of islands, each rich with summer verdure extending to the very water's edge. Farther to the north were the silvery waters of Lake Asquam, hedged in by the beautiful range of mountains—Chocorua, Passaconaway, Whiteface, and Sandwich Dome. Still farther to the north, the Presidential Range—Mount Washington in bold relief piercing the fleecy clouds. Farther to the west, Lafayette, Lincoln, and Moosilauke, and still farther to the west the mountains of Vermont. To the east, beyond Ossipee, were the mountains on the westerly line of Maine, and to the south, Belknap and Gunstock, as though keeping guard over the castle. Upon the broad verandah, Uncle Ben would not only discuss the beauty of the scene, but his breast swelled with pride as he recounted the history of New Hampshire and Old Dartmouth.

The castle is built entirely of top stones, which were quarried in Concord and brought to Laconia by train. From there, they were transported up the hill by horse and oxen teams, as were the field stones and granite obtained in back of Locke's Hill. Italian masons were employed to do the work, during which time they were boarded on Kimball's steamer *Lady of the Lake*, which was beached in Glendale and then, upon completion of the castle, disposed of in 40 feet of water in Glendale Bay.

KIMBALL'S CASTLE. The magnificent home is visible in the distance from the Lakeshore Railroad Station at Glendale.

This castle had many similarities of a fort, commencing with its overall appearance and the heavy oak front door, with wrought-iron window grating, hinges, and lion's head door knocker. All the exquisite oak woodwork was made in London and shipped to Boston via freight and reassembled inside the castle. All wrought-iron fixtures, at which the Germans excel, were custom-made in Germany. The handsome dining and living room furniture was elegantly carved of black cherry and oak, also made in Germany. Rooms in the castle included kitchen, pantry, four upstairs bedrooms with corner fireplaces, a sewing room, servants' quarters, and a large combination living-dining room, with picture windows overlooking the massive stone porch and breathtaking view of the lake.

When Mrs. Kimball passed away in 1960, the estate was willed to the Alvord Wild Life Sanctuary of Bear Island. It was felt that if the public wished the castle and its 250-acre park of flowers and shrubs restored and preserved for their society, the society was the most likely to inherit this fine property for proper restoration.

After being abandoned for several years, the inevitable finally happened—vandalism. What could be carried was stolen; windows broken, wrought-iron that wasn't too heavy, removed; stacks of very rare green bulls-eye glass replacements from the windows, smashed; even the huge stone and wrought-iron gates were eventually destroyed—all is gone. It is an era past, but let today's generations remember, affectionately, the bygone years of what it must have really been like to enjoy the lake in the elegance and refinement of the steamboat years.

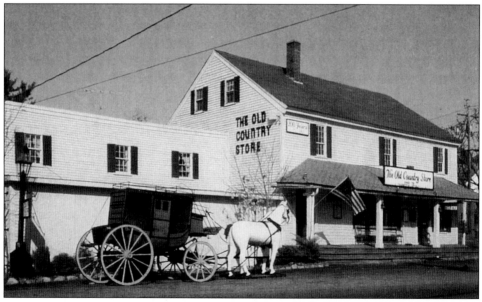

THE OLDE COUNTRY STORE. *This durable structure in Moultonboro is listed on the National Register of Historic Places.*

In the small New Hampshire town of Moultonboro, Freese's Tavern served as the social and political center of the community. Since 1781, its owner, George Freese, was issued a taverner's and liquor license, and in 1794, a retailer's license was issued by the town selectmen. Eventually, this building came to be used as a town meeting hall, post office, library, and trading center of goods.

In 1804, the tavern's meeting room was the site of the formal constituting Morning Star Masonic Lodge by the Grand Lodge of New Hampshire. After the ceremony, the store provided "a rich repast in a style magnificent and splendid" for the Freemasons. The store was then owned by Jonathan Wiggins, a charter member.

Freese was active in town affairs, and in 1816, the town voted to hold it annual meetings at Freese's Tavern rather than at the meetinghouse. This arrangement became commonplace during the 1830s, when the tavern was owned by David Bean (1778–1839). As a licensed taverner since 1809, he was even more active in public affairs than Freese, and the tavern consequently became more of a focus for the town business. In 1831, and almost every year thereafter until Bean's death, town meetings were held at the store. Bean's barroom served as a public meeting place, and legal notices were often posted there as well as at the town meetinghouse. The tavern also provided a convenient site for auctions, and began to assume its present-day role. David Bean became Moultonboro's postmaster in 1837, and the building assumed the further role of post office; a function to which it would return in 1861.

In the year 1851, James French (1811–1886), formerly a country merchant in the neighboring community of Tuftonboro, purchased the building and continued his mercantile business there on an enlarged scale until his retirement in 1873, when succeeded by his son, James E. French, who was a lawyer as well as a merchant and politician. In 1861, French was appointed postmaster of Moultonboro. The post office was first located to the left of the building's main entrance, but in the twentieth century, it was moved to the attached office at the north corner of the main building, where it remained until 1967.

The Olde Country Store is a two-and-a-half story structure with a braced frame of hewn timber, a gable roof, and clapboard exterior. The main building was irregular fenestration of the main floor, shed roofed porches. The store has two brick chimneys, one rising through the front slope of the roof and the second at the rear of the building near the north corner.

Attached to the south elevation of the main building is a shed-roofed wing. It is believed to have been built to shelter horses used on the stagecoaches as well as all horses that passed through town until the turn of the twentieth century. During the 1950s and 1960s, this wing was used as a cafeteria and restaurant facility, but today it has been converted over to an extension of the main store.

The main building is intersected by two other wings, which were added during the 1950s. One, a long two-and-a-half story gable roofed structure, is attached to the rear of the old stable wing. This addition is a wide, gable roofed structure that also extends to the northwest.

The main building has not changed in proportions, and still reveals it origin as a late eighteenth-century framed structure. Like many eighteenth-century New Hampshire taverns, the Olde Country Store contains a combination of semi-public rooms and chambers of types common to domestic buildings.

The present proprietors of the Olde Country Store are Mr. and Mrs. Stephen Holden, who have tastefully maintained the flavor of the eighteenth-century country store. To enhance the heritage of the store, the Holdens have placed a full-scale historic museum on the second floor of the main building, displaying many original artifacts of the period, as well as the town and store's history and legacy.

It is not certain when the first bridge replaced the ford that carried the heavy traffic of early days across the Swift River. This ford was nearly a quarter of a mile above the bridge. It is said, however, to have been a bridge here at the time of the freshet of 1820. There were other freshets in 1826, 1844, 1855, and 1869. The freshet of 1869 carried out the bridge, though it was fastened to its piers with 2-inch bolts. Lorenze D. Bean had just crossed it on his way home to Skinner's Corner after attending an auction, when he was swept away.

Joseph Berry, the builder of the covered wooden bridges of West Ossipee and Conway, was chosen to build the new bridge. He did away with the central pier that had carried all the previous bridges on this site, making his bridge span the whole width of the stream, and placing it high enough to escape freshets of even a 10-foot rise of water. Berry was very proud of this bridge. He said it was so strong that you could fill it full of wood without breaking it down. This was the fourth bridge to span Swift River since 1820. It was named for James Holmes Durgin (1815–1873), who ran a gristmill near the crossing, drove the stagecoach from Sandwich to Farmington, and was a link in the Underground Railroad, which ran from Sandwich to Conway.

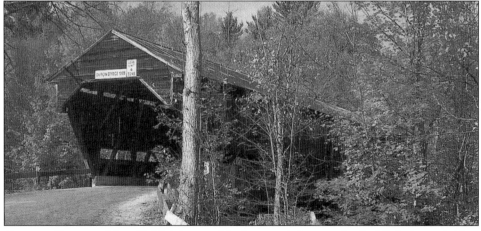

DURGIN BRIDGE, NO. 45. This is one of the few remaining wooden Paddleford truss bridges in the state.

Durgin Bridge is one of the few remaining wooden Paddleford truss bridges in New Hampshire. The bridge has an overall length of 110 feet and an outside width of 19 feet. The roadway within the bridge is 96 feet long and 14 feet wide. This structure sits on concrete-faced stone abutments and is supported by two Paddleford trusses, supplemented by a pair of laminated arches. Between the posts are two diagonal timbers jointed into the posts: a brace and a counter brace.

The bridge has two 12-panel Paddleford trusses, with the counter braces overlapping the posts at both ends and jointing into the upper and lower chords. The vertical posts are extended through the upper chords to support the simple roof trusses. With the support of the counter braces, the upper chords are extended at each end to support the overhanging portals. Resting on the lower chords are the transverse floor beams, which support the long floor planks. The two arches composed of laminated planks were placed on the inside of the trusses. The trusses and arches are independent, with the trusses carrying the dead weight of the bridge.

The sides of the bridge are sheathed with vertical boarding, broken by two short but long rectangular openings in each side. The gable ends of the overhanging portals have horizontal boarding with close verges and plain trim. The roof trusses, each composed of a tie beam, two rafters, and two struts, support the corrugated metal gable roof with its wide overhanging open eaves. This bridge, therefore, is an important reminder of the area's legacy and a significant episode in the state's engineering history.

In 1885, Dr. J. Alonzo Greene fixed his heart upon New Hampshire as a home. He spent the summer seasons of 1885 through 1888 in the Lakes Region. He had traveled extensively through the mountains and along the lakes and seashore resorts of New England in search for what his family and himself might consider the perfect location in which to reside, leaving the busy cares of city life to pass their remaining years in comfort and quietness in the country.

In 1889, he purchased the magnificent property on the largest and one of the most picturesque islands in Lake Winnipesaukee—Long Island in Moultonboro. In that year, Dr. Greene, with his wife and son, moved with all their personal belongings and established their formal and legal residence on this property. Desiring to extend his farming and stock-raising operations, which were even then very considerable, he purchased four adjoining farms on Moultonboro Neck in 1890. The deeds for these were made out by the owners of their agents and given to Dr. Greene's agent. It is interesting to note that two of these deeds are correct and give his residence as Moultonborough, while one inadvertently gave it as Centre Harbor and another as New York. Greene never had the pleasure of residing in either Centre Harbor or New York.

His Roxmont Stock and Poultry Farm had been visited during these first seven years by hundreds of friends and enthusiastic admirers, traveling by special trains and steamboats, including the Amoskeag Veterans and their ladies, the Masons and their ladies of Belknap and Carroll Counties, the Odd Fellows and their ladies of Lake Village (Lakeport), the Knights of Pythias and their ladies, the State Board

ROXMONT STOCK FARM. This is a November 1, 1896 advertisement for Roxmont Stock Farm on Long Island, near Moultonboro.

of Agriculture, and the State Grange and their ladies. In a single week, more than 4,000 guests were entertained by the hospitable doctor and his good wife at dinner—these numerous visitors comprising various delegations from all sections of the state.

This farm was highly stocked with fancy breeds of fowl and cattle and was a source of much pleasure and gratification to its owner, who spent the greater part of his time during the summer months in overseeing it and in hunting and fishing in the neighboring country, for Dr. Greene was a sportsman of no small caliber.

He organized the Winnipesaukee Transportation Company, built two steamboats, the *Eagle* and the *Roxmont*, and chartered still another, the *Cyclone*, and the facilities for lake transportation to and from his residence on the island.

His superb castle (Roxmont), located on the second lot from the bridge on Long Island, consisted of 40 acres and commanded an unobstructed view in every direction. This castle was a veritable treasure house of curiosities and rare articles of furniture and rugs collected by Dr. Greene and his wife during their journeys over the entire world. One could hear beautiful music from the 5-foot-long music box, one of the finest in the country, and could also listen to the Westminster chimes from the massive hall English clock.

The main hall was over 25 feet high, with a gallery running around it, and entirely finished in oak. Eastern rugs hung over the railing, giving it a rich, Oriental effect, and the great flames of hospitality roared in a magnificent broad fireplace. Among other curiosities that were displayed to visitors were Greene's swords and canes from nearly every country around the globe.

A visit to this elegant dwelling was especially interesting considering the fact that the entire plan for this home was drawn by Mrs. Greene from her own ideas. It was not an attempt to copy any foreign castle, but was an original concept of "what a good home should be like." In 1929, the Roxmont estate burned, leaving only the stone gateway and fond memories.

In 1896, Dr. Greene had 33 brood mares and 2 stallions: the famous "General Lyon Jr." and the well-known "Saucy Tom." The story of his blooded horses and cattle with their several pedigrees would of itself make an interesting book. He operated one of the largest horse-raising establishments in New England.

Along the sandy shore of the lake were placed houses for the accommodation of 1,000 ducks and 5,000 hens. A small brook, fed by springs, courses down through the valley for a mile or more, and this stream was lined on either side by nearly a hundred houses for the accommodation of chicks and ducklings. The incubator house was a two-story building, 70 by 40, in the cellar of which were arranged the incubators, each with a capacity of 600 eggs.

Although Dr. Greene retired from active participation in his city business, he became very active in business, social, and fraternal affairs in the Lakes Region. He was a director in two building associations of New Hampshire: the Masonic Lodge of Laconia and the Odd Fellows of Lakeport. He was an owner in the Weirs Land and Hotel Company and a co-owner in one of the most enterprising and widest circulating newspapers in the state. Greene had various other local holdings, making his responsibilities and liabilities one and the same and his home one of permanence.

In addition to these activities, Dr. Greene was president of the National Veterans' Association of New Hampshire and vice president of the New Hampshire Veterans' Association. His memberships in various dignified bodies were transferred, as far as practical, to the Granite State. Dr. J. Alonzo Greene died in 1917.

Local author and historian William H. Greene commented on the following in his book *Geneva Point Center 1919–1989*:

> In 1896, the Roxmont Poultry operations ceased and the barn was converted into an Inn for the growing tourist business. Broad verandahs were built on three sides of the building and a broad stairway was built from the western verandah. [The inn was properly named the Winnipesaukee Inn.]
>
> The tourist business suffered during the first World War. As a result, in 1919 the land and buildings were sold for $30,000 to the International Sunday School Association.
>
> At that time there were 236 acres. Because of some sales in intervening years, there are now under 200 acres. The central area with all of its buildings has been maintained. Some buildings have been moved and few have been replaced with more modern structures to meet the changing needs of the times.

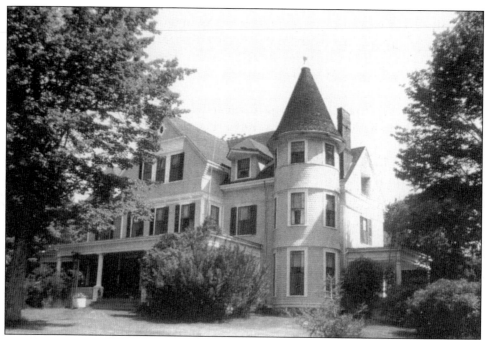

DR. GREENE'S WINDERMERE ESTATES. This lavish home was located on Long Island, near Moultonboro.

Dr. Frank Eugene Greene, Dr. Jared Greene's brother and partner in the patent medicine business, also purchased property on Long Island and erected a magnificent estate and home named Windermere. Windermere has the usual related buildings found on an estate of its time. Aside from the caretaker's house, also referred to as the gate house, the property contains a stable, icehouse, pump house, and a poultry house. The buildings today remain in fine shape as they did over a hundred years ago.

The story of the buildings of Windermere begins in 1891, when Dr. Frank Greene purchased the Lamprey acreage. Dr. Greene then consulted with the well-known Boston architect J.H. Besarick. The blueprints prepared by Besarick are among the Greene family's records. At this time, Dr. Greene sought out two contractors, one was from Boston and the other from Laconia. Busiel, the Laconia contractor, was the low bidder and he was given the contract. As construction proceeded, the Boston firm requested permission to see the finished product. A representative who visited the estate declared that he could not have done as good a job.

The construction of Windermere and its related buildings was spread over two years. All the materials used came by boat, barge, horseboat, and by steamboat from Lakeport. Approximately 100 workmen camped in tents on the property while the mansion was under construction. This was customary in the days before the automobile made possible the daily "portal to portal" approach. Dr. Greene,

while the building went on, frequently stayed at the Long Island Inn, as he watched and guided the progress. Although the materials were transported by boat and although 100 men were involved in the construction, the cost of the three main buildings, the mansion, the gate house, and the barn, added up to only $16,000.

Dr. Green and his wife were frequent travelers abroad, where they collected art objects of all kinds, many of which are among the furnishings of Windermere (paintings, sculptures, artifacts, and other treasures). Following a visit to the Lake Country in England, they chose the name for their country estate, impressed as they must have been with Lake Windermere, which has been so often described poetically for its beauty and peaceful charm. No doubt, they saw a similarity between the beautiful British lake and New Hampshire's Lake Winnipesaukee.

An important landmark in Alton Bay was the establishment of the Second Advent Campground on the Bay. The idea for an Advent Campmeeting Grounds may be accredited to Elder J.G. Smith and a layman Charles Willey, who, in 1860, decided to seek a site out of doors. No one really knows why they chose the large plain overlooking Lake Winnipesaukee in Alton Bay, but perhaps it was because they thought this would be a restful location where their organization might thrive.

Taken from an article in *World's Crisis*, an Advent publication, the following item pertains to the first meeting of 1863: "Providence permitting there will be a campmeeting at Alton Bay, N.H., to Commence September 7, and to hold over the following Sunday. Come ye servants of the living God to the New Hampshire Campmeeting to feed the flock of Jesus Christ and save souls from the second death. Full particulars herewith. For the brethren, J.G. Smith."

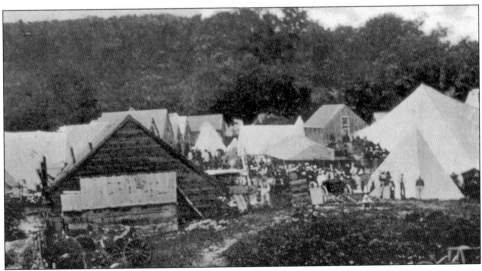

THE CHRISTIAN CAMPGROUND. This peaceful setting has served as a religious campground since the 1860s.

The land for the campground was leased from the Boston and Maine Railroad at its inception, and this situation continued for many years until the territory was later purchased by the association. Soon, on the flat plain, a large tent was erected, which was immediately divided into two sections, one for the men, the other for the women. This tent was filled with straw upon which the people slept. The August issue of *World's Crisis* reported, "Be sure to bring underbeds to fill with straw on the ground, also other bedding. All that can, will provide themselves with tents, but let none stay away that are without, for we will see that they have a place to lodge."

According to local lore, there were approximately 10,000 worshippers attending from every adjacent town and city—some by train, others by horse and buggy. Soon the committees, which planned and prepared the programs of the camp meeting each year, were organized into a manager system. This was incorporated in 1876 as the Alton Bay Campmeeting Association. Many improvements were made as the association grew; a large tabernacle was erected near Rand Cove, Back Bay, and people were finally given permission to put paint on their dwellings.

The campground soon increased and widened its facilities, adding retreats and conferences for the young people of the church. It was fast becoming one of the most widely known institutions in all of New England.

The New Hampshire Veterans' Association (NHVA) is the natural outgrowth of the camaraderie that binds men and women together in times of war and of the desire to perpetuate that friendship in days of peace. The idea of forming this unique body—the only one of its kind in the United States—grew out of regimental organizations formed after the Civil War.

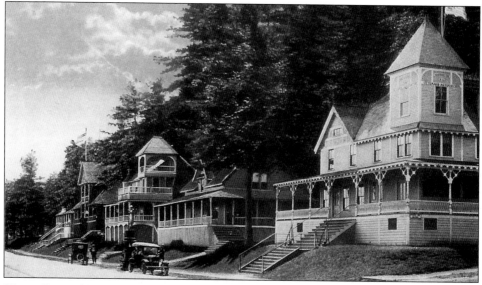

THE CAMP MEETING GROUNDS, EARLY 1900S. *The New Hampshire Veterans' Association bought property on Lake Winnipesaukee in the late nineteenth century.*

THE SOLDIERS MONUMENT. This monument, located outside of the headquarters of the NHVA is the figure of Private Loammi Bean, a member of the 8th New Hampshire Volunteers who was killed in the 1862 Battle of Georgia Landing in Louisiana.

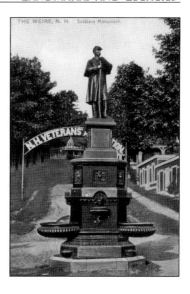

The Veterans' Association was formed in 1875, primarily of Civil War veterans. One of the main purposes was to hold annual reunions during the summer months to renew the ties of fraternity, friendship, and loyalty that had been forged in the camps, hospitals, prisons, and on the battlefields. Articles of Incorporation were granted by an act of the General Court of New Hampshire on July 7, 1881. When originally organized, the association consisted of men who had served in the armed forces of the Union on land and sea during the Civil War. All veterans who are residents in New Hampshire who have served in the armed forces of the United States since that time are eligible for membership.

The site chosen as a home for the association would be hard to duplicate in this or any other state. Soon after 1870, the Methodists commenced holding summer camp meetings at the Weirs, and in 1879, the NHVA held their first annual reunion there. The 7.7 acres of land now occupied by the association at the Weirs and within the city limits of Laconia slopes upward from Lake Winnipesaukee. The association was given this land by the Boston, Concord & Montreal Railroad; however, it was not deeded to the association until 1924. The property offers a beautiful view of both lake and the White Mountains beyond.

During the 1880s and 1890s began the erection of permanent camps for the various Civil War regiments as well as a headquarters building. By the 1920s, many of the Civil War veterans had passed on, but the association became revived by the infusion of World War I veterans, and eventually, veterans of all wars. The number of buildings in Veterans' Grove has declined. During the 1920s there were as many as 35 structures on the property, but today only 15 remain, mostly of late nineteenth-century architecture.

This property belonged to the Boston and Maine Railroad when first occupied by the association, and it was leased to the group for 43 years. Then, the General Court, by making adequate appropriations for it, enabled the association to buy

the entire tract of land from the railroad. The NHVA purchased the land in 1924 for the sum of $4,000. Today, this property now belongs to the NHVA and has only one proviso attached, namely as follows: "That whenever said corporation, from any cause, shall become extinct and cease to exist as a corporation, then all the property, real, personal, or mixed, shall be and become the property of the State of New Hampshire to be used and expended by said State for charitable purposes and none other."

In 1944, an auxiliary was formed to be known as the New Hampshire Veterans' Association Auxiliary. A section of the NHVA bylaws read as follows: "There shall be an Auxiliary to the NHVA known as the NHVA Auxiliary, made up of wives, mothers, daughters, and sisters of veterans who have faithfully in the aforementioned services of the United States, and who have received an honorable discharge therefrom, and of Sons of Veterans organizations in the NHVA, also members of Auxiliary bodies of organizations participating in the NHVA."

Lying at the north point of Weirs Bay, between Meredith Bay and Center Harbor, lies Meredith Neck, extending into Lake Winnipesaukee. This point of land is not a long, narrow piece, but better than 2 miles wide, divided near the end into what appears like three smaller necks. The first division, nearest the Weirs, sloping from the Pinnacle, is called Spindle Point. It is recognized by its lighthouse, which was constructed by Colonel Charles Cummings for his daughter as an art studio.

The origin of Spindle Point can be traced to a 500-acre farm owned by John Eaton and later sold to his son, John Morton Eaton in 1847 for $600. In 1901, John Morton Eaton sold the land for $3,000 to Colonel Charles Cummings, who was a 33-degree Mason. Colonel Cummings intended to leave the Spindle Point Farm to the New Hampshire Grand Lodge of Masons for a Masonic home and retreat; however, the cost and maintenance of such a project was far too excessive for the fraternity, thus the land was sold to developers.

Today, one can see Lighthouse Point, which extends from Observatory Road on Meredith Neck, as a beacon for navigators and tourists alike.

SPINDLE POINT, 1950s. A couple in a rowboat enjoys the scenic charm of the lighthouse.

9. Navigation and Recreation

With the large number of crafts being used on the lake, consideration of lake navigation became inevitable. For over 40 years steamboat navigation went on without specific aids to navigation. The lake was uncharted, and as a pilot learned new courses, he or she established his/her directions by landmarks and navigated the craft and its course by this visual aid: a mountain range, a church steeple, or an island. But one had to know where the unseen hazards were located. Basically, New Hampshire's boat navigation became an issue, when, in 1881 the steamer *Eagle* fell to an accident in Paugus Bay. It was in that year that the New Hampshire Legislature enacted the first law for the inspection of public boats because of the near sinking of this vessel and a rebuilt steamboat on Lake Winnipesaukee off Rattlesnake Island in Alton in 1880.

In 1882, Colonel Drake was appointed boiler inspector by the State for inspection of commercial vessels. Later, in 1889, the legislature appropriated $1,000 for navigational buoys on New Hampshire lakes. In 1915 the Legislative Act granted control to the Public Service Commission and required registration for private boats. The first year of private boat registration occurred in 1916, numbering 1,509 vessels and fees of $1,509. In 1931, New Hampshire started placing flashing navigational lights on public waters—the first being placed on Winnipesaukee and Winnisquam.

Through the Public Service Commission, the State of New Hampshire has kept pace with the increasing concerns for safety on the state lakes. A portion of these increases can be attributed to the State's program of lighting and buoying the New Hampshire lakes.

In 1937, the Fish and Game Department, in its program to improve the state's fishing waters, greatly benefitted from the Public Service Commission's work to light and buoy the lakes, and the nonresident fisherman, who had a boat in the state or who brought a portable craft to New Hampshire, was afforded protection for his boat when on strange waters. New Hampshire's front position in its inland

water buoying program added inducement for fishermen in 1937, which few states possessed.

It would be impossible to list all the small improvements made during 1937, but some of the larger items accomplished by the Public Service Commission are worthy of note: dredging or other clearing of navigable waters to the extent of approximately 11,000 cubic yards; 45 new spar buoys were placed in new locations in Lake Winnipesaukee, Squam, Winnisquam, Island Pond, Sunapee, Connecticut, Newfound, Massasecum, and Cobbett's Pond; 4 new steady light beacons were placed in Lake Winnisquam and Winnipesaukee; Lovell Lake and Silver Lake (at Chesham) were buoyed for the first time.

By the completion of the 1937 season, the Public Service Commission maintained 776 spar buoys, 46 modern flashing light buoys, and 30 steady lights in 25 lakes of the state. This represents an investment of approximately $15,200 in lighting and buoying equipment for New Hampshire waters. In comparison to an early-1900s map of the lake, there were 205 spar buoys and 18 numbered electric light buoys.

It wasn't until 1961 that legislation created the Department of Safety and Boating under the jurisdiction of Safety Services. During that year, records indicated that 37,750 motor boat registrations were issued for New Hampshire waters. By 1965, 40,790 boats were registered.

In 1972, Governor Walter Peterson appointed Richard M. Flynn as commissioner of Safety; Douglas A. Whittum, the first boating education officer; and Alton H. Stone, director of the Division of Safety Services. The following year, Thomas J. McCabe Jr. was hired as the first full-time boating education

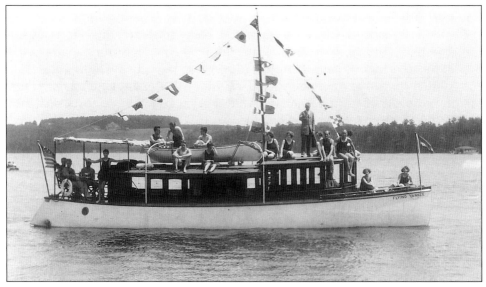

RECREATIONAL BOATING ON THE FLYING YANKEE. A rather large crowd of passengers are enjoying Jim Irwin's personal boat as they glide by Governor's Island.

RECREATIONAL BOATING. In this 1935 photograph, Jim Irwin (standing on the dock in the white hat) acts as judge for the annual boat show.

officer, and Richard Dame, as maintenance foreman. During that year William Hancock retired after 42 years of service as supervisor of navigation. In 1974, Francis E. O'Donnell was hired as the supervisor of navigation. In 1976, John F. Bridges was appointed director of the Division of Safety Services by Governor Meldrim Thompson and resigned in 1980.

By 1980, there were 57 uniform officers, 237 lakes were patrolled on a regular basis, 7,570 boats had been stopped, and 83 accidents had been investigated. During that same year, Charles R. Stanton became the new director of the Division of Safety Services. In 1983, there were 47,800 registered boats, and 55 uniform officers were employed covering 300 lakes. In 1986, Thomas J. McCabe Jr. was promoted to marine patrol chief, and Mark K. Gallagher, deputy chief. By 1988, Kevin M. Monaham was appointed the director of the Division of Safety Services, followed by David T. Barrett as director in 1989 and re-appointed by Governor Merrill in 1996.

The State considers boat safety a very serious business, and under the direction of Captain McCabe Jr., water safety (its constant improvement and maintenance) is priority number one. The New Hampshire Department of Safety Division of Safety Services, regularly publishes updated navigation maps with all the necessary legends, buoy marking and locations, and updated regulations, so as to keep the state's lakes safe for boating and recreational enjoyment.

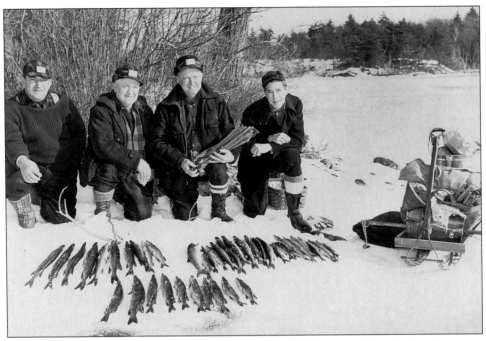

ICE FISHING, 1950. These four proud fishermen display their successful catch from the waters of Lake Winnipesaukee.

Ice fishing in central New Hampshire has long been a way of winter life, and it is here that great hordes of people congregate on the ice to enjoy this recreation and to exchange pleasantries with other winter fishermen. The lake is stocked with salmon, which are taken from early spring through the summer months. Lake Trout, native to the lake, are caught from January 1 through September 30. Smelt, whitefish, smallmouth bass, yellow perch, horned pout, suckers, and chain pickerel are all taken in season.

Many visitors to the Lakes Region ask, "What enjoyment do these people get from ice fishing in those shanties? How do they know where the best fishing is on such a large lake, and why, for Pete's sake, do they call them 'Bob houses'?" Contrary to the seclusion desired by the summertime fisherman, ice fishermen seem to be a friendly lot. They delight in visiting together and sharing fishing lore. Very few will mind if a person walks from group to group asking questions. When seeing a group of fishermen and women huddled together out on the ice, one can be sure of two things: there is a lot of idle chatting going on, and there is probably a good school of fish right below them, waiting to be caught.

For a first-timer at the sport, probably one's best bet in determining where to go ice fishing is to experiment at first and go with the crowd, but more important, go with someone who knows what he/she is doing. Most successful fishermen don't mind sharing their secrets, and many old-timers derive great pleasure from helping a newcomer acquire skill. There are exceptions to this, of course. A few

old-timers take their ice fishing so seriously that they resent any intrusion into their fishing time.

The lake's fish are not nearly as active in winter as in summer. During the spring months especially, almost every species of fish is busy spawning, eating, and hiding to keep from being eaten by larger fish. They are also kept occupied chasing pesky neighbors away from their nesting sites so the fry won't be swallowed alive. During this period, fish eat almost everything that moves, including various lures and flies that summertime anglers throw at them. They will even chase and strike at lures three times larger then they are.

But in the wintertime, fish act quite differently. The only requirement of fish in the winter is that they eat enough to stay alive. The less they move about, the less food and energy they need to live. So the job of enticing a fish to hit a lure or to move very far to take live bait becomes quite a challenge. Locals believe, however, that wintertime fishermen catch more fish per man-hour of fishing than summer anglers. The reason for this is "The ice fishermen can handle more rods and tip-ups, and his average catch per rod goes up."

Generally, fish in the wintertime are quite lethargic, coming out to feed only part of the day. The rest of the time the fish hide in the few weeds left on the bottom of the lake and rest. Weeds that grew tall, even reaching the surface during the summer, recede and fall to the bottom of the lake during freezing weather. Fish that need to hide to stay alive seek cover in these weedy remains.

Each lake's fish population lives according to a fairly stable timetable. Bass have predictable feeding periods, bluegills seem to hit well in the morning and evening. Competition for food seems to be the key to fish's feeding habits. Therefore, it stands to reason, if one learns when the fish's movements occur, one can save a lot of fishing time.

For many years ice fishing has been a tradition on New Hampshire's lakes. Shortly after Christmas, ice begins to form across most lakes, and one by one, the

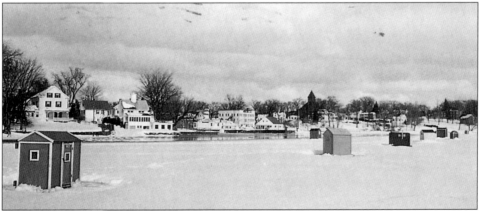

ICE FISHING, 1961. This scene in Wolfeboro shows the traditional "bob houses" that dot the frozen surface of Lake Winnipesaukee.

ice shanties (Bob houses) appear on the bays, until literally hundreds are scattered across the entire lake. The term "Bob house" came about by the "bobbing" action of the line in the hole of the ice.

During the past 22 years, the Meredith Rotary Club has sponsored "the Great Rotary Club Fishing Derby" as an annual fund-raiser for the many projects of the club. This derby is usually conducted during the first half of February each year and attracts thousands of participants from all over the East Coast of the United States and Canada. On Lake Winnipesaukee, ice fishing is more than a sport, it is a way of life.

In addition to ice fishing on the "Big Lake," there are many other joys to be had on the ski and snowmobile trails that abound the area. A carefully planned network of trails are well marked and mapped, as well as slalom courses and jumps for beginners and advanced alike. From the ski trails on Gunstock Mountain in the Belknap Mountain Range, a visitor may pause for a moment to enjoy the panoramic view of the "Broads" in Lake Winnipesaukee framed by the Ossipee Mountains in the distance.

Skating, tobogganing, snowshoeing, and winter carnivals may also be enjoyed in most towns in the region. Sled-dog races are an exciting feature of the region, highlighted by the World Championship Sled Dog race in Laconia every winter since 1923. This sport has become a very popular feature in the region. For a number of years, the town of Meredith had its own team of sled dogs for its annual winter carnival.

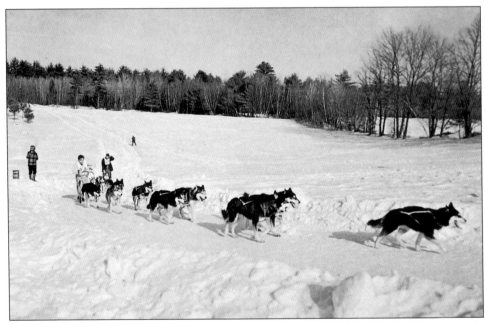

SLED DOG RACING. These sled teams are competing in the 1968 World Championship Sled Dog Race in Laconia.

EPILOGUE

There is no limit to the diversity of outdoor recreation for the vacationer in the Lakes Region. Whatever one's age and pleasure, there are activities which will entice the tourist and visitor to the Lakes Region. It may be a relaxing interlude at a fine hotel, or on a beach with the family and friends. Whether one lingers in one town or drives around the lake by automobile, there are constantly fine views of the lakes and mountains in the region.

To the west are Newfound and Sunapee Lakes. Twenty-five miles northeast is beautiful Lake Chocorua, at the foot of matchless Mount Chocorua. From there a fine road leads through the White Mountains and points north. It may be a reflective moment in a canoe or sailboat, which seems to flow in concert with the spirit of man—a rare marriage of simplicity and efficiency as it whispers across the quiet lake. The intrusion is gentle and welcomed—a quiet interloper in a primitive scene. Henry David Thoreau once wrote that there is a certain ethereal quality to the mere act of floating upon water that heightens one's perceptual receptiveness. It may be a speedboat ride in the broad expanse of the lake; possibly, a 50-mile cruise aboard an excursion boat on some balmy August afternoon. There is nothing quite as unquenchable as a seasonal devotee on Lake Winnipesaukee. From the boats that ply over these waters, one experiences commanding views of the hills and more distant mountains. However, the famed loveliness of this region, its groves of hemlocks and white birches, its many hundreds of green islands and charming coves, may best be seen from a cruise of the lake itself.

For nearly 300 years, thousands of sailing vessels have plied the waters of Winnipesaukee. Whether they be the first historic gundalow, the steamers and side-wheelers of the 1800s, the classic sailing boats, or the motor-powered speedboats and yachts of today, they have become an ever-present form of recreation on New Hampshire's lakes. The wealthy had their yachts, sail boats, and party boats, the tourists could rent a speedboat or enjoy a cruise aboard one

PEACEFUL SETTING. This photograph captures the rustic beauty of the lake's north shore.

of the many commercial vessels on the lake, but whatever the pleasure, these crafts have certainly played an active role in the development of the recreation on the lake. Dotted on the shores in the bays, harbors, and coves in every town around the lake, one most certainly will find a marina to service, sell, and store craft.

New Hampshire abounds with an almost infinite variety of lakes and ponds, inexhaustible in resources and unlimited in beauty. Surely such a scenic feast has never been set before the eye of man within such comparatively circumscribed limits of space. Visitors from the world over have admired its beauty and charm and are constantly awed as to how well the people in the area have preserved the region from overdevelopment and the spoils of tourism. Simply, there are those in the Lakes Region, such as the Lakes Region Conservation trust, who have seized the opportunity to celebrate and preserve the ways of life that are passing by the New England wayside while some still remember what a New England wayside is.

The Lakes Region Conservation Trust, founded in 1979, is an independent non-profit volunteer organization whose mission is to conserve land for wildlife habitat, for thoughtful public use, and for the preservation of the character of the region. Presently, the trust manages 66 properties totaling more than 9,000 acres, including that of Stonedam and Five Mile Islands on Lake Winnipesaukee.

Equally, the Loon Preservation Center at Lee's Mills in Moultonboro was founded on the belief that loons and other wildlife can thrive in the company of people if people respect their needs. Loons have come to symbolize the wilderness character of Lake Winnipesaukee and all of New Hampshire. This organization is

presently celebrating its 26th year of working to preserve loons and their habitats through research, management, and educational activities. A perfect area to experience the habitat is at the Markus Wildlife Sanctuary on the shore of Lake Winnipesaukee. Here, the visitor may enjoy the natural beauty of upland forests, marshes, clear streams, and a mile of pristine shoreline. Wildlife viewing opportunities abound on guided trails in the sanctuary, and one may even catch a glimpse of the resident loon pair.

When the bugles of spring sound in the New Hampshire valley, they echo in the hearts of its people everywhere. Memories locked as tight as a winter brook stir to life and burst through the mind in a tumult of recollection.

From marshy lands and small ponds at twilight rise the shrill peeping of frogs and the cry of the loon—that constant, indescribably lonely chorus which, more than other sounds, floods the mind with a thousand memories. To walk along some country roads in the gathering dusk, a soft wind in one's face and the very air filled with that lonely cadence is to drop the present from one's shoulders and stroll into a past that is far away and long ago.

As the season unfolds, the tang of smoke from grass fires yields to the fragrance of apple orchards, and a myriad of bursting buds and opening flowers is heavy with the scent of spring. With the blossom-laden air coming through windows, people are lulled to sleep by the soft May rain that patters on fresh, new leaves and on the shingles of roofs.

At the mossy doorsteps of a thousand forest-captured cellar holes bloom wild roses and purple lilacs until the air itself is like a benediction to the Nature-awakened memory of those who have been, by man, so utterly forgotten.

The hazy mountains call. The river's bend beckons. The open country road, lying faintly white and still beneath the stars, lures one on. The crisp clear, windy

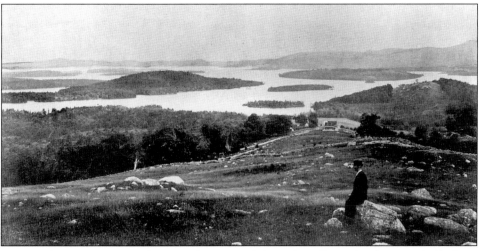

LAKE WINNIPESAUKEE. This view from Meredith Neck reaffirms the charm and refreshing character of the lake and its islands.

air of northern mountains tingle in the blood. For through it all runs a longing that grips the mind just as Nature seizes the land and frees it from the clutch of winter. Spring has swept across the open lake.

It was here, in this peaceful background at the northern tip of the lake, that poet John Greenleaf Whittier found such a plentiful store of enjoyment and inspiration. It was here that he loved to watch the shadows play on the meadow grass and creep over the dark pines on the rolling hills. It was here that he loved to see the neighboring peaks of Chocorua, Paugus, and Whiteface outlined against the vivid mountain blueness, or wrung into a somber damp and grayness that is the mountain's own. And it was here that he loved to hear the northwest wind as it blew from the notches to play with the slender arms of the elms, and torment the river into a multitude of ripples.

Winnipesaukee, the Queen of all New England lakes, still reigns with undimmed glory over an ever-increasing host of loyal subjects. Its vast store of water, scenery, bracing air, fine fishing, bathing, and its natural charm and local color certainly make it a paradise for the artist and camera enthusiasts. The Winnipesaukee habit is one that seldom leaves the visitor who has become addicted to it. And so it comes to pass that, no matter what the season of the year, the region witnesses the return of most of those who have previously enjoyed the lake. It is through this glorious vestibule that visitors pass to seek rest and recreation—indeed New England's summer playground.

RESTING UNDER AN OAK. Mrs Eaton and her friends enjoy the shade of an oak on the shore of Meredith Bay.

SELECTED BIBLIOGRAPHY

Andrew, Henry N. "The Royal Pines." *Appalachia, Vol. 27, No. 2*. 1948.

Athletic Department. "A Center Harbor Race." *Yale University*. 1852.

Bardwell, John D. and Ronald P. Bergeron. *The Lakes Region, New Hampshire*. Norfolk, VA: the Donning Company, 1989.

Bear Island Conservation Association. *Bear Island Reflection*. Newton, MA: Roberts Printing, 1989.

Belknap, Jeremy. *History of New Hampshire*. Dover: S.C. Stevens and Ela & Wadleigh, 1831.

Bement, Louis D. *Camping Handbook, Summer Camps*. Boston: Porter Sargent, 1931.

Bickford, Gladys and the Center Harbor Historical Society. *Center Harbor, New Hampshire*. Center Harbor: J. & J. Printing, 1986.

Blackstone, Edward H. *Farewell Old Mount Washington: The Steamboat Era on Lake Winnipesaukee*. Staten Island, NY: the Steamboat Historical Society of America, 1969.

Blaisdell, Paul. *Three Centuries on Winnipesaukee*. Somersworth: the New Hampshire Publishing Company, 1975.

Carver, Jonathan. "Travels through the Interior Parts of North America in the Year 1766, 1767, and 1768."

Colby, Solon B. *Colby's Indian History*. Exeter: Walkers Pond Press, 1975.

Drake, Samuel. *The Hear of the Mountains*. New York: Harpers and Brothers, 1882.

Dudley, Laura H. "Annals of Three Mile Island Camp." *Appalachia*, June 1965.

Fiske, John. *New France and New England*. Boston: Houghlin, Mifflin, & Company, 1902.

Gray, P. *The History of Castle in the Clouds*. Boston: Bromley & Company, n.d.

Greene, Howard F. "Winnipesaukee Voyage." 1872.

Greene, William H. *Geneva Point Center, 1919–1989*.

Greenwood, Grace. Letter. 1886.

Griffin, Barton McLain. *History of Alton, New Hampshire*. Somersworth: the New Hampshire Publishing Company, 1995.

Harris, I.F. "Mayor W.F. Knight's Address to the New Hampshire Board of Trade: the Weirs." 1907.

Heald, Bruce D. *Follow the Mount*. Meredith: Winnipesaukee Flagship Corporation, 1971.

Heald, Bruce D. *Mail Service on the Lake*. Meredith: Winnipesaukee Flagship Corporation, 1971.

Heald, Bruce D. *Steamboats in Motion*. Meredith: Moultonboro Historical Society, 1980.

Hewins, Gilbert M., ed. *The Mountain People of Moultonboro*. Meredith: Moultonboro Historical Society, 1980.

Hurd, D. Hamilton. *New Hampshire*. Philadelphia: J.W. Lewis & Company, 1885.

Huse, Warren D. *Images of America: The Weirs*. Dover: Arcadia Publishing, 1996.

Huse, Warren D. *Images of America: Laconia, New Hampshire*. Dover: Arcadia Publishing, 1995.

Jewell, E.P. "Memorial Address of Endicott Rock Monument." Laconia: 1892.

Jolly Island Centennial Committee. *Jolly Island: One Hundred Years (1893–1993)*. 1993.

Jones, Walter. *The Sands of Time*. Boston: the Boston YMCA, 1998.

King, Starr. *The White Mountains*. Boston: Crosby and Ainsworth, 1866.

Lancaster, Daniel. *The History of Gilmanton*. Gilmanton: Alfred Prescott, 1845.

Manning, Robert E., ed. "Mountain Passages." *Appalachia Anthology*. 1982.

McClintock, John N. *New Hampshire History*. Concord, 1889.

Mulligan, Adair D. *Gunstock Parish*. West Kennebunk, ME: Phoenix Publishing Co.

New Hampshire State Papers XXXIX, Vol. I and Vol. VI, 1896.

Parker, Benjamin F. *History of the Town of Wolfeboro, New Hampshire*. Somersworth: New Hampshire Printers, Inc., 1974.

Pillsbury, Hobart. *New Hampshire History*. New York: the Lewis Historical Publishing Company, 1927.

Powers, Samuel L. "Benjamin Kimball." Boston, 1920.

Price, Chester B. "Historic Indian Trails of New Hampshire." *New Hampshire Archaeologist, No. 14*. 1967.

Rosel, Lorenca L. *God Save the People: A New Hampshire History*. Oxford: Equity Publishing Company, 1988.

Sanborn, Frank B. *New Hampshire: An Epitome of Popular Government*. Boston: Houghlin, Mifflin & Company, 1904.

Sandy Island Centennial Reunion Committee. *The Sands of Time, Sandy Island Camp: The First 100 Years, 1899–1998*.

Sargent, Porter. *Summer Camps: A Survey*. Boston, 1931.

Speare, Mrs. Guy E. *New Hampshire Folk Tales*. Brattleboro, VT: Stephen Daye Press, 1936.

Starbuck, David R. "A Bibliography of New Hampshire Archaeology." *New Hampshire Archaeologist*, Vol. 28, No. 1. 1987.

Sweetser, Moses F., ed. *The White Mountains: A Handbook for Travelers*. Boston: J.R. Osgood, 1884.

Thompson, Ralph E. and Matthew R. Thompson. *First Yankee: David Thompson (1592–1628)*. Portsmouth: Peter E. Randall Publisher, 1997.

Vaughan, Charles W., ed. *The Illustrated Laconian*. Laconia: Louis B. Martin Publishing Company, 1899.

Waite, Otis, ed. *Eastman's White Mountains Guide*. Concord: E.C. Eastman, 1895.

Wilcomb, Edgar H. *Old Davisville Governor's Island*. Laconia, 1923.

Wilcomb, Edgar H. *Rambles about the Weirs*. Laconia, 1923.

Wilcomb, Edgar H. *Winnipesaukee Country Gleanings*. Laconia, 1923.

INDEX